JASPER CONRAN

COUNTRY

JASPER CONRAN
COUNTRY

PHOTOGRAPHY BY ANDREW MONTGOMERY

conran
OCTOPUS

This book is dedicated to Kathy Gilgunn, Aileen Skinns, Sue Foulston and Karin Stretford-Grainger, with very much love.

INTRODUCTION

"Country" is an idea – a texture, a flavour, a state of mind – and can be perceived in many different ways. Close your eyes, and imagine the English countryside. What do you see or hear, smell, feel or taste? It might be a sweep of beautiful landscape or the warmth of a roaring pub fire; perhaps a porch filled with dripping coats and muddy Wellingtons, the scent of ripe apples and freshly baked bread, or the hum of bees in a sleepy kitchen garden. My idea of "country" involves all the senses and situations, both outdoors and indoors, and most of them involve, at some level, people.

This book is a celebration of that idea; an attempt to capture in words and photographs some of the many threads that, woven together, make up some of the fabric of the English countryside. It records the people and events I found during a year of exploration – an extended ramble that constantly surprised and delighted, intensifying my lifelong love affair with country life. The fact that I am a designer who has worked all his life with fabric, form and colour does not make me an expert on rural affairs but, when it comes to appreciating part of the texture of the English countryside, I think it might have helped.

This is a very personal book, celebrating the particular areas in which I grew up and in which I now live, as well as the encounters during my year of exploration. It is also a book about universal themes. Our world is being transformed, not just by globalization, but by urbanization, too. For the first time in history, more people live in towns and cities than in the countryside. Across the globe, we are forgetting our rural roots, but I believe that country life, its values and people have never had more to offer.

I have also tried to capture in this book the distinct atmosphere and flavour that permeates country life. This is not some imagined past, but about life as it is lived today, in all its wonderful complexity. I worry these treasures can be all too easily lost. In some countries, grey urban landscapes merge from one city to the next. I hope something similar does not happen in England.

Human beings were never meant to live too far away from nature. We become depressed and bewildered if we stay in our cities for too long, alienated from the seasons, cut off from nature and uprooted from the soil. In cities the pace of life may be faster and louder, the parties more glamorous, but I admit that I only really feel comfortable and at home in the country.

I have nothing against change or modernity. Supermarkets, roads and new housing all bring great benefits, in the right measure. The countryside needs innovation and investment. It also needs us to appreciate what is already there. During my travels around rural England collecting impressions of what I like, I have observed a delicate balance of man-made and natural beauty, of old and new, and wild and tame. We should not take it for granted.

The countryside belongs to all of us, or rather I should say it belongs to none of us. It is merely entrusted to our keeping, to be tended, watered, nurtured and handed on to the following generations in good condition. In committing my experiences to print, I hope that I will encourage others to share my sense that our rural heritage is priceless. We need to cherish it.

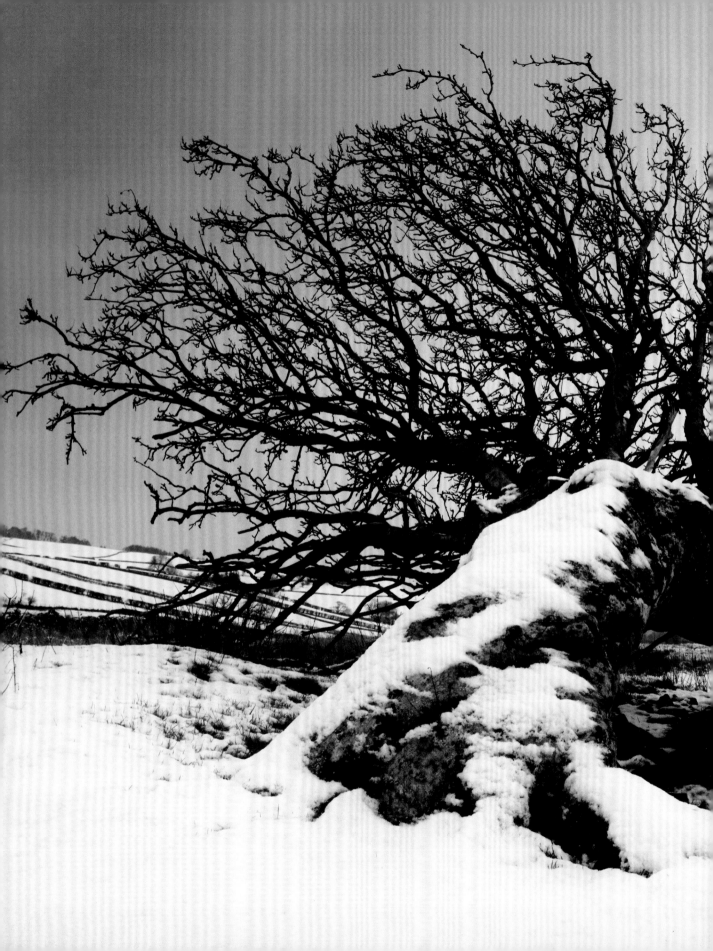

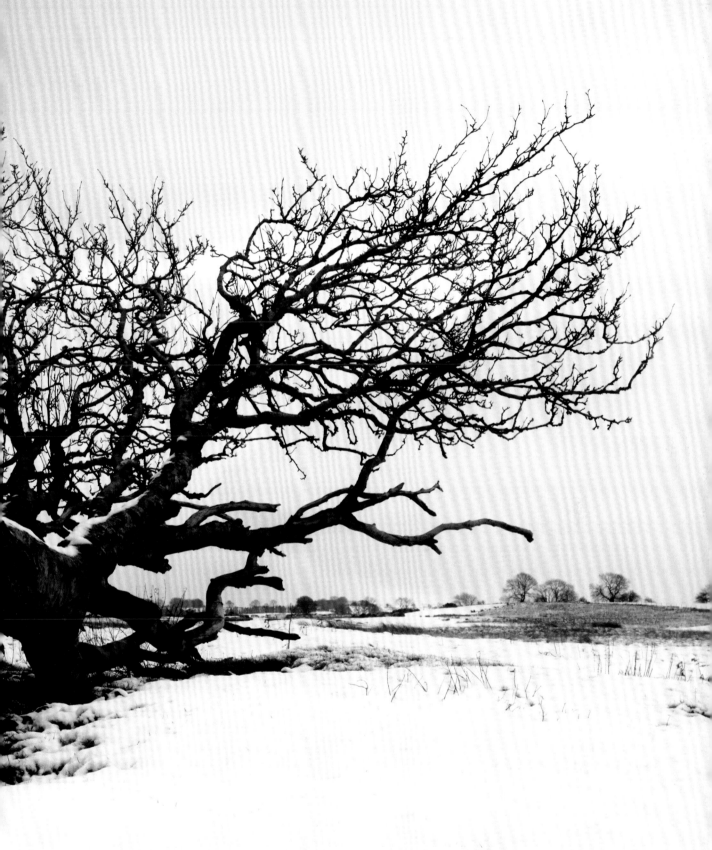

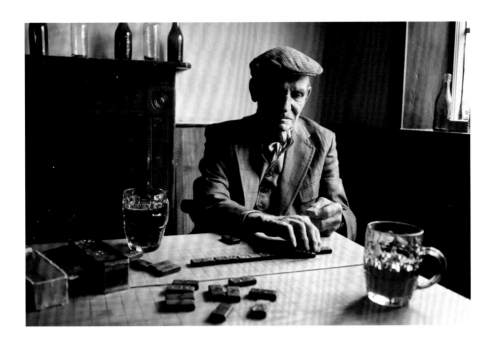

YOU ARE CLOSER TO NATURE IN THE COUNTRY and more aware of its changing moods. That's why, in choosing a place to begin this collection of rural impressions, I think of two complementary moments. One was an icy afternoon in Derbyshire, standing in the shadow of a cold, wet centuries-old tree, its trunk weighed down with age and snow, and watching, in some alarm, a blizzard sweep down from the Pennines. The tame English countryside suddenly felt like a wild and dangerous place as we hurriedly retraced our steps to the nearest village.

The other was a no less icy afternoon in Suffolk, enjoyed from the warmth of the fireside one of my favourite pubs, the

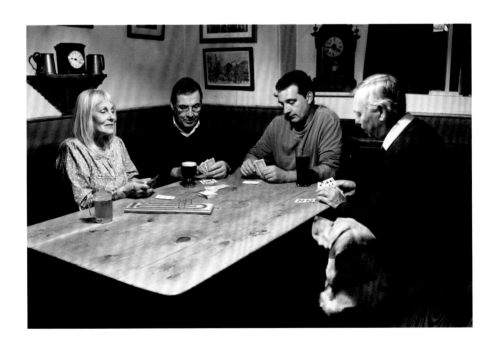

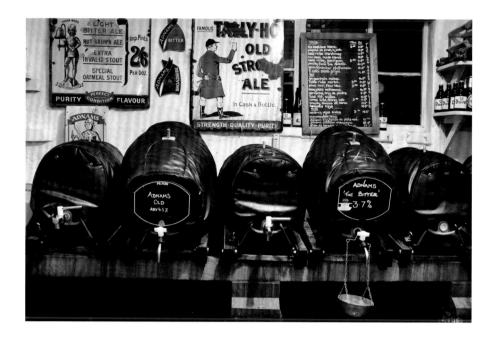

King's Head in Laxfield. Also known as the Low House, it is a pub that is as traditional as they get. It has low ceilings, high-backed settles, an open fire, real ale and plenty of locals coming in for a chat or a game of dominoes or cards. It doesn't even have a bar. You simply serve yourself from the casks in the taproom, adding to the feeling of being in a shared living room.

Each scene captures, for me, the essence of a country winter. On the one hand, there is a sense of exposure to the elements and, on the other, a sense that together you can keep them at bay. The two feelings complement one another. The romance of a landscape blanketed by snow deepens with the thought that a warm fireside and kindly neighbours are within easy reach.

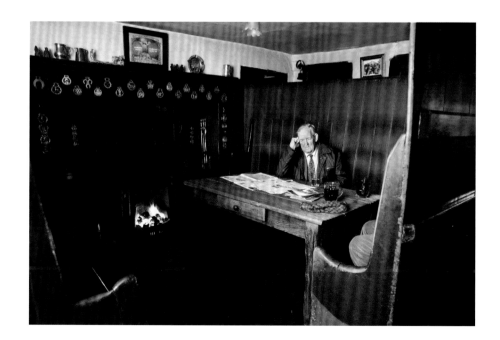

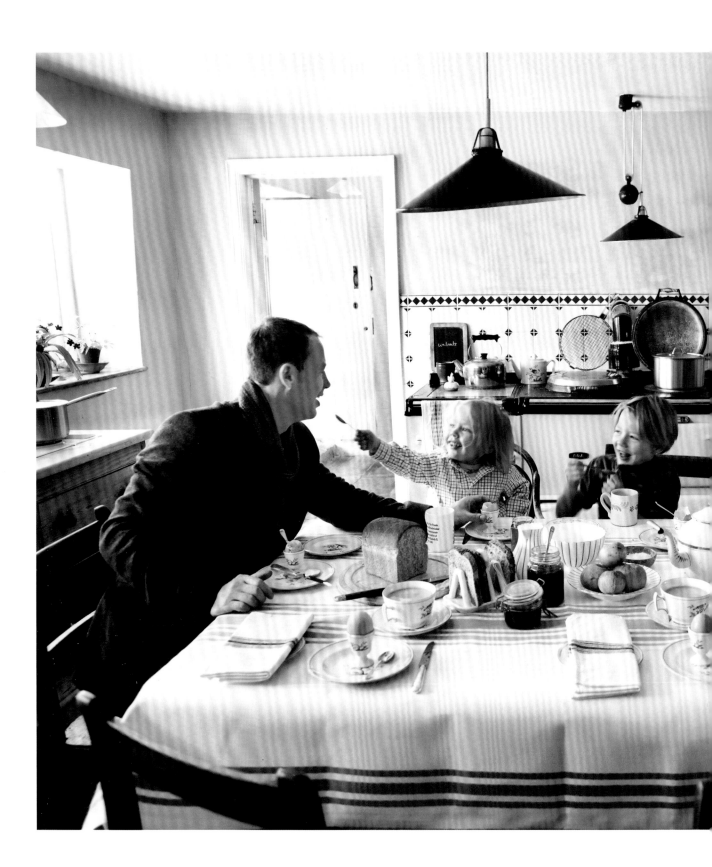

IT IS EASY TO IDEALIZE THE countryside, particularly if, like me, you have happy memories from childhood. I don't believe that there is anything false about such memories or even, perhaps, much that is false about the ideal. I think of it as the "rural dream"; a vision that, in my lifetime, has drawn many from our towns and cities to start new lives in the country.

In this idyllic life, we live, to some extent, as people used to live. Not in the sense of enduring the physical hardships that until recently disfigured those with more rustic lifestyles, but in the sense of enjoying life's simpler, more natural pleasures.

As well as unspoilt landscapes and heart-stopping views, my rural dream includes friendly communities, families and neighbours who have time for each other and children who get their excitement from the world around them, rather than the worlds within their PlayStations. Does this make me a sentimentalist? Perhaps. Yet my encounters of country life strongly suggest that this dream is still in places a reality.

Travelling through the West Country, East Anglia, Cumbria, Yorkshire and beyond, I encountered elements of it again and again. There were villages where old and young still gather together to enjoy traditional pastimes; flagstoned kitchens where children and dogs cluster around the warmth of the Aga (or curl up on ancient armchairs in front of a log fire); craftsmen and women who support simple but satisfying lifestyles by keeping traditional skills alive; families who linger over a breakfast of newly laid eggs and home-made bread, locally made butter, apples from the orchard and jam made last summer, savouring both the food and each other's company.

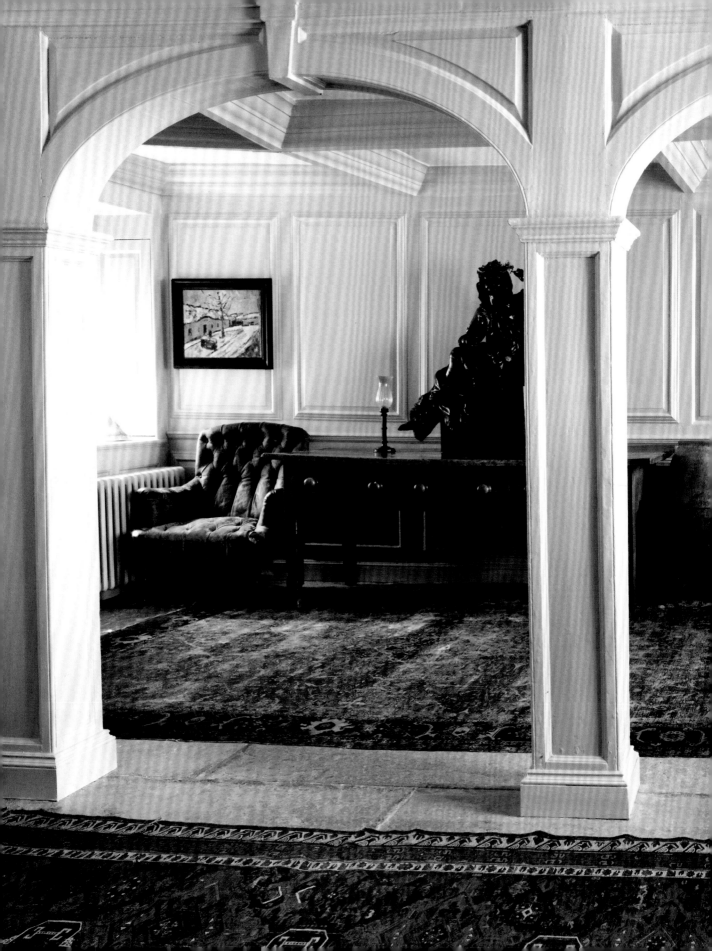

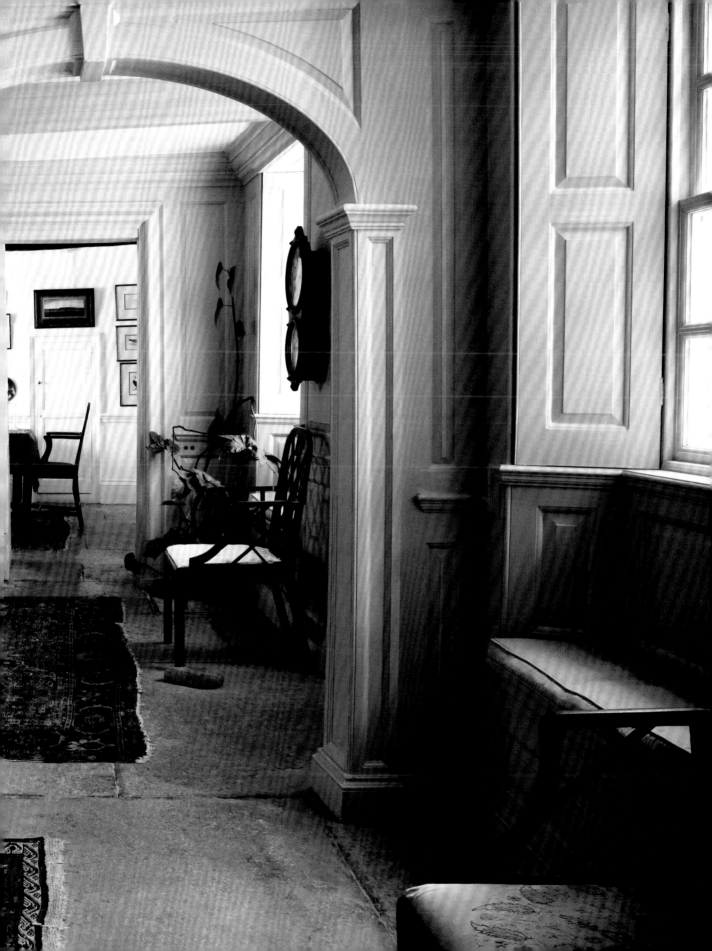

Are these things rural? I think so. I visited many country homes, some grand, some humble, some old, some less so. Most shared a unique quality. Once inside, you somehow knew you were in the countryside. It was partly a matter of telltale clues; a greenness or lightness beyond the windows or perhaps the worn muddiness of the floors. There seemed an approach to homemaking clearly distinguishable from urban design. In cities, we seek perfection. We design, improve and buy our way into the aesthetic ideal of our dreams. In the country, people are more likely to make the best of

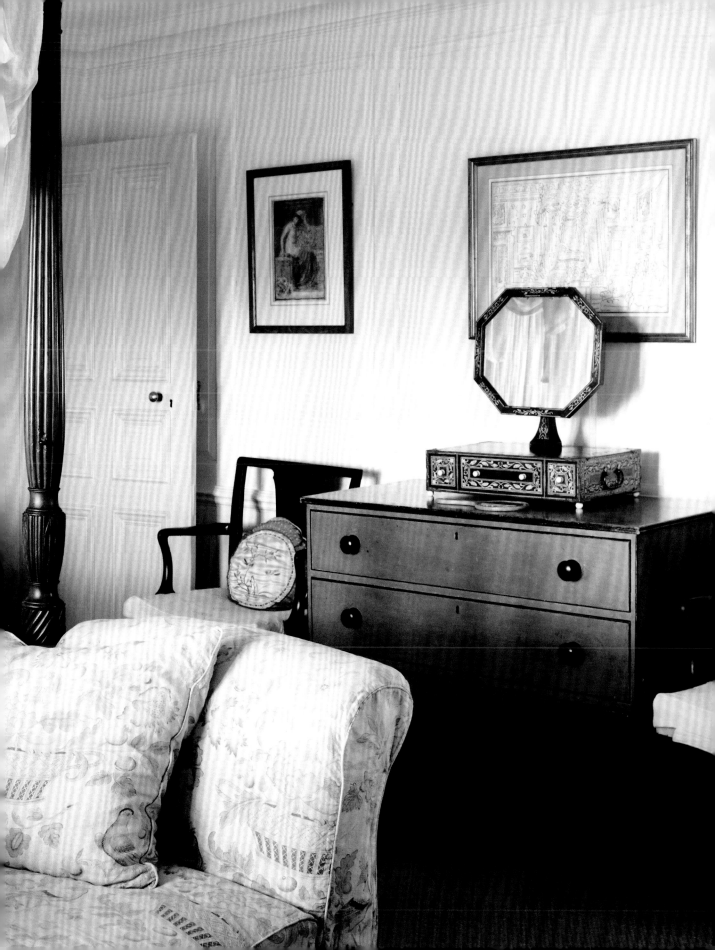

what is there; an eclectic mixture of styles and objects from different periods and places. There is a well-worn accumulated-over-time quality to the furniture; the same eroded non-angular lines that distinguish landscapes from cityscapes.

Perhaps it sounds somehow anti-modern to prefer an idealized past to a necessarily imperfect present, but the homes celebrated here are all to be found in the countryside today. If people live happily in them, it is not because those homes are old, but because they answer some of the needs of modern lives – and also, I think, because of the spirit in which we enjoy them.

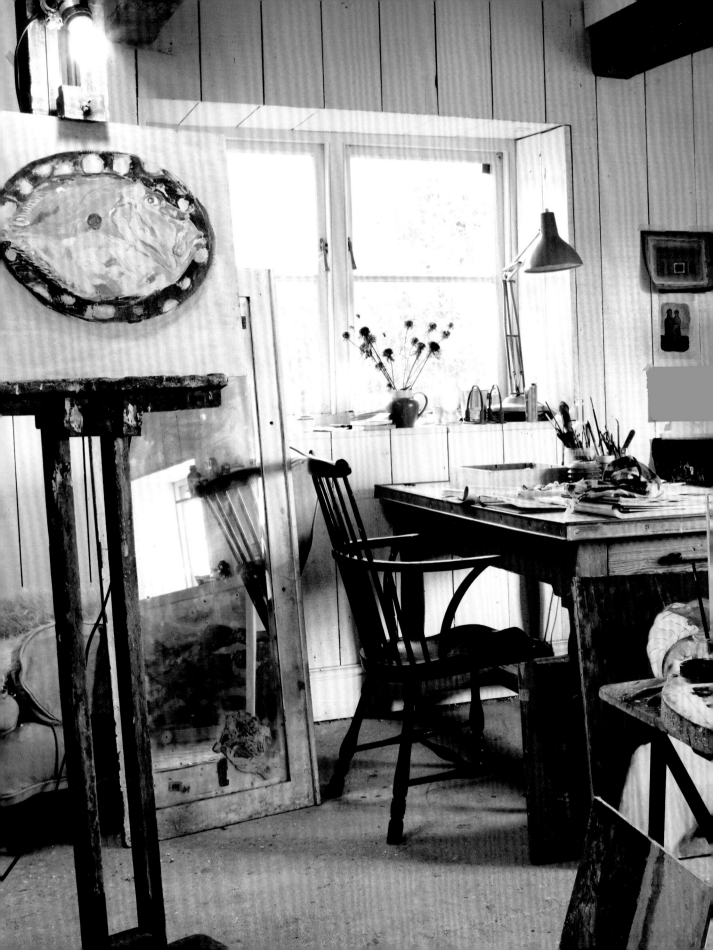

That's why I make no apology for appealing to the memories of my childhood. One of the first stops on my journey was a house in Dorset where I spent a great deal of time as a child. It was a happy house then, and it is happy now. Nestling at the mouth of a secluded valley, it has a permanently peaceful air and, for me, the quality of being a retreat and a place where good things happen. I remember Sunday lunches, long, bracing walks and family games in front of the fire, and my most recent visit evoked many happy thoughts. In the house, the past was everywhere, imprinted on old chairs, paintings and odd-shaped baths. The deserted outbuildings, as well as the gardens and woods beyond, were all calling to be explored, and were where I discovered an unexpected burst of early snowdrops scattering the banks of a stream.

Perhaps it was my reminiscing that made me see the house and garden in that way, but it was also, I felt, the right way in which to see them. I wanted to travel through the countryside filled with that same sense of wonder, excitement and curiosity. The countryside is, after all, there to be explored.

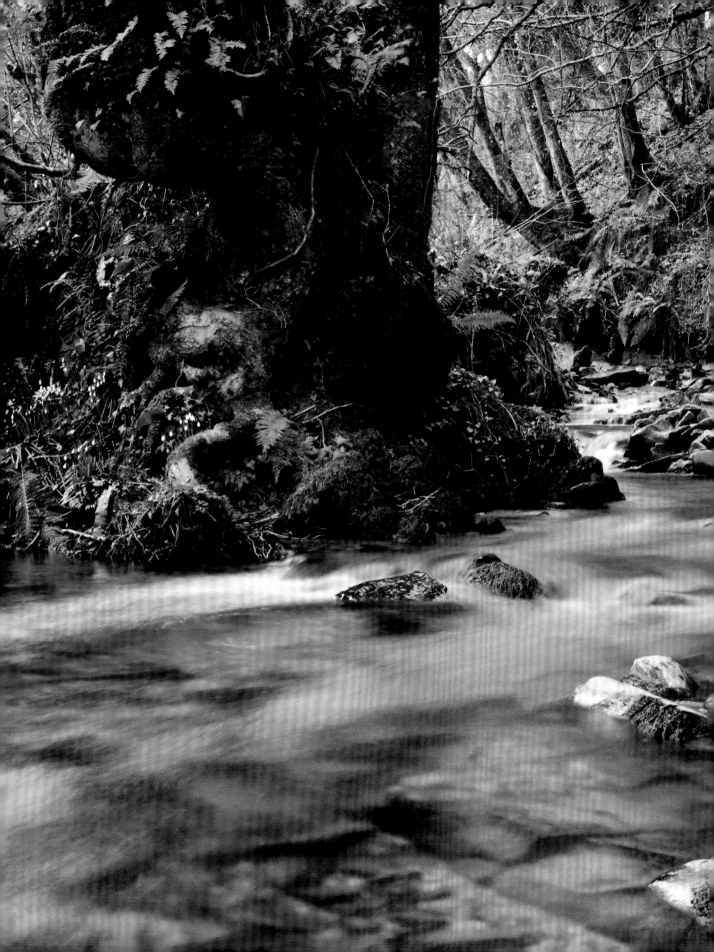

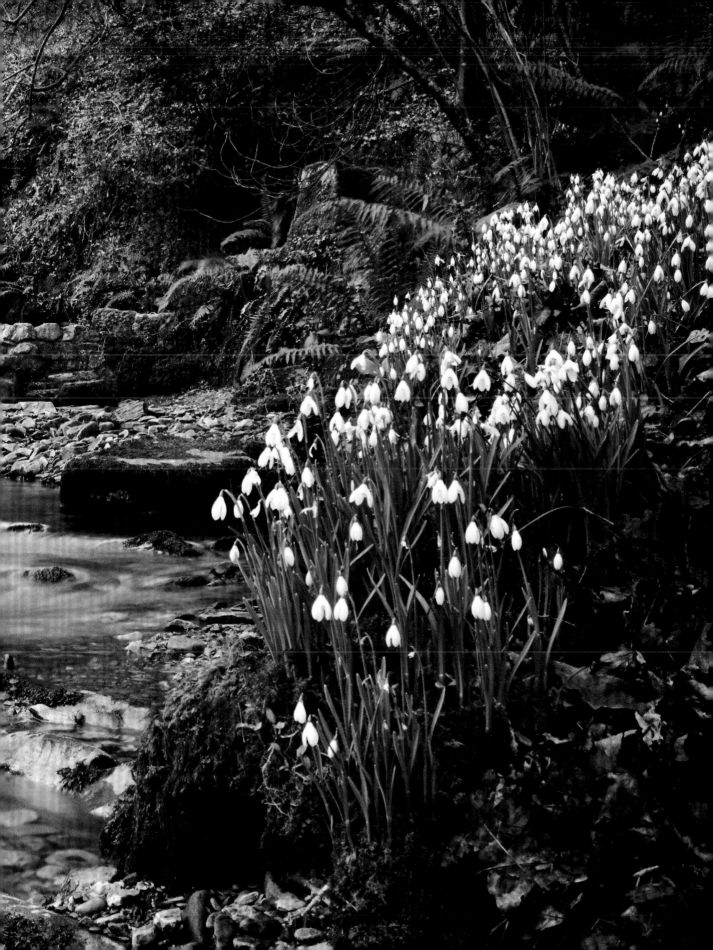

I WOULD HATE TO LIVE IN A WORLD WITHOUT SEASONS. It would be like living in a world where clothes were all the same colour and made from the same fabric. In the country the seasons are felt in the unfolding of each day. The verdant green of early summer is my favourite time, but there is great beauty in the bareness of winter; in the sparse patterns made by leafless trees or the damp, cold earth of a kitchen garden.

In Coombe Bissett there is a kitchen garden that once belonged to friends, Edward and Jane Hurst. When I turned up, it was bare and empty. You could feel the depth of the winter sleep from which it was emerging. Paint had peeled and flaked in the cold, flowerpots were cracked by frost and the soil was black and lifeless, but you could tell that, come the summer months, this garden would be bursting with life.

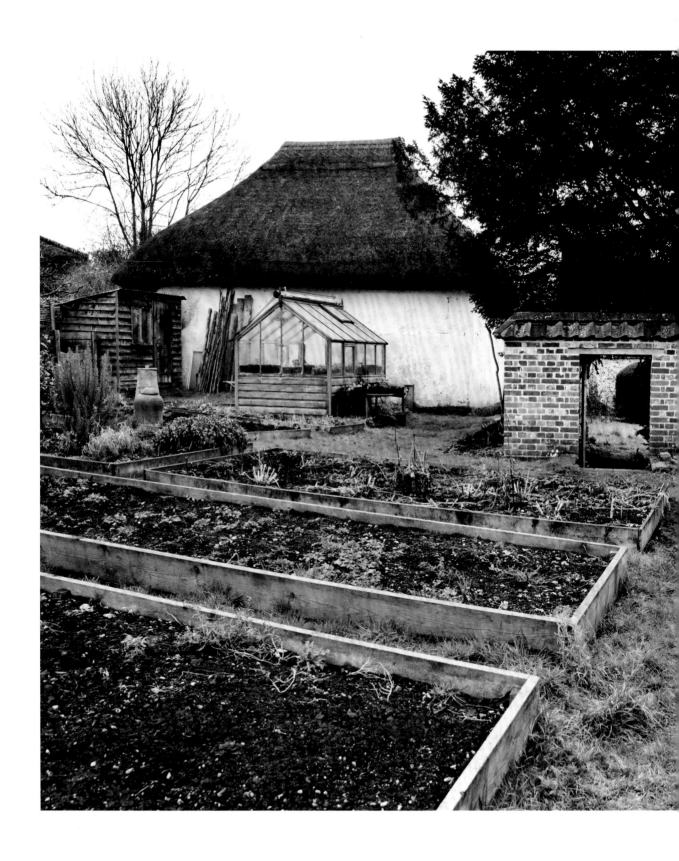

I love kitchen gardens. When you work in one, you feel in tune with the rhythms of nature, the harmony of dig, plant, grow, pick and eat. Few smells are as evocative as the earthy scent of freshly dug carrots or potatoes, and few tastes can rival the sweetness of vegetables still growing an hour before they are eaten.

The other quality that struck me about Edward and Jane's garden is that, although at first glance it seems lifeless and deserted, there is always a sense of the people who created it. The more you look, the more you become aware of years of painstaking care; of planning and laying out and of different

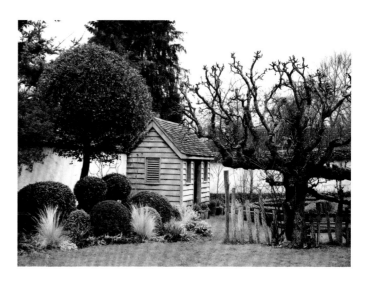

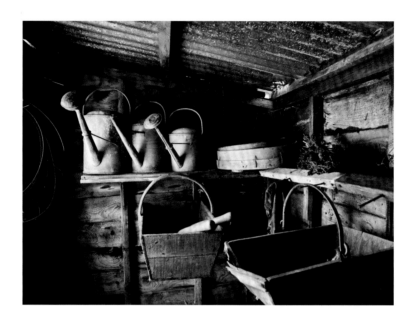

generations who have planted, weeded and dug, as well as the stories unfolding as paint peeled and glass cracked. Many layers of time are visible. That deep sense of the past is one of the pleasures of living in the country. Wherever you look, at a house or garden, a village or church, or even a local custom, there are the echoes of the memories of many generations. One of the most intriguing aspects about the photographs in this book is how they also depict a more modern age. In them are insights into country life as it is lived by some now, an understanding that the present is merely one brief moment in a centuries-old process of growth.

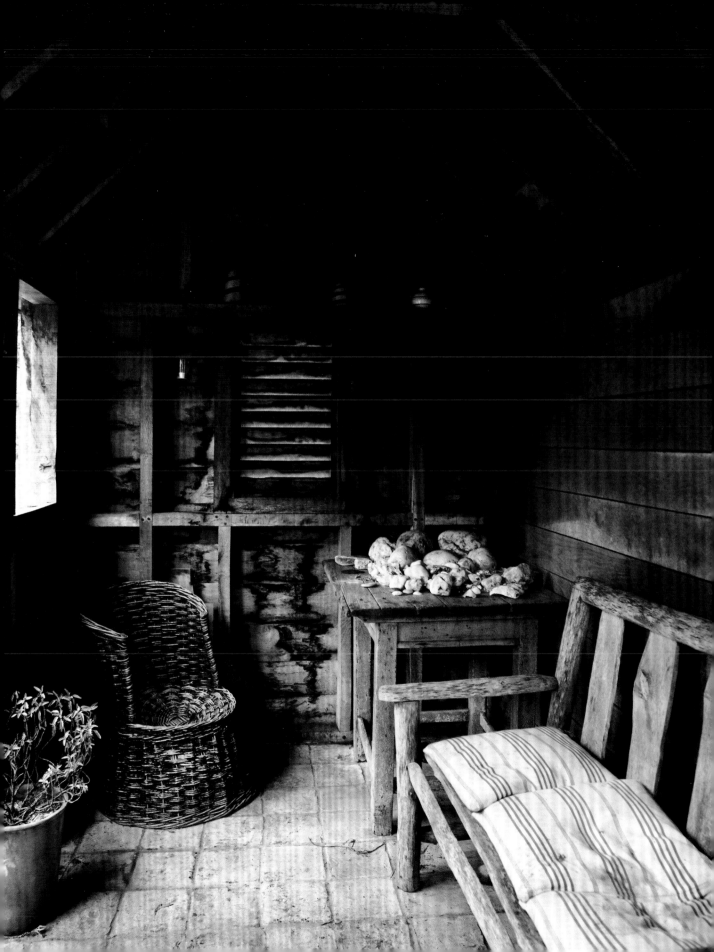

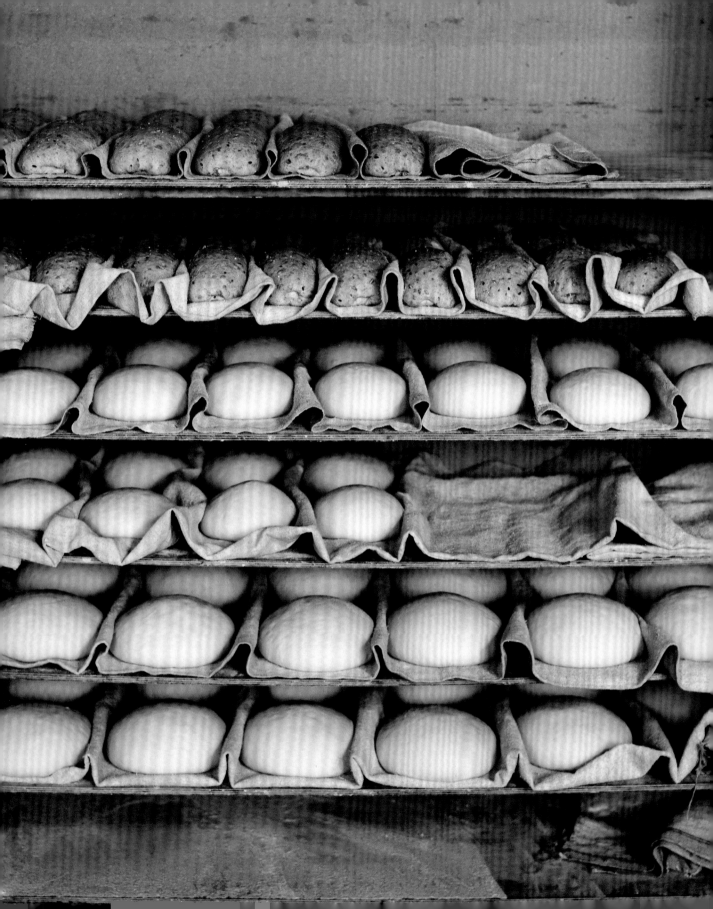

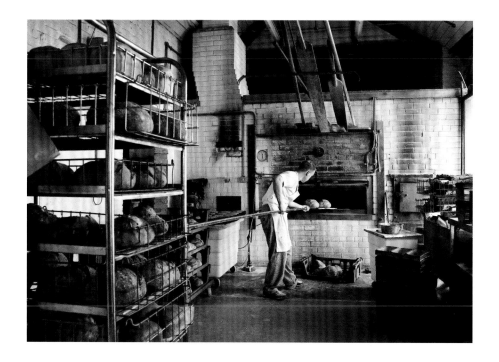

THERE IS A WIDESPREAD REVIVAL OF interest in traditional ways of food making. A bakery in Long Crichel, near Wimborne in Dorset, famous for its breads and pastries, has as its head baker James Campbell, who learned his craft from a master baker in Tours, France. In Britain, he says, "The artisanal tradition was pretty much lost for several generations." The ingredients he uses are mainly local and his secret is time. "We give the bread much longer to ferment".

The bakery, in a converted eighteenth-century stable block, is a feast of sourdough bread, olive and rosemary loaves, almond croissants and pains au chocolat. If you linger, you might see James or his baker Scott, pictured above, patiently kneading and moulding the balls of dough, allowing them time to prove, checking the temperature of the oven and gently slipping each

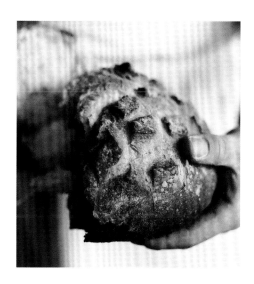

loaf from his long-handled "peel" onto the oven floor. It is both an art and a science. He looks like a stoker on a steam train as he shovels in the loaves. During each stage of this quasi-industrial process, he is exercising the finest judgment about ingredients, timing and heat. It is, as James puts it, "a magical process of transformation through fire". He is clearly a perfectionist, obsessed with "keeping the integrity of the product". His business thrives because people prefer his traditionally made breads to the "Frankenstein foods" (as James calls them) that they can buy more cheaply in supermarkets.

Sometimes, of course, the appeal of traditional ways is more to do with nostalgia than with the food itself. A little country sweet shop in Pateley Bridge, North Yorkshire, is

just like the one in Hampshire where my grandmother often took me as a small child. I can remember deliberating over whether my threepenny piece was best spent on gobstoppers, pear-drops or wine gums. The choice was no easier in Yorkshire.

There is much to be said for the way food is traditionally made in the country. It is a long, many-layered process, from the slow cycles of agricultural production to the painstaking transformation of fresh ingredients using techniques that have been refined and passed down through the ages. To some eyes, it might seem inefficient, but there is a point to the slowness, as adherents of the growing Slow Food movement will testify. It works only if it is not hurried.

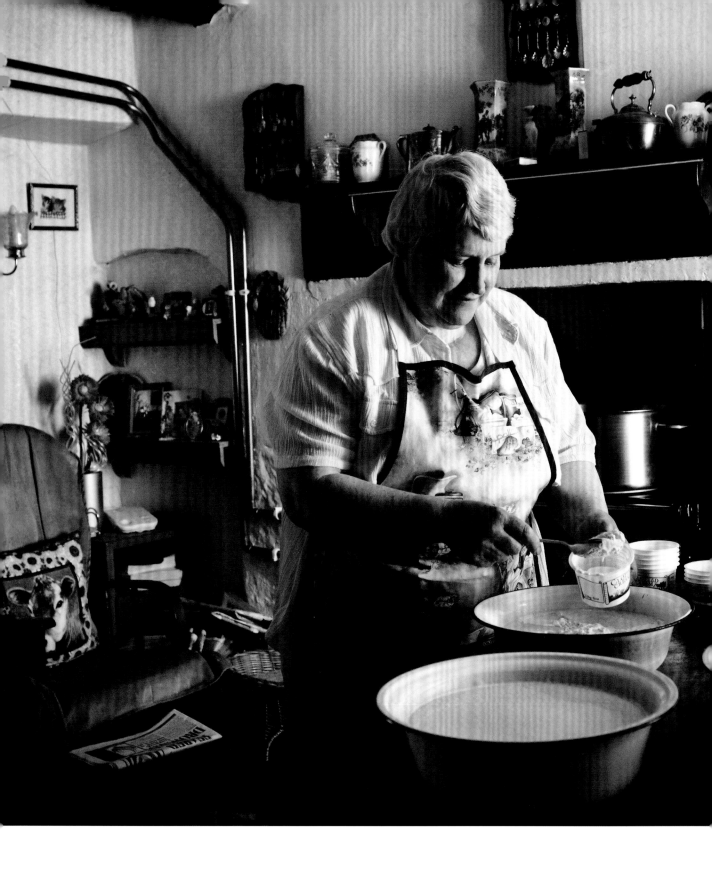

I DON'T KNOW WHAT A MANAGEMENT CONSULTANT would make of Barbara Lake's working practices. She lives alone in Coades Green, near Launceston in Cornwall, on the farm where she was born. She has eight acres, eight cows and, for the past eight years (since her mother died), she has looked after them herself, apart from a little outside help at harvest time. She's out milking early and late, and thinks nothing of taking on other chores, such as ditching, well after dark. It sounds like a hard life

but she smiles broadly as she explains how she still makes cow's milk into "budder" and clotted cream in the old-fashioned way. This involves scalding milk in a shallow pan over hot water for up to two hours at a time (for the cream), while an enormous amount of patient stirring and patting is needed to make her creamy unsalted butter. The results are deliciously different from the pale imitations found in supermarkets. These methods have been passed down through the generations for a good reason. They work.

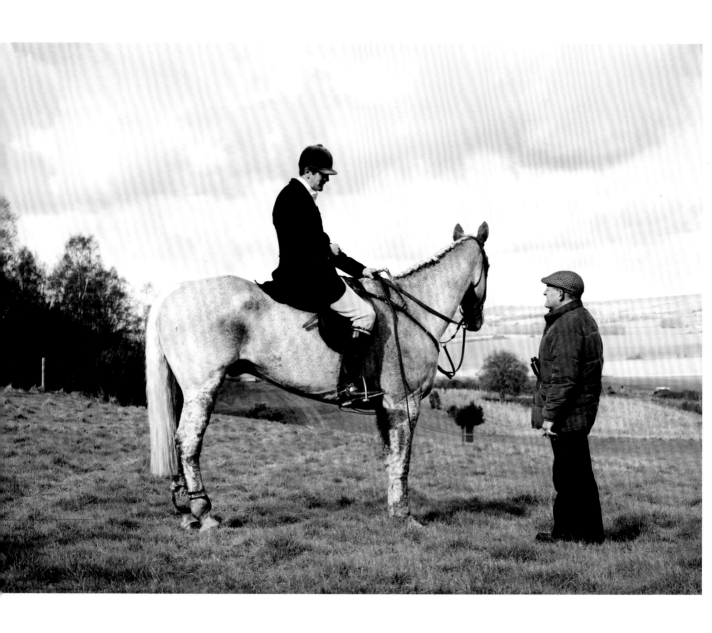

I'M NOT MUCH OF A RIDER MYSELF, BUT I DO FEEL
sympathy for those whose lives revolve around horses. You cannot keep horses or
work with them without being in touch with the land. At times, it is hot and sweaty
toil; at others, cold and wet. There is always mucking out to be done, both on dank,
winter days and warm midsummer ones. That constant sense of being attuned to
nature inspires a sense of harmony among those who share an enthusiasm for horses.

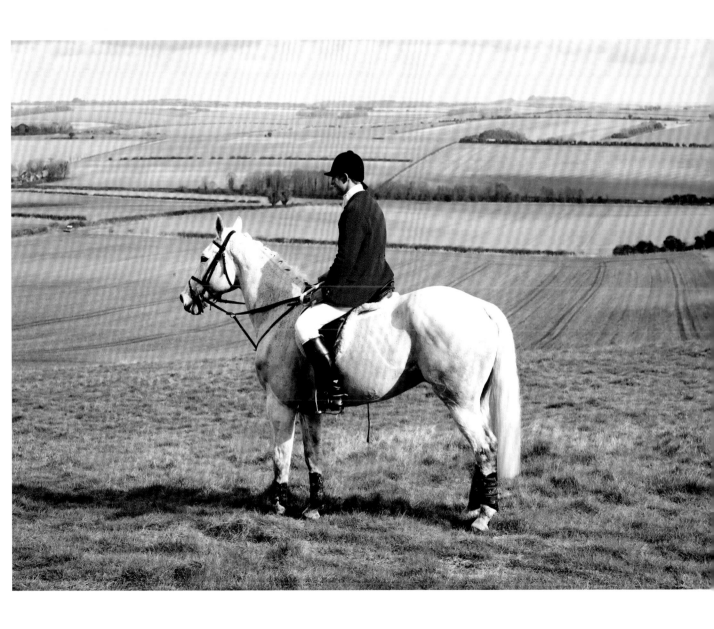

You notice this particularly with hunting. I followed two West Country hunts, the Wilton and the Blackmore & Sparkford Vale, and did not see any foxes killed (something which is no longer supposed to happen). Instead, I found a wide cross section of people of different backgrounds and generations whose shared interest in horses, hounds and nature outweighs any distinctions of class, age or wealth. The young Doggrell brothers (overleaf), sons of the Blackmore & Sparkford's huntsman

Mark Doggrell, are participating in a tradition that has been part of the local social fabric for hundreds of years, enjoying sights, sounds and smells that can scarcely have changed since the days of their great-great-grandparents.

According to Edward Hurst (pictured on page 40, on horseback, chatting to Les Kale, a local cattle dealer, during a day out with the Wilton), "There's no better way

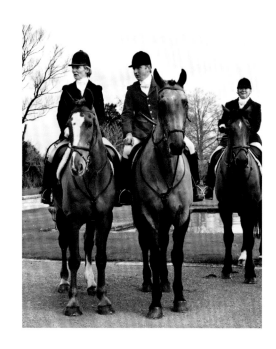

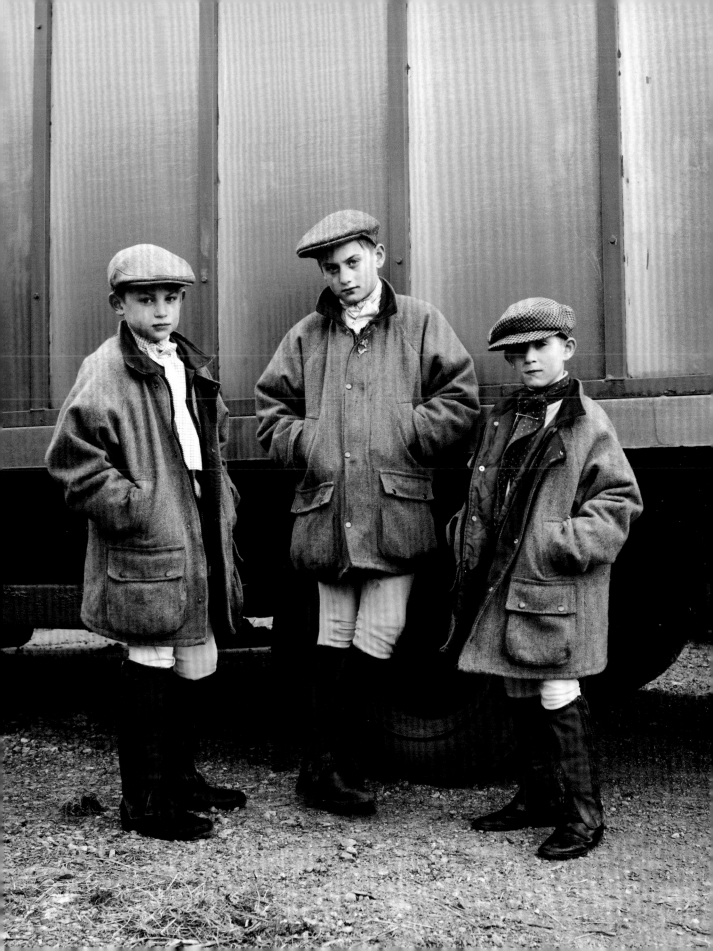

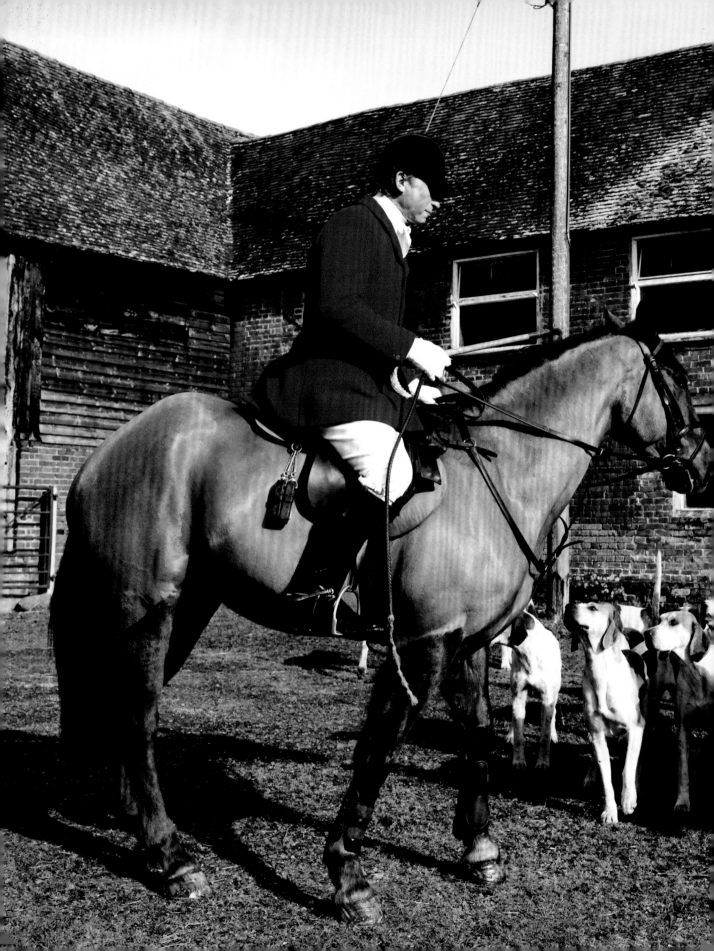

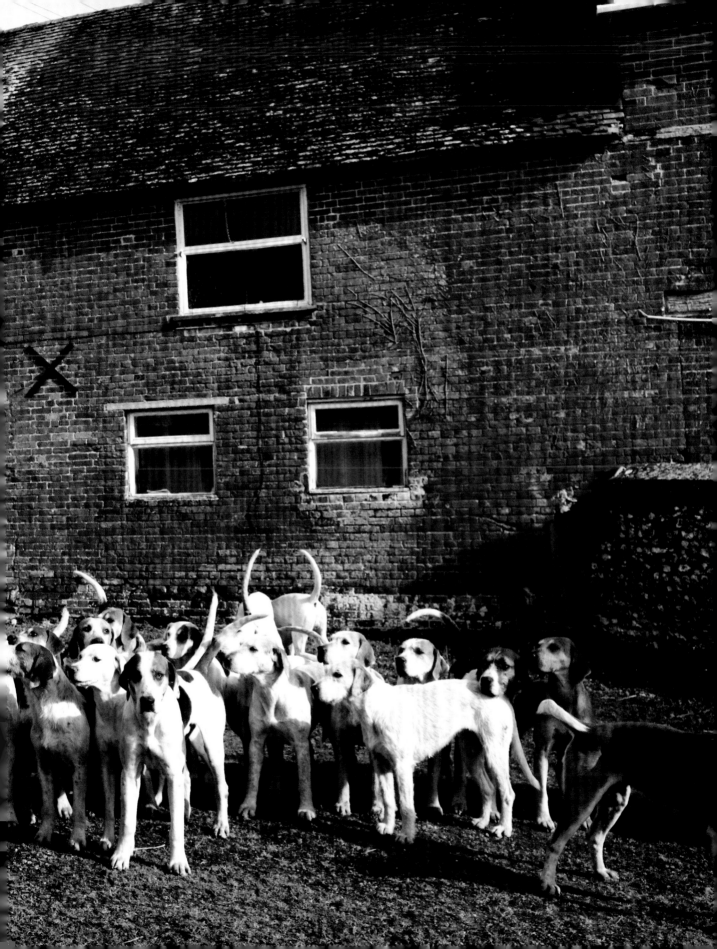

of getting to know the country you live in, or the people who live there." Nor can there be many better ways for country people to keep in touch with their roots.

It is very natural to want to hold on to the rituals of our ancestors. Some see traditionalism as the essence of country living. I disagree. I believe in progress, but respect the tradition of following in the footsteps of previous generations. There is something charming about the collection of mud-spattered rosettes and horseshoes found in old stables. Who knows what childish passions and dramas, what ghosts of pony clubs past, live on behind its innocent display?

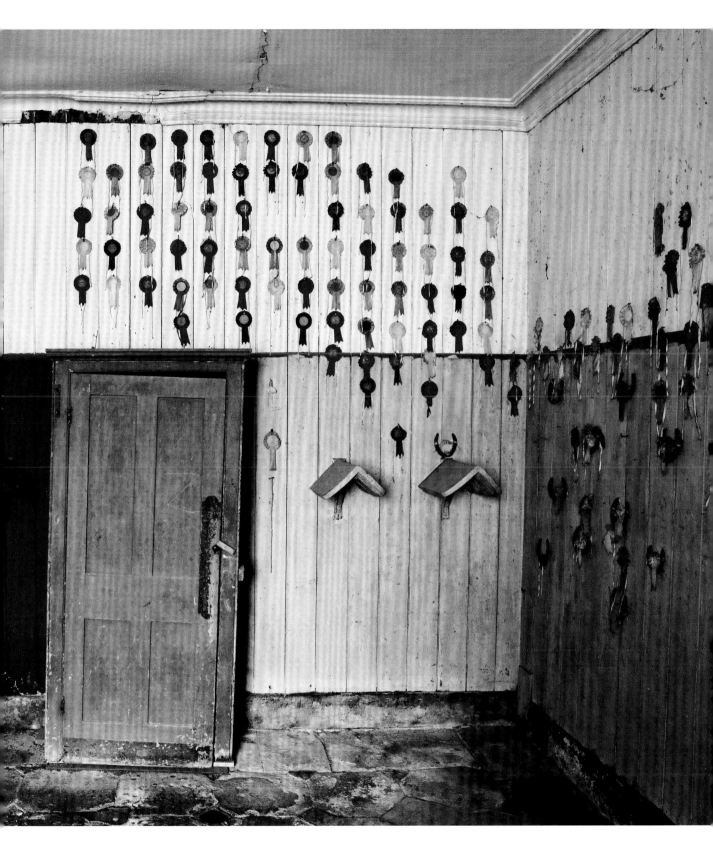

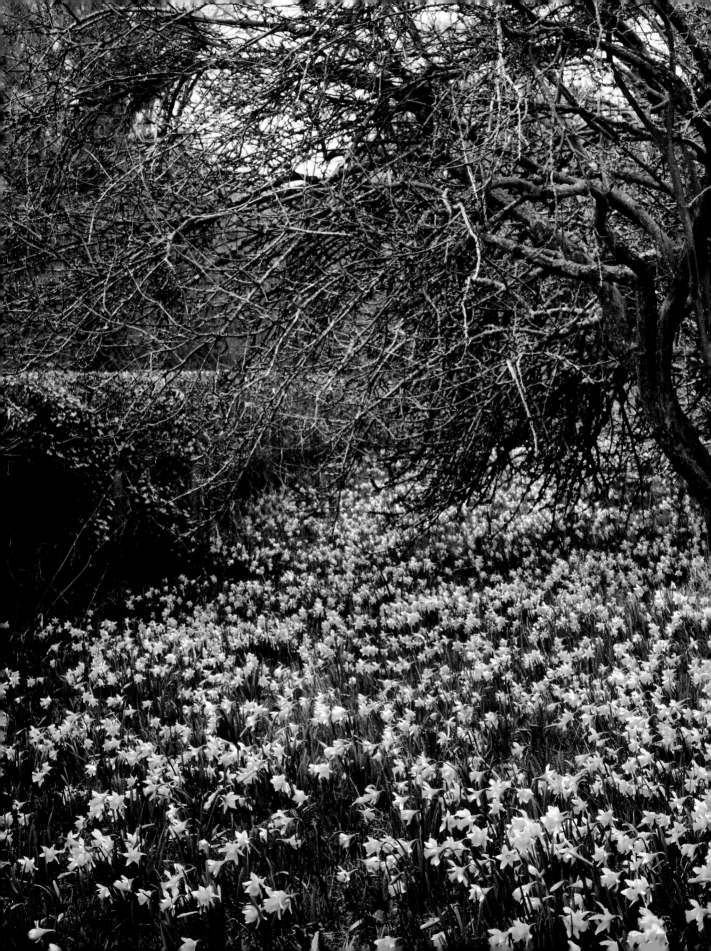

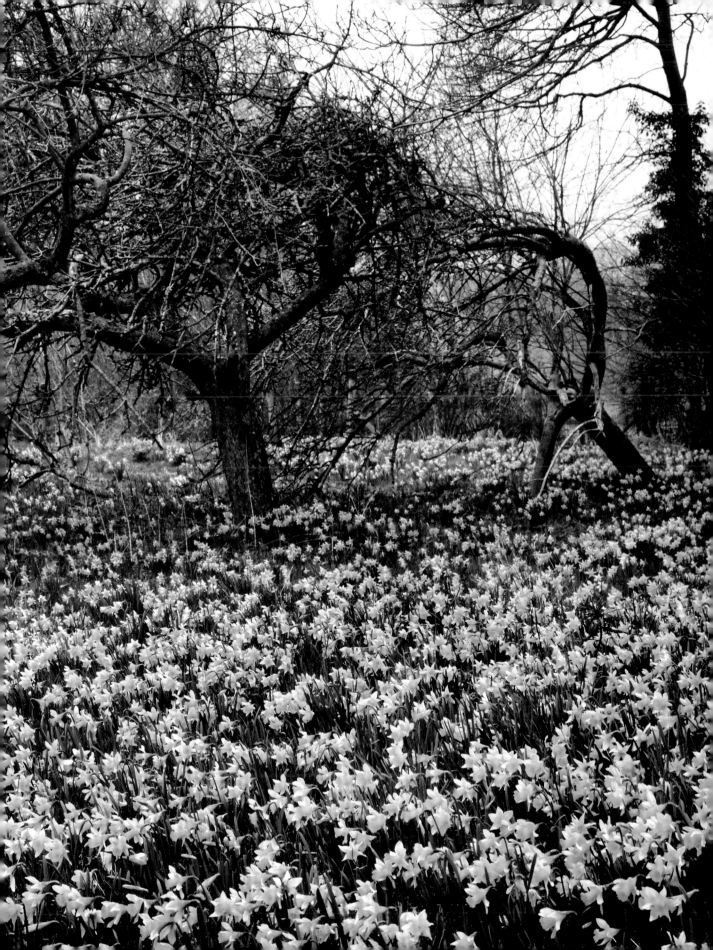

LIFE NEVER STANDS STILL IN THE COUNTRYSIDE,
just as the seasons never fail to surprise. Walking in Gloucestershire, near
Kempley, I came upon a fanfare of daffodils bursting into view, fluttering
and dancing in the breeze, the warm wind sweet with their scent. Until that
moment, I had scarcely noticed it was spring at all. Those surprises are as much
a part of the seasons as tradition is a part of the lives of a new generation.

In Patterdale, Cumbria, some hardy souls still eke out their existence in
the old way, raising sheep on the harsh slopes flanked by the eastern shadow
of Helvellyn. Mary Bell has been farming for more than three decades, at
Crookabeck Farm, where her parents lived before her. It's a brutally hard
life. In 2008 the average hill farmer earned an income of less than £10,000
per annum, but it was all Mary ever wanted to do. She farms Herdwicks, a
hardy local breed with coarse water-repellent coats, rarely seen beyond the
Lake District. Some say their ancestors swam ashore to Cumbria from a
ship wrecked with the Spanish Armada. Mary sells blankets made from the
sheep's wool and her animals for slaughter. It is a curious contradiction
when you see the tenderness with which she nurtures a newborn lamb, but
such complexities give life its uniquely rich texture.

Mary was thrilled when her son and South African daughter-in-law
(seen overleaf, in Mary's kitchen) returned to Patterdale. They live in a
converted barn adjoining the farm, offering not just support, but also the
prospect of another generation continuing her work. Is it odd that a bright
young cosmopolitan couple faced by a world of opportunities has committed
to such a hand-to-mouth existence? Perhaps, but there are a lot of similar
stories that make up the fabric of country life.

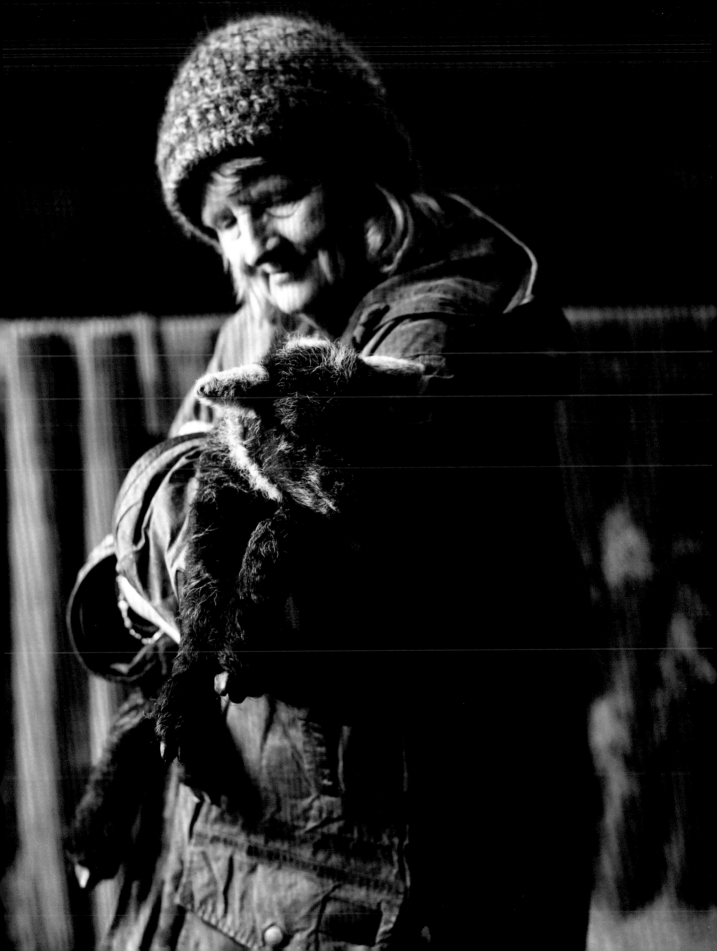

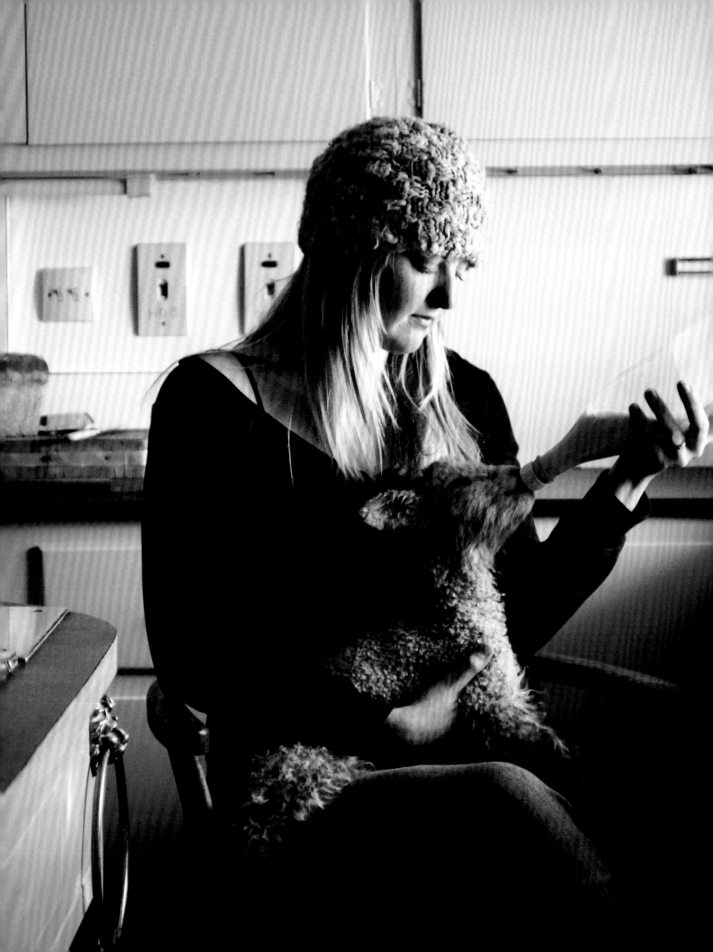

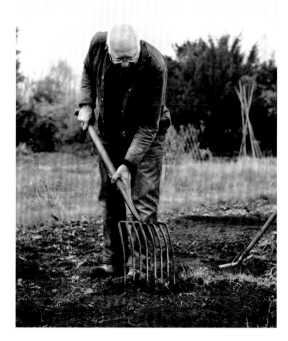

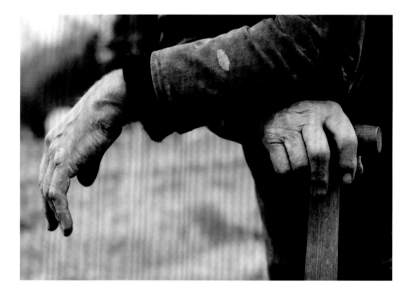

NOT SO LONG AGO, PERHAPS IN A SINGLE lifetime, many people lived and worked in the fields and villages where they grew up. Their roots were in the soil, their memories tangled up with the landscape. These days, born-and-bred villagers are a rarity. You do still find them and, when you do, it is sometimes hard not to envy them.

Take Thomas Faulkner (opposite, wearing a cap). A retired bricklayer, he is 81 years old and has lived all his life in rural Oxfordshire. His family has been in the area for as long as anyone can remember; his grandfather and his great-grandfather were both shepherds nearby. He spends much of his retirement on his allotment (actually, three allotments) on the edge of the quiet village of Ducklington.

"I grow everything and anything," he says. "I'm out there, just about any

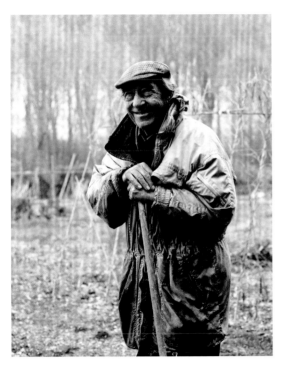

time. I've got six children, and they're always begging stuff." His brother-in-law John Seymour (with the fork, opposite above right) also has a patch on the allotments. They both love it. As John says, "You go out there and there's no pressure, is there? It gives you a bit of exercise, and you can sort of switch your brain off." Thomas adds,

"It's not hard work unless you make it hard. It's leisurely and the greatest pleasure is the result you get at the end, the food you grow."

What could be less fashionable or less enviable? Yet how peaceful Thomas looks, leaning on his hoe; coat, cap, hands and face all coloured and worn by the weather. You sense a mind ticking over in time to the slow rhythms of the soil, much as those of his ancestors' must have done.

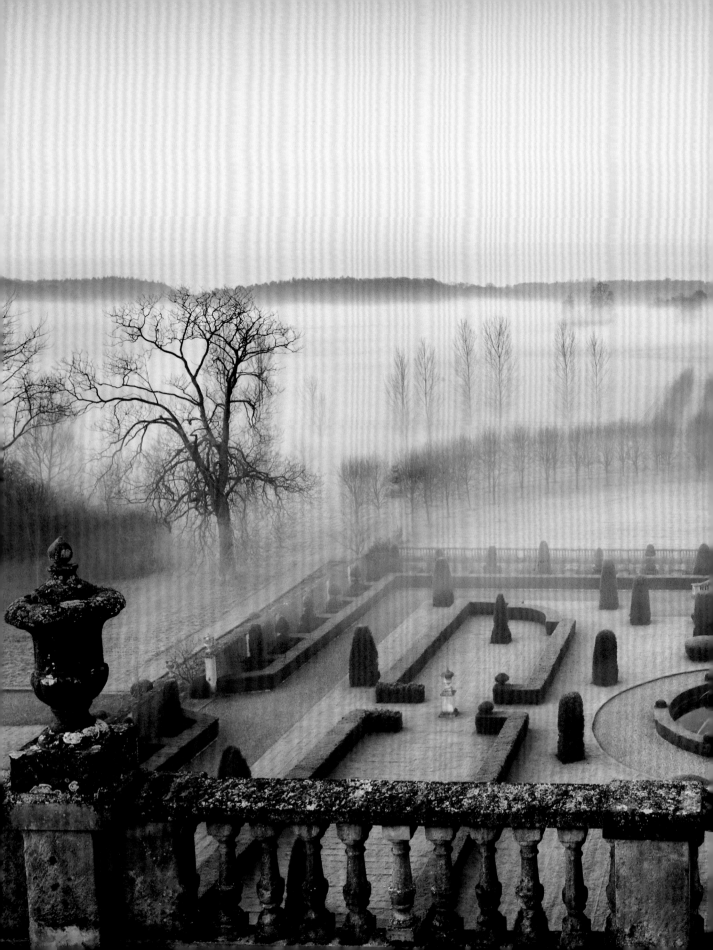

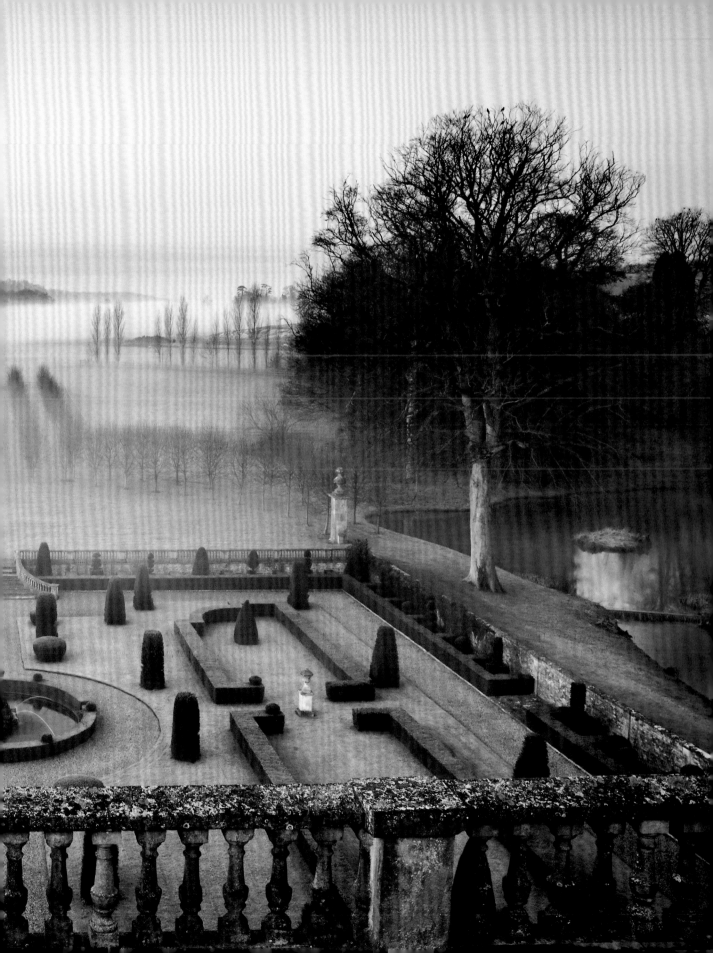

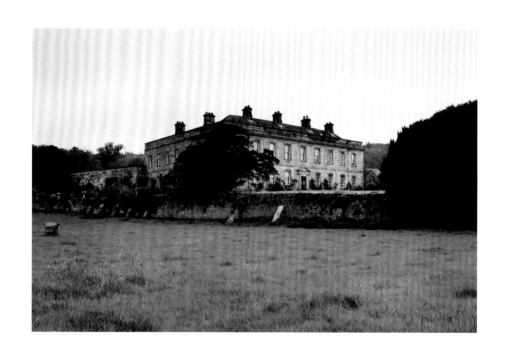

AT DALEMAIN, IN CUMBRIA, THERE ARE MANY LAYERS OF PRESENT and past, but you need patience to unfold them. A passer-by might see only the solid, pinkish Georgian front of a small stately home. A closer inspection would reveal rather more; two sixteenth-century wings, a medieval manor hall, a twelfth-century pele tower and a name (meaning "manor in the valley") that suggests a home of some sort has existed here since Saxon times. In the house are enough cluttered rooms, staircases and junk-filled attics to inspire several Gothic novels, while further afield is an exotic garden whose treasures include more than 200 varieties of roses, as well as some famous Himalayan blue poppies.

A visit on a particular day might also reveal some lively activities. These include sheepdog trials, food and craft fairs, a fell pony show, a tractor show, some apple and conker celebrations and a classic car show. The one that I liked the most was the marmalade festival, a relatively new event that takes place in early February and attracts hundreds of marmalade makers from all over the country, as well as thousands of enthusiastic tasters. Every possible variation of marmalade is represented here, some made by professionals, but most by enthusiastic amateurs. Representatives from the local Women's Institute judge about 400 entries in categories ranging from "dark and chunky" to marmalades made by men and a special children's category. Presentation, appearance, set, aroma

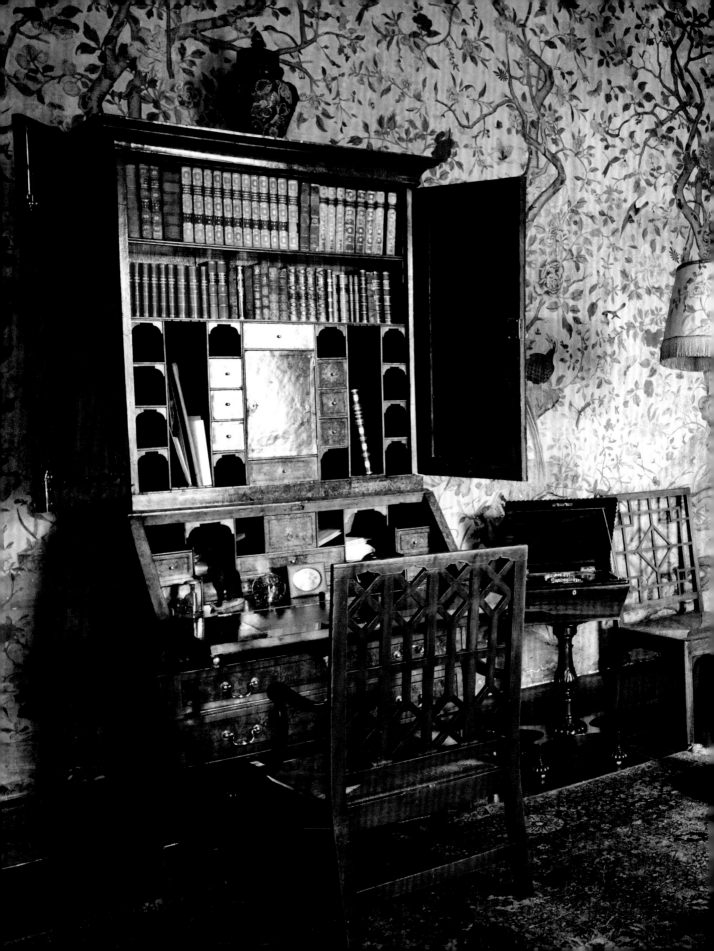

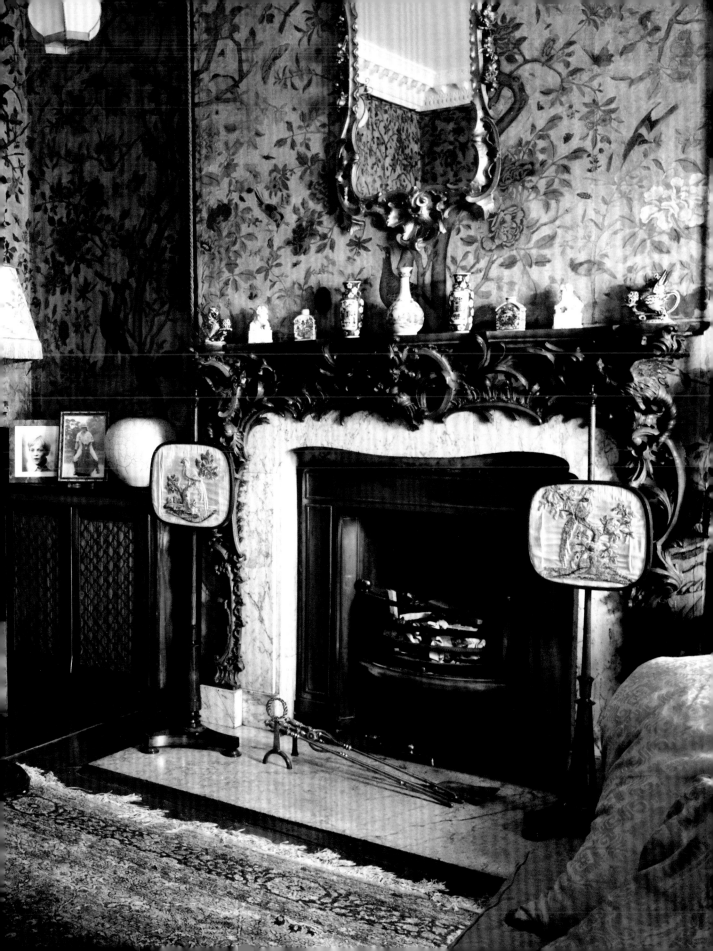

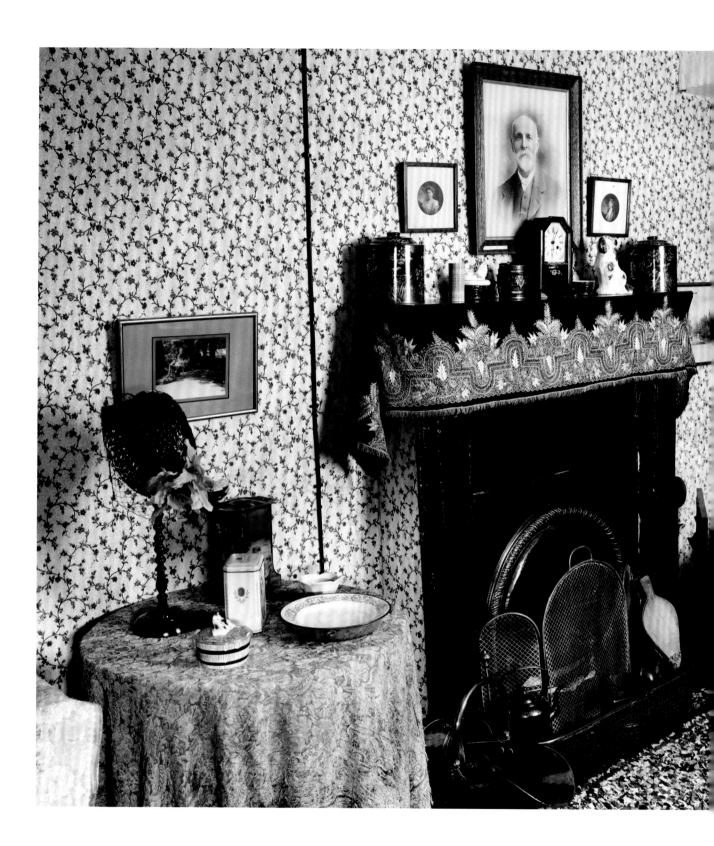

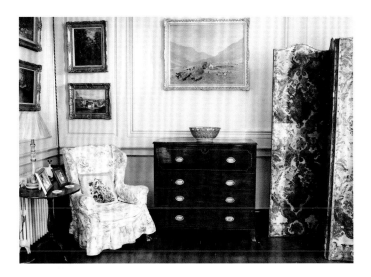

and flavour are all taken into account. The Best in Show wins a silver spoon, but for everyone else the only reward is the satisfaction of doing something well and participating in the age-old process of turning fruit into food. There is also, of course, the chance to try some excellent marmalade. All proceeds go to a local hospice charity.

The beautiful chinoiserie wallpaper in the study at Dalemain is reputed to have arrived as wrapping paper for packages of imported tea. During the festival, the pale February sunlight streams through the bright marmalade jars collected together in the house and gleams like liquid gold against the dark oak panelling. No one can appreciate country life without understanding events such as these. These activities are not about making money, but about people doing their own creative, mildly eccentric thing for the love of it, for fun, or just for the sheer satisfaction of getting together with like-minded people. "Congregation" is the word that keeps coming to mind. The country comes alive at the times and places where people congregate. I think that it is perhaps one of the most important words in the rural dictionary.

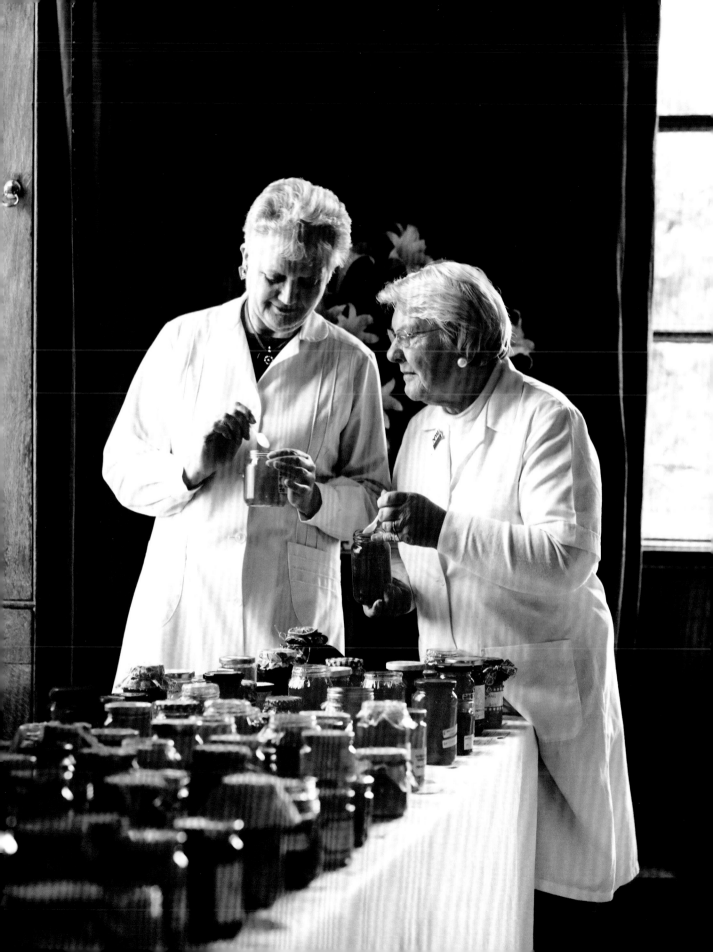

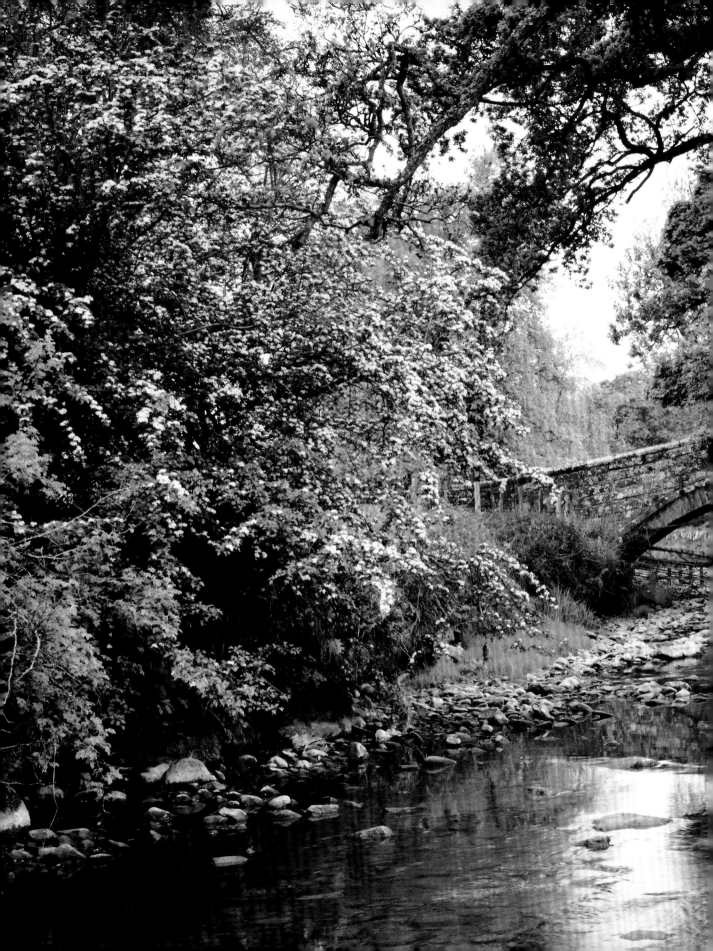

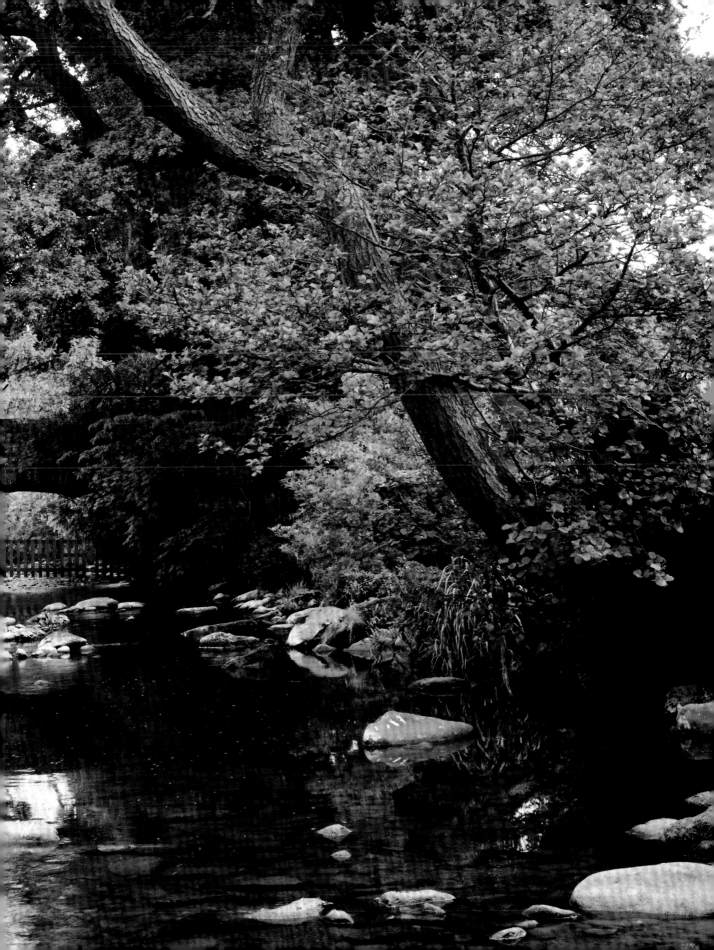

Eventually, the crowds go home, and Dalemain is quiet again. It is hard to put your finger on the specific aftereffect, but the recent activities have added to the atmosphere in the house and have left lasting memories. Both house and garden have, in their own way, been touched by the past.

I think we are sometimes too quick to discuss country life in impersonal terms. We talk of landscapes, landmarks and views as if they existed independently of humanity. Yet so much of what we see in the countryside, good and bad, is about people whose individual acts of conservation or creativity live on, even if their names are, in many cases, forgotten.

THERE ARE WELL-DOCUMENTED LINKS BETWEEN living in the countryside and happiness. In rural areas, people live longer, experience less crime and enjoy more cohesive communities. It makes sense. We evolved as free-range creatures and become stressed when we are forced to live as battery ones. There are more specific benefits. In the country, people tend to get more exercise and more sunlight and fresh air, which are all good for mental and physical health. Given that there is a proven link between mental wellbeing and keeping pets, a walk in the country with a dog must be one of the most effective ways of raising the spirits. Dogs are a wonderful excuse for exploring. Not only do they force you out in all weathers and at all times of year, but they also encourage you down unfamiliar paths and provide an instant introduction to other dog owners. I suspect that those walks are often of more benefit to the owners than to the pets themselves. My dogs are generally quite happy pottering around in the garden and dozing by the Aga stove but, as their owner catering to their need for daily exercise, I create for them a

relationship with the local landscape that they might otherwise lack. Some people seek out new routes; others prefer to stick to familiar paths. Either way, the landscape changes each day according to the weather and the seasons. You get to know when and where wildlife is to be found, and particular trees or streams become like old friends. You re-establish a relationship with the land. For some, that relationship goes deeper. Whether it is a small garden or an entire woodland, people get to know their particular patch better than they do members of their own family.

Exploring the countryside is partly a matter of tapping into that knowledge. On the edge of Ducklington, not far from the allotments, is an ancient water meadow spotted with the rich colours – purple, gold and brilliant white – of a host of snake's-head fritillaries. They are a miraculous sight, both close-up and seen as part of the tapestry of the meadow. As with most patches of land, there is a story behind them.

The meadows in this part of Oxfordshire were once liberally splashed with fritillaries, but most were ploughed up during

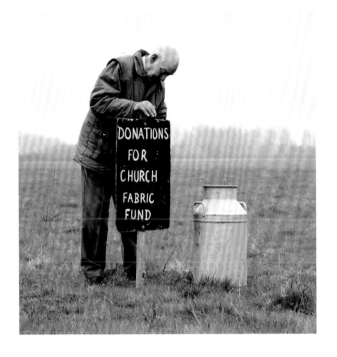

World War II. This meadow was spared because the Druce family, of Church Farm, had nowhere else to graze their cows and the flowers (*Fritillaria meleagris*) survived because the Druces grazed their animals on only one part of the meadow at a time. Forty years ago, a local solicitor, Roger Peel, bought the field and dedicated it to the preservation of fritillaries. Some thought of him as eccentric, but time has proved him right. Since 1945, Britain has lost 97 per cent of its flower-rich meadows, and this one is considered a regional treasure. Mr Peel's sons have continued the tradition, and the meadow and its flowers are thriving. Mr Strainge, a local farmer, still grazes his sheep on it, but the fritillaries remain the priority, and people come from all over Oxfordshire to see them. Mr Strainge is happy to share his treasure and simply asks for donations to the church fund in return.

PEOPLE FIND BEAUTY IN MANY THINGS
and express their creativity in many different ways, not just
on a grand scale. One of the aspects of the countryside that
means so much to me is the physical presence of animals
and the way in which they bring a different perspective to
the world, rather than simply the narrow human one.

In Dorset, as a sideline from his main employment as
a landscape gardener, Andrew Dodge looks after chickens
alongside a few cows in a rented orchard in Halstock.
Andrew has never wanted to do anything except keep
chickens. Even as a small boy, he was fascinated by them.

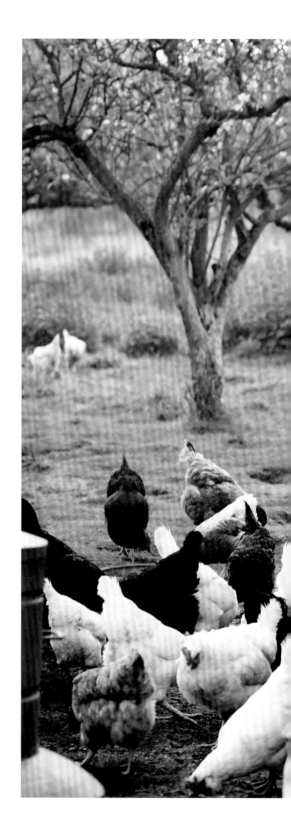

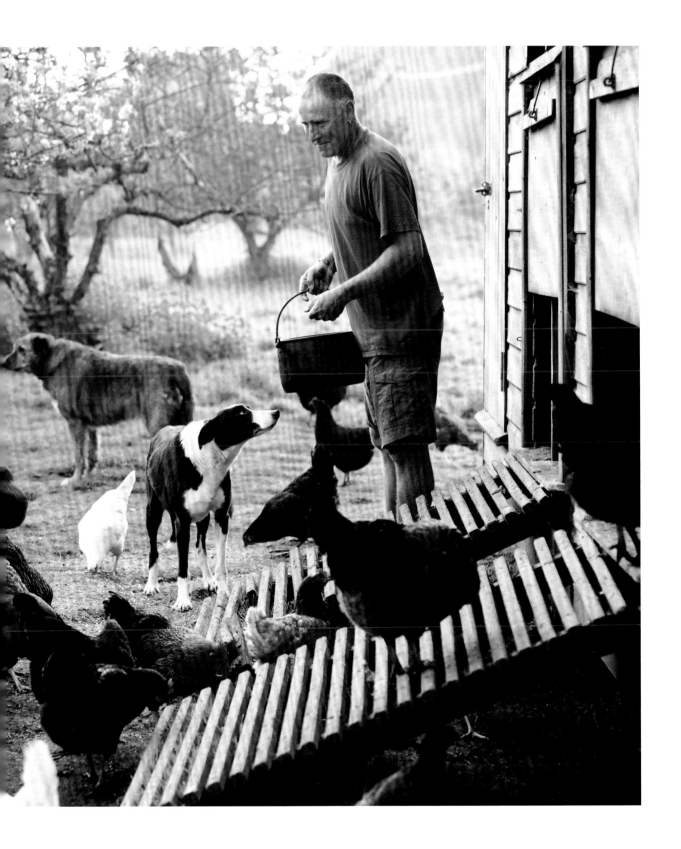

If he ever disappeared, his mother always knew where to find him. The same is true today. You have only to look at him with his birds to realize the strength of the bond between them.

I have nine chickens, all Rhode Island Reds, and each has its own name and character. If I have a favourite, it is Ivan, the cock. The sound of his crowing shatters the calm of daybreak as he glows with pride and self-satisfaction, strutting about like a pop star followed by his harem of ladies. He reminds me of James Brown.

Andrew keeps chickens in an entirely different sense and understands them with the same deep, instinctive empathy that a huntsman understands his hounds. As he interacts with them, he has the relaxed, confident bearing of a man comfortable in his own skin. I suppose part of his secret is that he is pursuing his particular passion. Throughout my travels, I never went far without coming across some kind of idiosyncratic enthusiasm that both surprised and delighted. The countryside is full of people who have a love of gardens, flowers, chickens, cheese, flowers and festivals. They are not huge or world-changing concerns, but the fact that someone really cares makes a profound difference to the colour of local life and the richness of the countryside. I suppose you could say that, consciously or unconsciously, these people are acting as the guardians of our heritage.

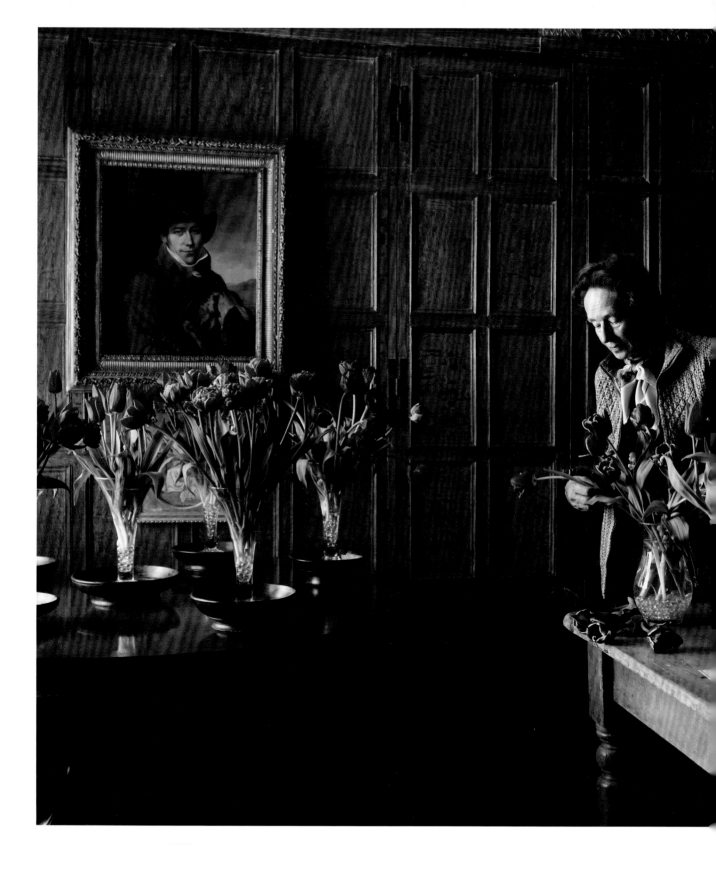

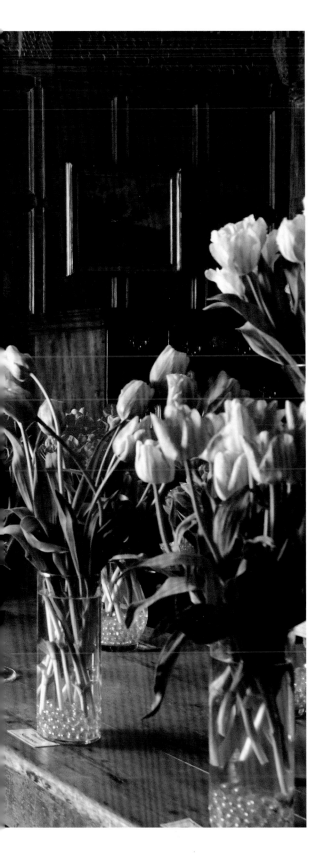

FOR MANY IN THE COUNTRY, THERE is only one passion that truly matters: flowers. That passion might be focused on a single species or may embrace a vision for an entire garden, but the most dedicated have an empathy with their flowers that is on a par with Andrew Dodge's for his chickens.

Travel anywhere in the countryside, and you will find flower-lovers whose dedication embraces deep expertise, as well as enthusiasm. James Sellick, in Ticehurst in East Sussex, has a passion for tulips. His annual tulip festival at Pashley Manor has to be seen to be believed. James created the festival on a whim 15 years ago, to mark the 400th anniversary of the arrival of the tulip in Europe from what was then Persia. He had only a few cut flowers to show, but shortly afterwards planted 3,000 bulbs around the manor's gardens. The festival has been expanding ever since. Today, it draws thousands of visitors and has been compared to the Chelsea Flower Show. When I visited, there were 20,000 bulbs in the gardens from 90 varieties of tulips, and 200 cut flowers in the house.

The festival, which began as a labour of love, has brought new life to the house. The gardens (filled with fountains, ponds and romantic plantings) are open to the public for much of the year, and there are plenty of other attractions, from rose and lily weekends to painting and photography courses, that ensure that the place is never deserted. It is yet another example of the way in which owners of big houses have made them work by innovation, as well as proving that, if you want to arouse the enthusiasm of the British public, you cannot beat flowers.

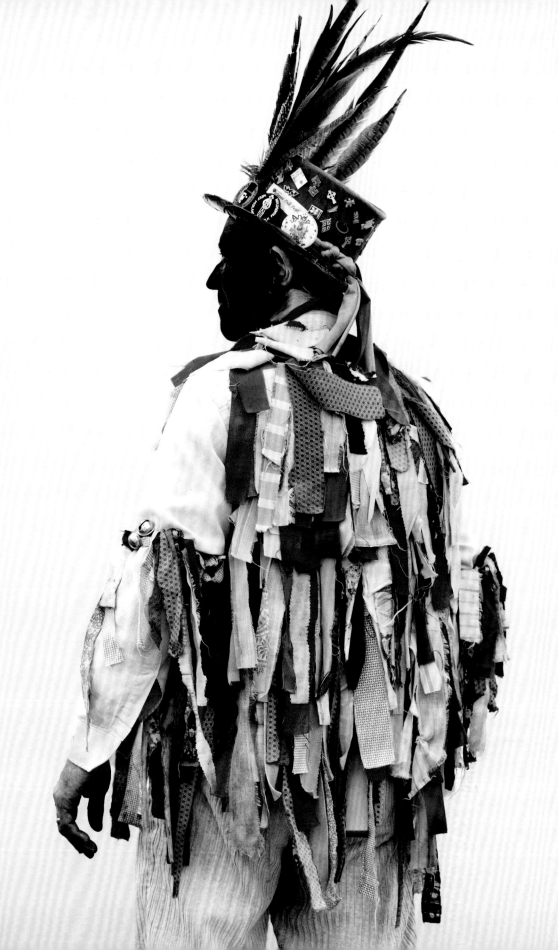

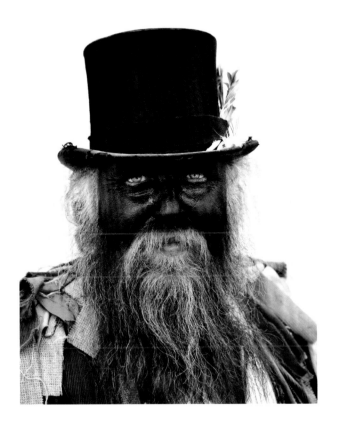

In Kent, shortly before dawn on May Day, hundreds of people climb Bluebell Hill on the edge of Rochester to see a huge garland on a wicker frame being lifted up to greet the rising sun before being carried down into the town. The garland is called the Jack-in-the-Green and is one of several that, in various places around the country, forms the centrepiece of an awakening ceremony held each year at dawn on May Day.

Teams of exotically dressed Morris dancers escort the Jack down into Rochester, where the neo-pagan ritual associated (if not directly linked) with ancient celebrations of fertility blends with more recent traditions involving chimney sweeps. On May Day in the eighteenth and nineteenth centuries, Rochester's sweeps (of whom there were

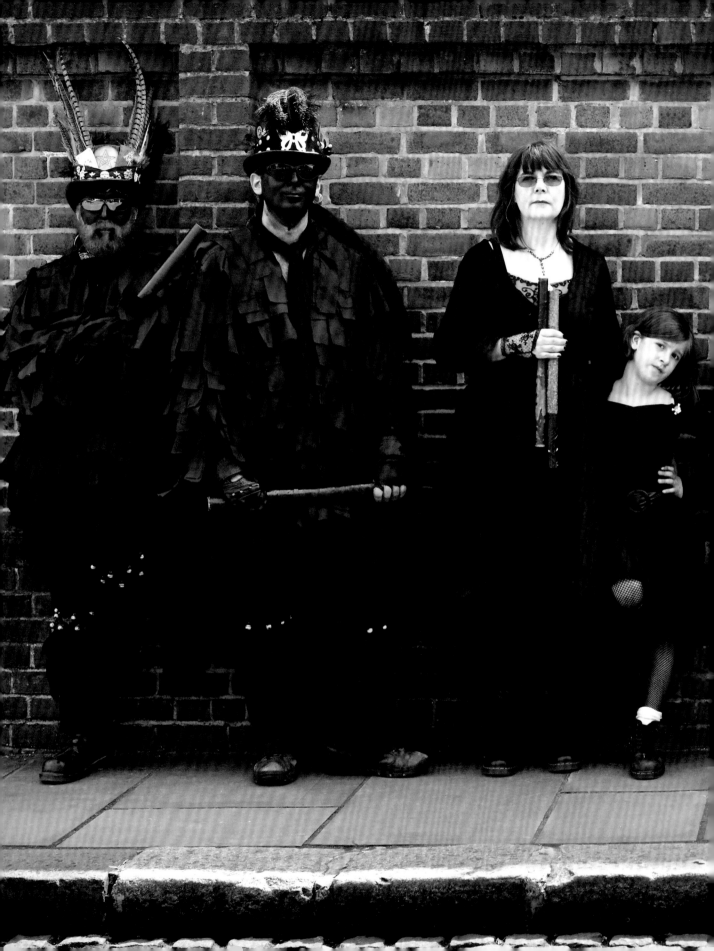

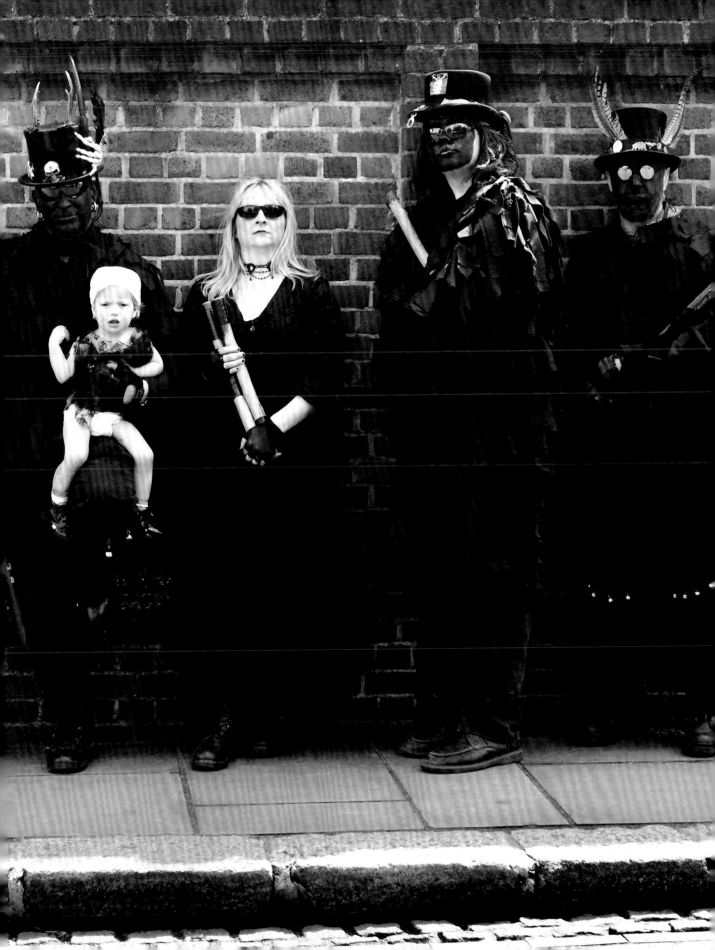

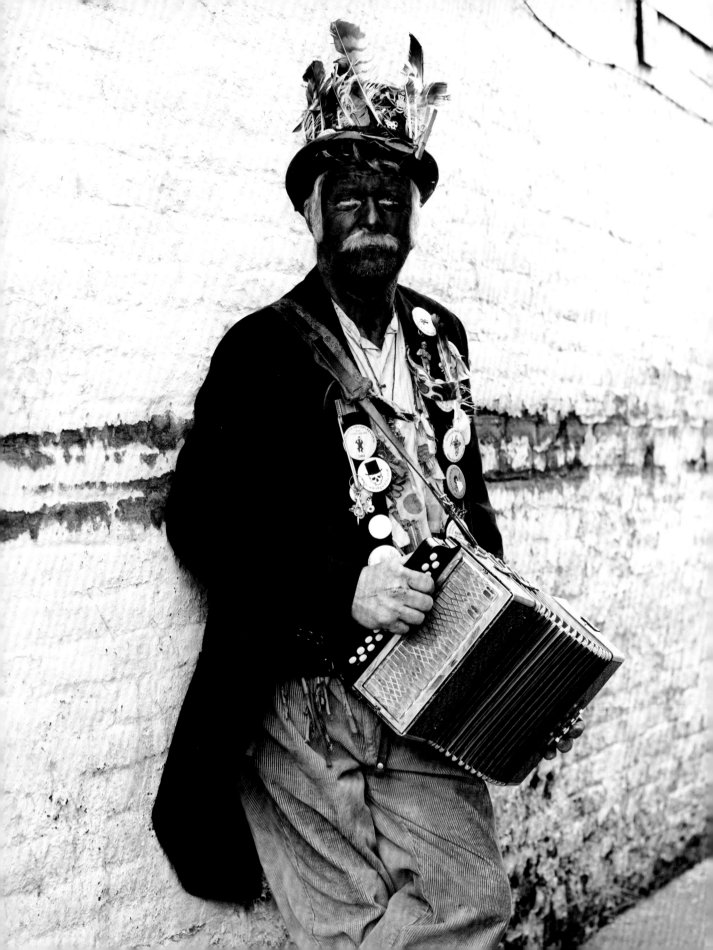

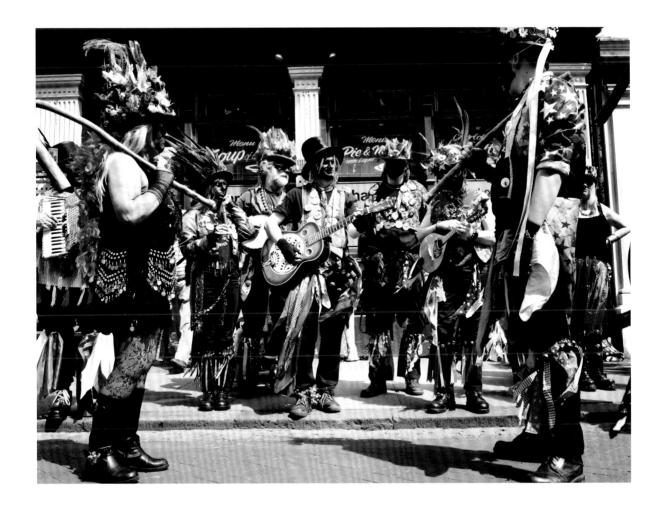

many because of the docks at Chatham) used to come out in force, together with the children who were notoriously sent up less accessible chimneys. The festival developed a reputation for wild revelry and drunkenness – Dickens described it in *Sketches by Boz* – but died out after the Climbing Boys Act of 1875.

The memory lingered on and, in 1980, Gordon Newton, a local businessman with an interest in Morris dancing and Green Man myths, revived it. "It was just one of those things that seemed like a good idea. I would never have believed that one day it would become the huge attraction it is today." It is thought to be England's biggest traditional May festival, with up to a hundred extravagantly costumed Morris "sides" coming from

far and wide to take part in the spectacular dancing that is now the festival's most striking feature. It has a shamelessly amateur feel, but that's part of its joy. Lose yourself in it, and you are immersing yourself in the human story of a particular slice of rural England.

Dickens associated the Rochester Sweeps Festival with a particular kind of rural nostalgia in which the thrill of a "bright spring morning" conjures up memories of a world "where the sky seemed bluer, and the sun shone more brightly, where the air blew more freshly over greener grass, and sweeter-smelling flowers".

This ancient tradition still plays a huge part in modern life.

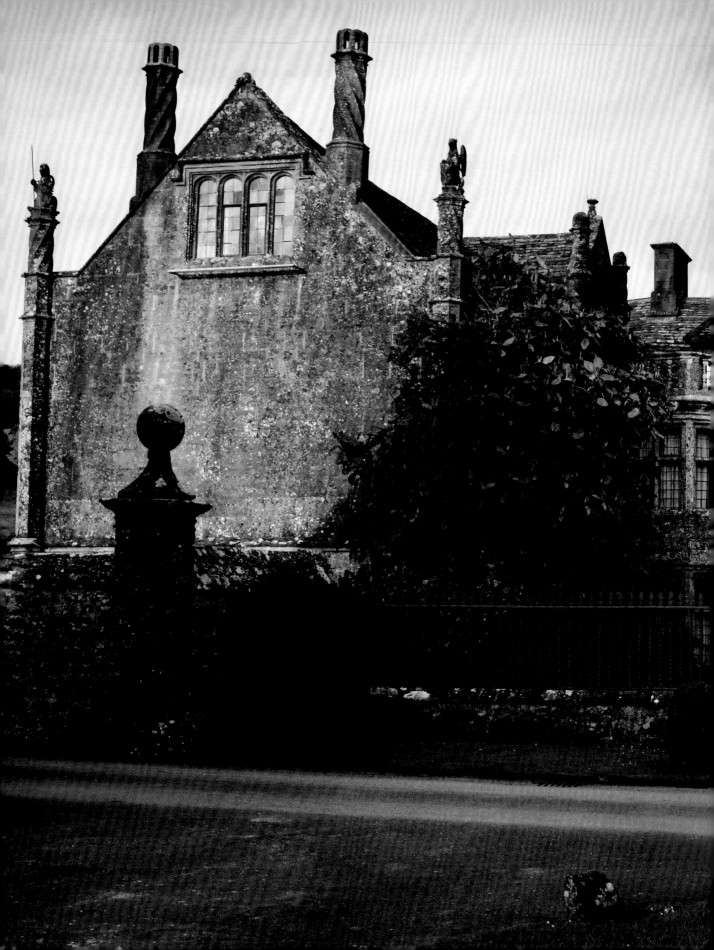

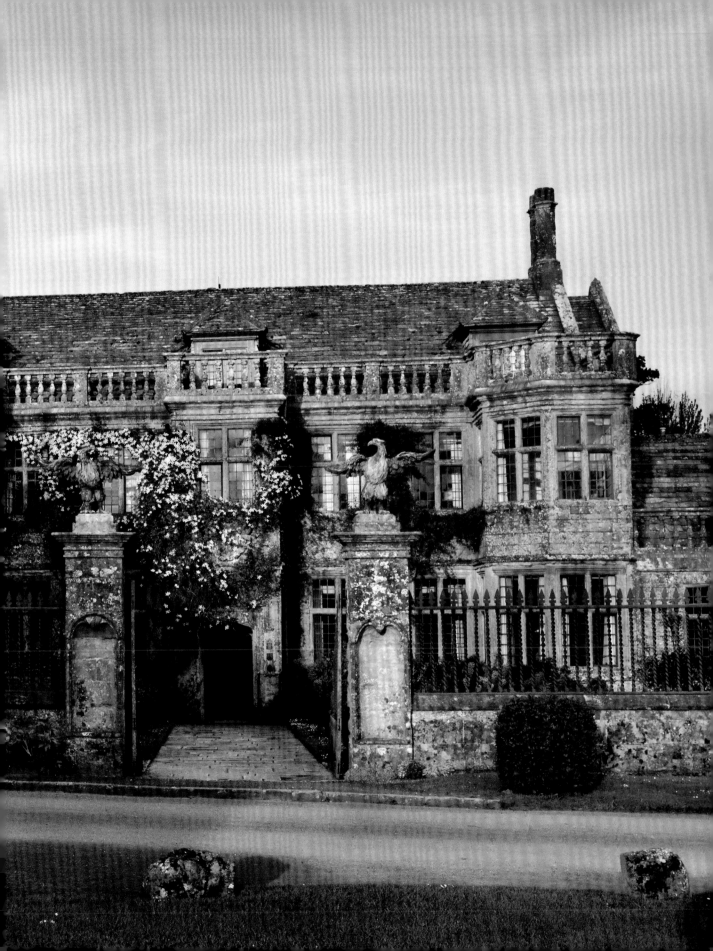

ONE OF THE PLEASURES OF TRAVELLING around the countryside lies in the stories that there are to be discovered. You may think that you are looking at a scene empty of people, but there is always somebody in the background, living or dead, whose passion or vision inspired it. Perhaps that's why we are so addicted to visiting stately homes. In the United Kingdom, the National Trust now has 3.5 million members. Visitors are not necessarily architecture enthusiasts, often being more interested in learning about history and discovering the heritage of the past.

Not far from my home in Dorset is a romantic valley surrounded by hills where Mapperton, a honey-coloured Elizabethan manor draped in wisteria, sleeps among ancient trees. The dovecote, stable block and church are all built from the same local stone (from the famous Ham Hill quarry) and seem to grow out of the landscape so naturally that the valley would be unimaginable without them. The gardens are famous – a mix of Italianate formality and wild romanticism – and you cannot go far without coming across a grotto or a fountain court where you sense the inspiration of the past.

Half a century ago, Evelyn Waugh called England's country houses our "chief national artistic achievement". That could sound like a rather elitist statement. In Waugh's day, how many people

actually saw the inside of a stately home? Yet in recent years there has been a rather wonderful democratization of our grand houses. Local people once depended for their living on the patronage and employment of aristocrats, but today the houses are dependent on the local people. The Earl and Countess of Sandwich, the owners of Mapperton, admit that they could not run the place "without the goodwill, devotion and benevolence of the people who work or live there". The house, as Lady Sandwich puts it, is a "mixture of delight and problems. Something in the house is always going wrong. I don't think there's ever a time when there is nothing on the repairs list." This means that the estate has to be imaginatively managed by letting out several buildings as homes or admitting paying visitors to the house and gardens for a few weeks each summer, or by appointment. They show around many of the 11,000 visitors who turn up each year themselves, but also depend on volunteers and employees drawn from the local community.

"We have never thrived; we have simply kept our heads above water," says Lady Sandwich, but the sense of a constant struggle with the forces of decay is part of Mapperton's magic. Family members traditionally share "bucket duty", which involves rushing to put down buckets beneath leaks whenever it rains heavily.

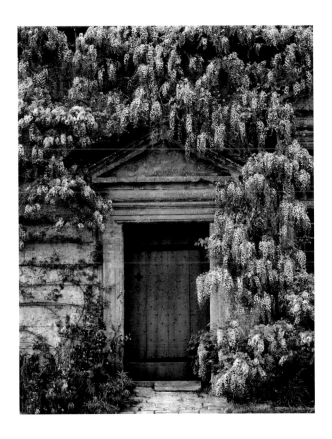

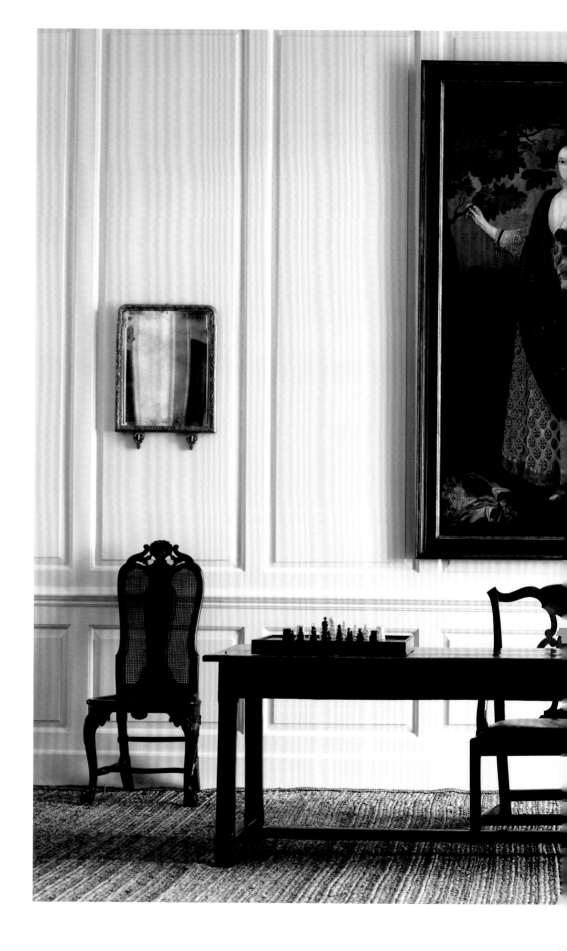

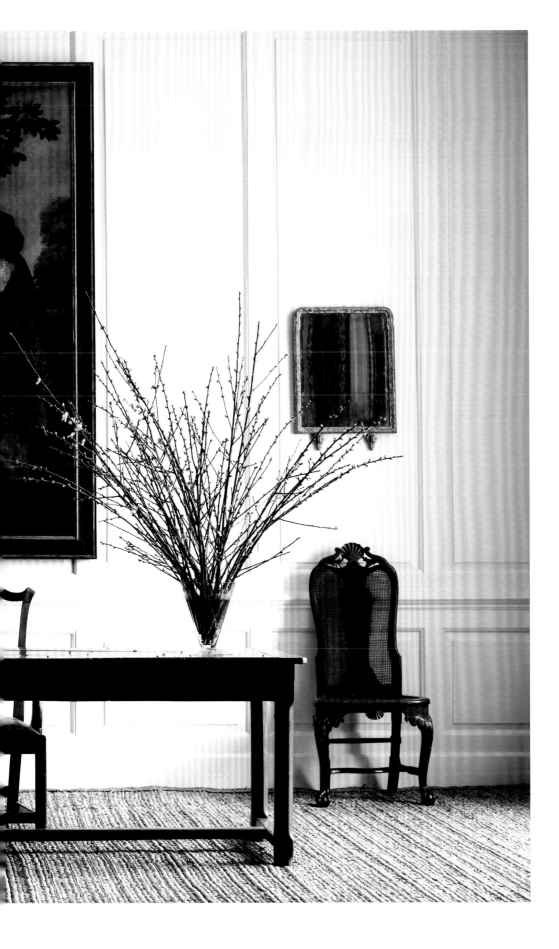

ALL GRAND HOUSES REQUIRE
a level of commitment and dedication from
their owners to maintain them, inside and out.
The photographs inside this Chiswick house, built
during the same period as Mapperton, show
some of the finest preserved interiors in England.
What I love about this house and other grand
houses such as Mapperton is that they are first
and foremost people's homes. Lady Sandwich
says of Mapperton, "People love the sense that the
house is lived in, slightly untidy but comfortable,
with old cushions and kids' toys under the table."

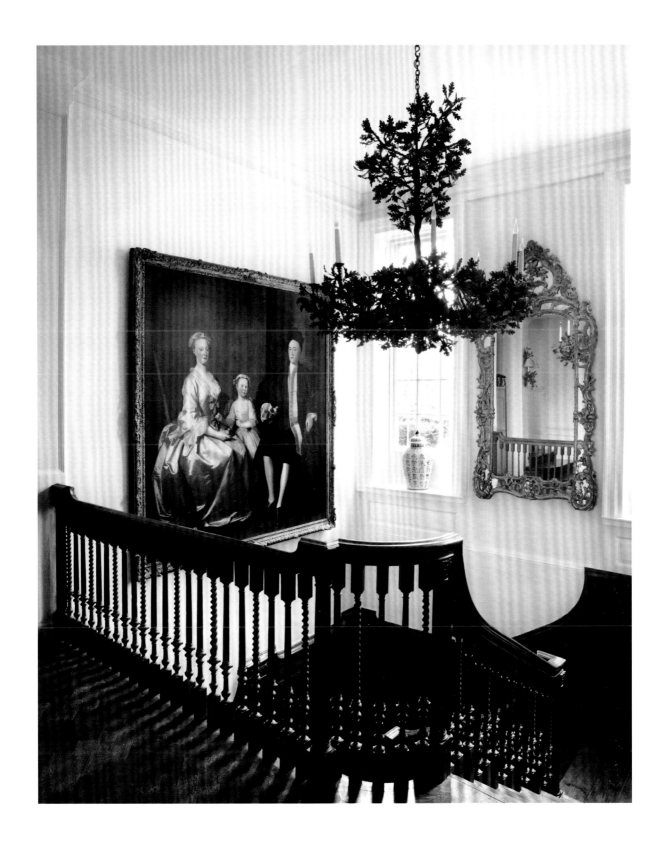

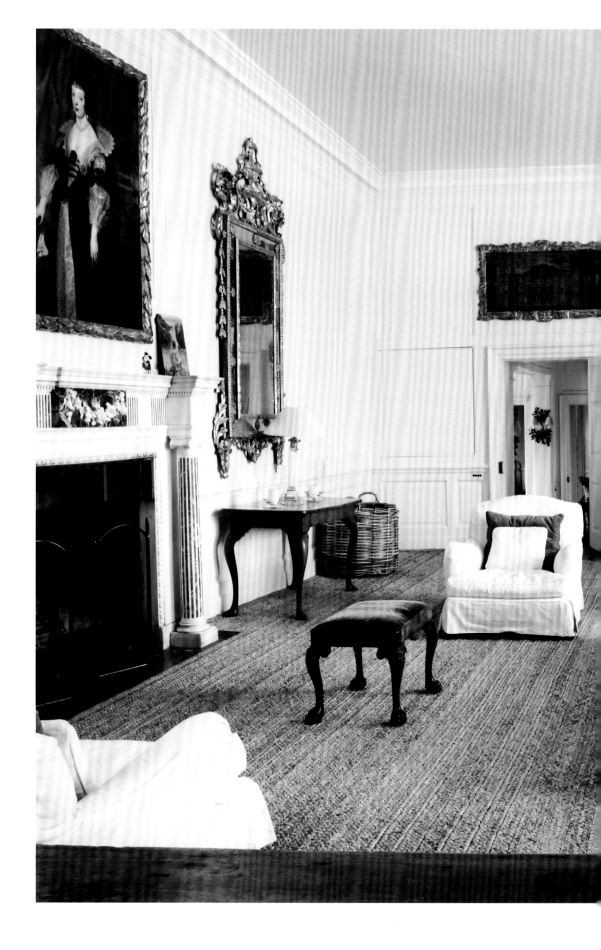

"We haven't done much in the way of innovation," she says. "We deliberately left it as a time-honoured manor house, and I suppose it has benefited from the fact that it has never been 'interior-designed'."

To me, Mapperton, glowing with age and beauty, represents the English country house at its best. Built for the few, but enjoyed by the many, while still having that essential quality of being lived in, it is a like a gnarled old oak tree, its loveliness mellowed by age, but still growing and thriving.

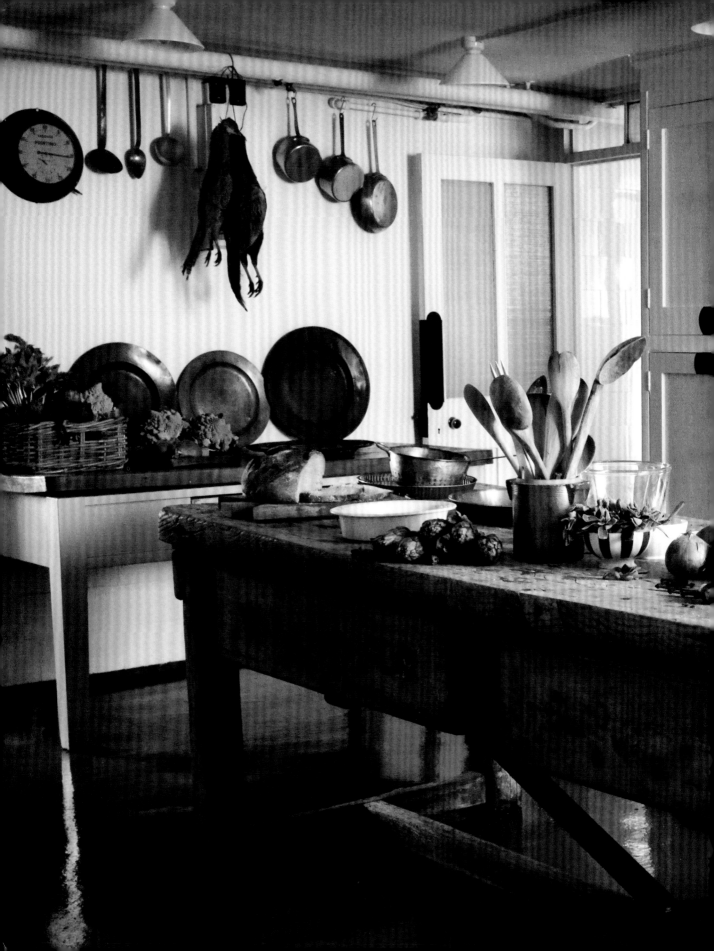

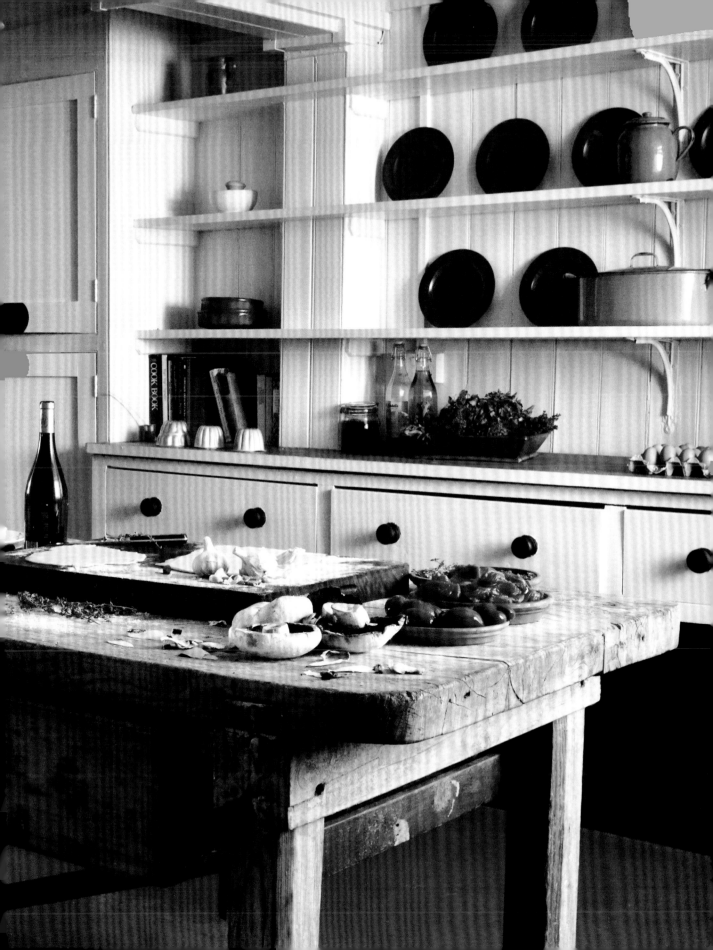

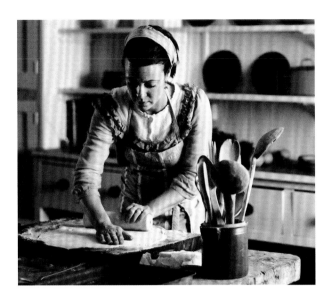

There are comparable stories to be found at grand houses all over the country, and it is a mistake to imagine that they are of interest only to the families who own them. Houses such as Dalemain, Mapperton or the Chiswick house seen here survive only because their owners have found ways of engaging the interest of the public. Even in their heyday, English stately homes were the hub of their local communities, the backdrop for a network of interrelated lives, few of them grand. If they still speak to us today, it is partly because of what they tell us about those lives.

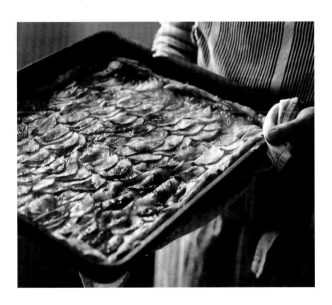

IN DORSET, I REVISITED A HOUSE IN the Marshwood Vale, set in an idyllic spot on the edge of a hamlet surrounded by endless woods and valleys. It is spectacular in late spring when the woods glow with bluebells, but I love, at any time of the year, to look in on one particular outbuilding: a converted dairy shed in which a local potter, Tim Hurn, pursues his craft. There is a particular atmosphere about the smell of clay, the warmth from the firing and the neat stacks of wood piled up for his huge brick kiln. It is a single chamber kiln, of the "anagama" variety, which he built himself. He fires it four or five times a year, and it takes two to three days just to pack his pots into the firing chamber and another two to build up the fire,

gradually loading it with more and more wood as the temperature increases. It can reach as high as 1,300°C (2,370°F) and takes four days to cool down. "A few people from the village normally come and lend a hand," he says. "It can be pretty tough work."

Tim, who has been working there for 20 years, lives in a cottage nearby. When he isn't potting, he works on the landlord's estate, "looking after sheep, hedge-laying, cider making – that sort of thing". He feels that there is a strong link between his work and the landscape. "I use local clay. The kiln is fired with local wood. And, in the end, I'm keeping to a tradition of English pottery that has been going on for generations. I think there's a certain romance in the process."

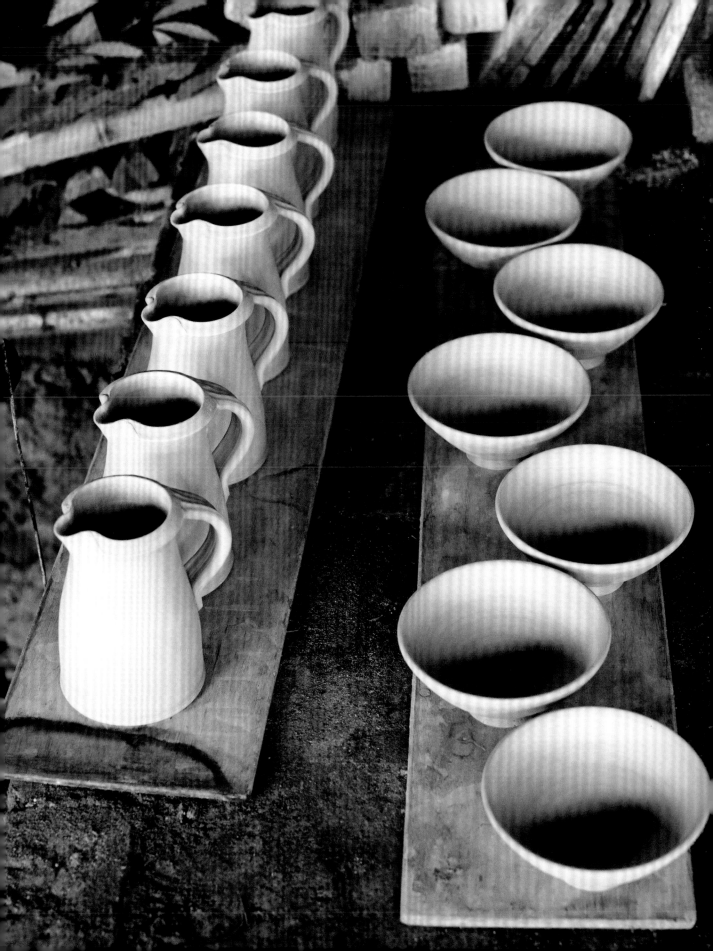

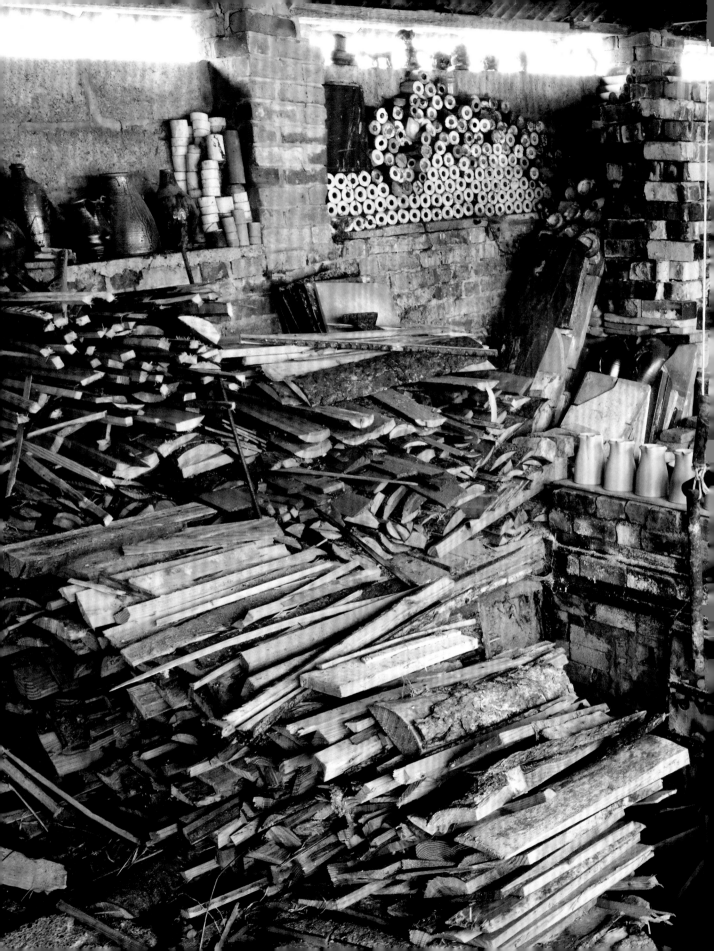

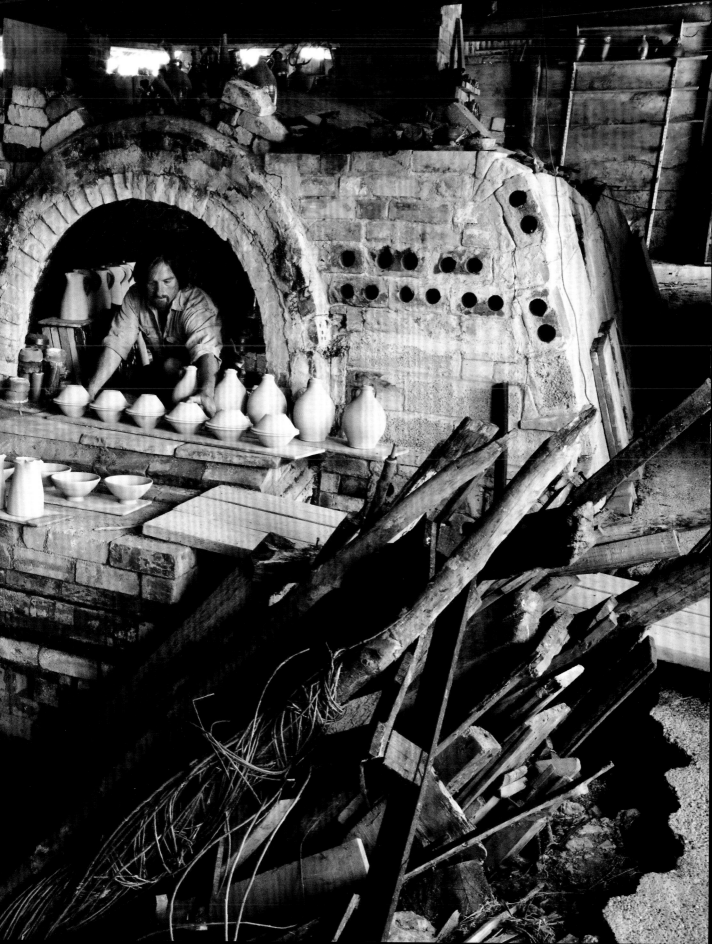

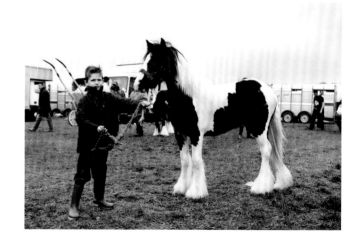

THERE IS ROMANCE IN KEEPING OLD RURAL traditions alive. Every May, tens of thousands of travellers and gypsies from all over Britain and Ireland gather at Stow-on-the-Wold for the first of three great annual horse fairs. The gathering is centuries old; the charter authorizing it dates back to 1476. Others take place at Appleby in June and back at Stow in October. I am not sure everyone in Stow necessarily welcomes the arrival of the travellers. You can sense a certain uneasiness lingering behind the shutters of closed shops as crowds of boisterous travellers flood the streets with the loud high spirits of fans approaching a football stadium. Those who venture into the grassy bowl to the southeast of the town where the fair is held are rewarded by an unforgettable spectacle of communal exuberance.

The atmosphere is cheerfully anarchic. Loud music, louder voices, swirling crowds of old and young, stalls selling shameless tat ("Chanel" plates, "Dior" towels, "Crown Derby" china – even a "Crown Derby full-length mink gown"). There are litters of puppies and rabbits for sale, as well as toys and trinkets, ice cream and canned drinks, the noise and bustle mingling with the heady scents of hot dogs, cigarettes, cheap perfume and horse. Young and old paddle side by side through the mud, oblivious to any notion of a generation gap. There are men and women in mud-coloured coats and caps, swaggering boys in sagging jeans and ludicrously beautiful girls in impossibly short skirts. Everyone seems to know each other or, in many cases, to be related.

Every now and then, beyond the bustle, you see traces of an older, simpler culture. Old men sell and buy fire-blackened pots and pans, which they weigh in their hands with a connoisseur's touch; a woman

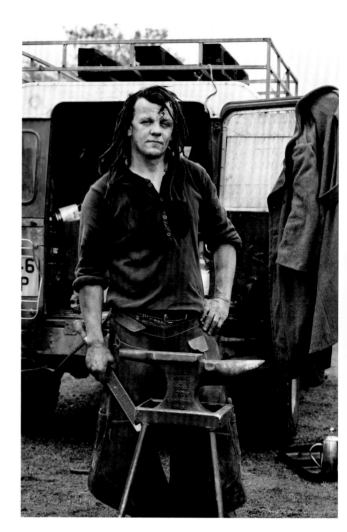

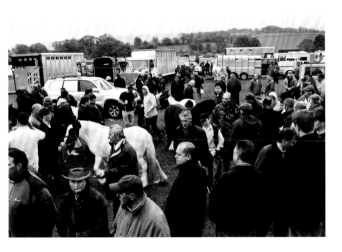

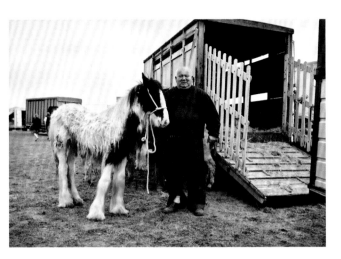

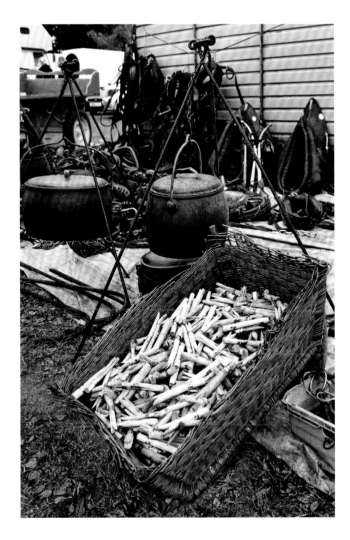

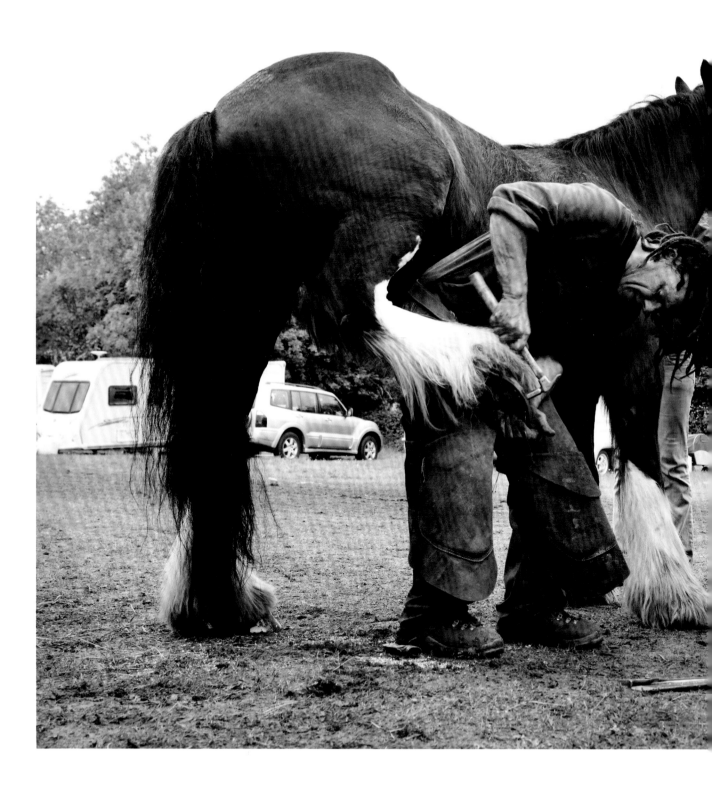

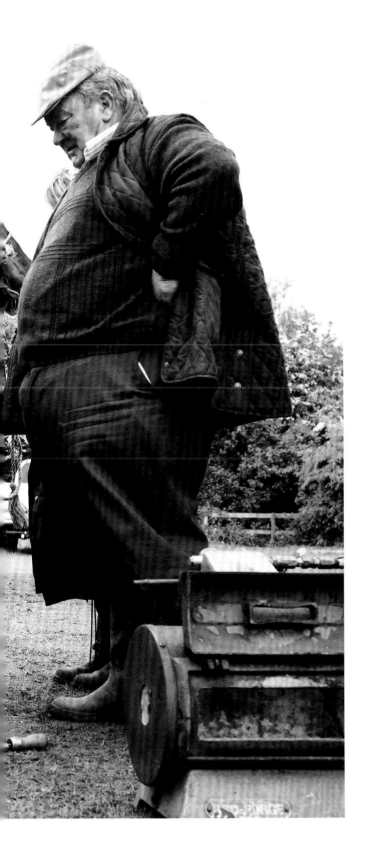

slices hunks of bread in midair and feeds them straight into her toddlers' mouths. There are glimpses inside exotic wagons, and horses standing patiently in the gaps between stalls and vans, or grazing placidly while their owners and buyers discuss their virtues and shortcomings.

Everyone appears completely relaxed. When a young man driving a sulky (a little two-wheeled horse-drawn cart) came clattering at breakneck speed towards a group of young mothers, they barely glanced up as they shifted their buggies out of his path. Nearby, two men were trying to coax a giant piebald horse with a foolish fringe into a horsebox not much bigger than the horse itself. Each time it made it halfway up the ramp, it would hesitate, wave a hoof in the air and tiptoe backward. The ritual continued for ten minutes or more. The man who was leading from the front was extremely patient, encouraging it with the gentlest of arms laid on its shoulder. It was impossible not to be struck by both his tenderness and courage. If the horse had panicked, the man would have been trapped and trampled.

The most striking aspect for the outsider is a sense that you are somehow invisible. People are friendly enough if you approach them, but seem almost to look through you, enjoying instead the people they know, are related to or who share their world. I suspect that, in other times and places, it may be how the rest of us would look at them, too – as outsiders with apparently no relevance to the lives we lead.

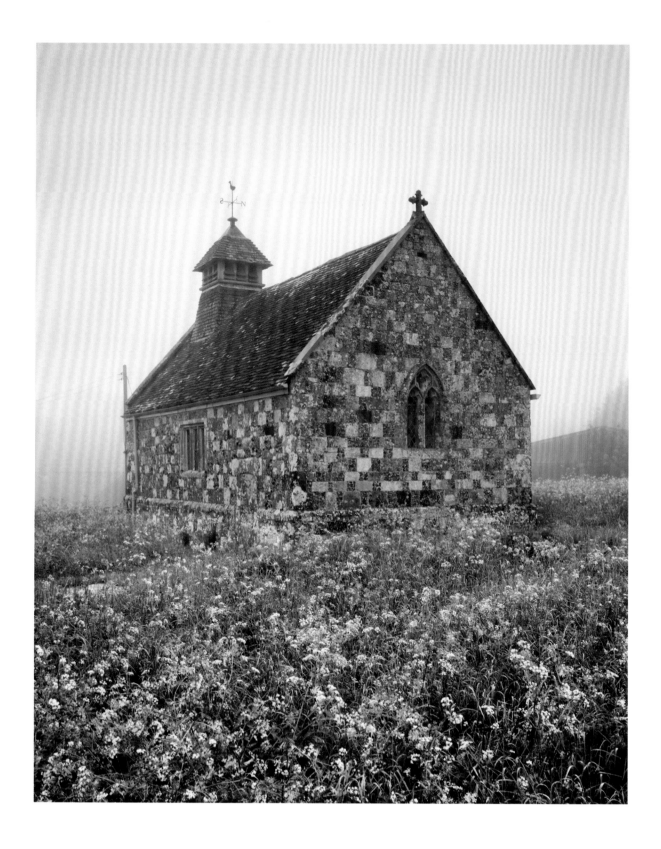

SOMETIMES THE COUNTRYSIDE IS SO FULL of magic that travelling through it is like entering a dream. Perhaps the frost has caught the landscape in its silver net, making intricate ice sculptures out of trees and hedges. There may be hares at play, oblivious to your watching eyes, or the pale rays of a rising sun caught in a weightless veil of mist. It is often in the very early morning, in the first hour after sunrise, that the landscape seems at its most enchanted.

One morning in Wiltshire, I was walking down a little lane near Fifield Bavant that led to what seemed like a dead end. A muddy track wound through a dark wood, and I was picking my way through its puddles when, without warning, the sun brightened and the path was suddenly flooded with light. The damp mist, floating between the old overhanging branches, shone golden and the green leaves seemed touched with flame. It was as if I had stumbled into another world.

The path led on and, before long, emerged into a brilliant sea of dew-topped grass glinting in the sunlight. In the field was a tiny church, knee-deep in cow parsley. It was a simple rectangular building built of stone and flint, scarcely altered since the thirteenth century. The interior was plain, whitewashed and modest, with simple wooden chairs and home-made kneelers. There was no room for a pulpit, but even so it glowed with quiet sanctity.

It is hard to imagine the countryside without its churches. Like country houses, they are places where visitors can find echoes of previous ages. It can be extraordinarily peaceful to walk among the empty pews, envisioning the village families, both grand and

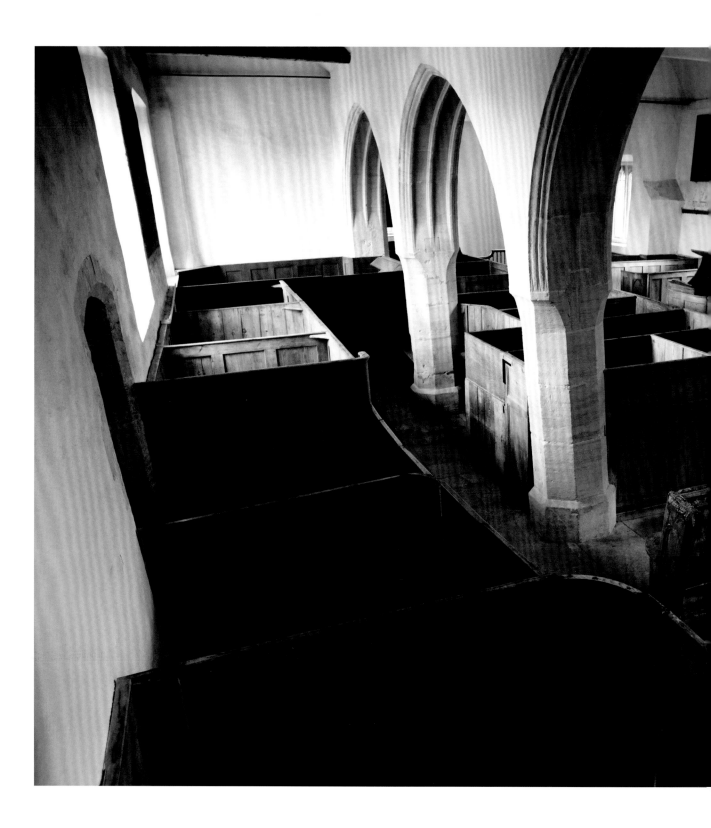

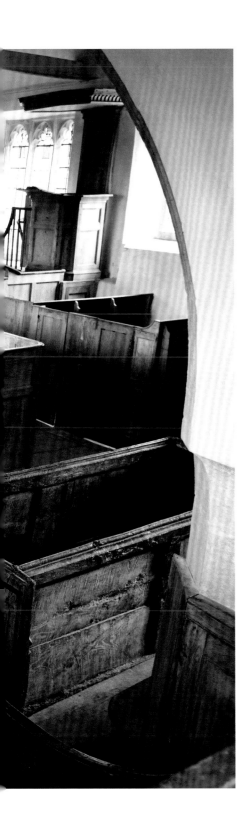

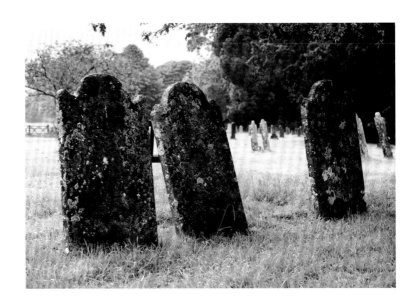

humble, who sat in them in the past. It is just as peaceful to wander in the churchyards, discovering obscure inscriptions on timeworn gravestones overlaid with intricate patterns of lichen. It is natural, when you are visiting a village, to contemplate those who lived there before and helped to give the place its unique character. The soothing presence of nature in a country churchyard, the old yews, wildflowers and "soft wind in the grass", makes you wonder, as Emily Brontë put it in *Wuthering Heights*, "how anyone could ever imagine unquiet slumbers for the sleepers in that quiet earth".

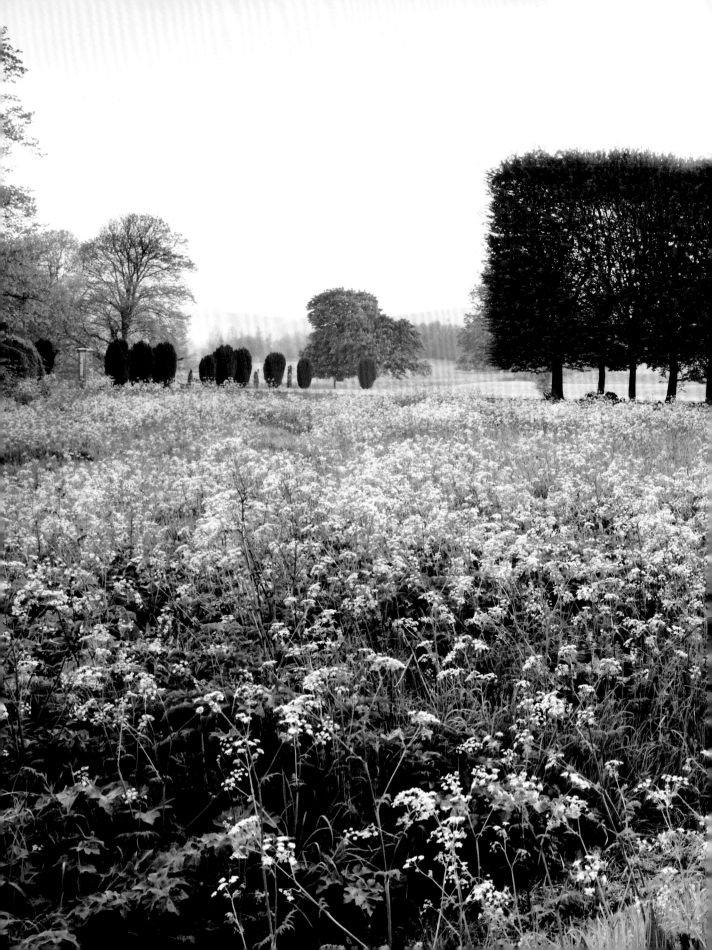

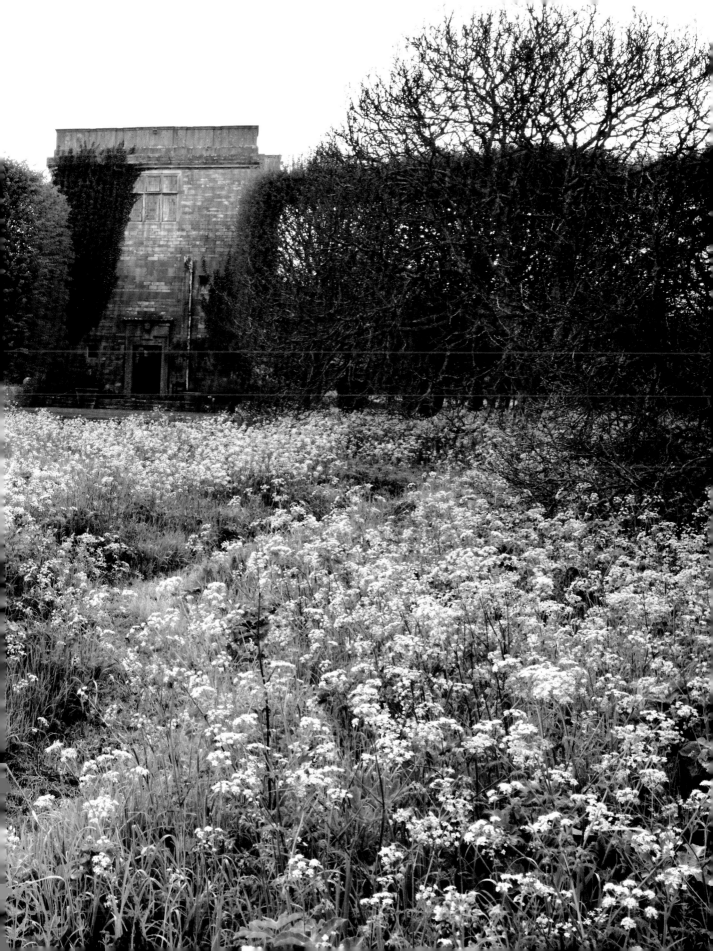

ANOTHER FEATURE OF COUNTRY CHURCHES is their wonderful flower arrangements. The English are rightly known as a nation of flower-lovers. In the country, this passion is at its most visible in the village flower shows, the flowers festooning churches and weddings, and in immaculate gardens. At certain times of year, there are breathtaking flower festivals.

In Castleton, in Derbyshire, I joined streets filled with delighted villagers to watch the annual Garland Day. This has been going on for as long as anyone can remember, at least 200 years, possibly far longer, and consists largely of people decorating themselves with flowers, drinking and laughing, and generally making merry. The ritual centres on a huge garland placed on a bell-shaped wicker frame, large enough to contain the head and shoulders of a man, which is paraded through the streets on horseback after first being displayed (without the man) at all six of the town's pubs. The man in the garland is known as the King. He is followed by a Consort, who is not be confused with the Queen, which is the name reserved for a smaller floral wreath hung on top of the main garland. Both are followed by the Castleton Silver Band and a team of young Morris dancers dressed in white. The King's garland is eventually delivered to the church, where it is hoisted onto the bell tower and, a little later, the Queen is hung on the war memorial. There is dancing, including the Garland Step, which seems to involve almost everybody, followed by more drinking, laughing and singing, and money is collected for charity.

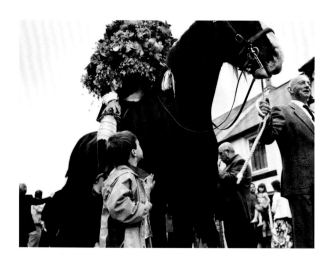

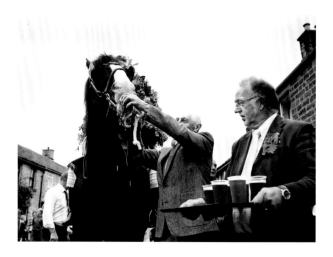

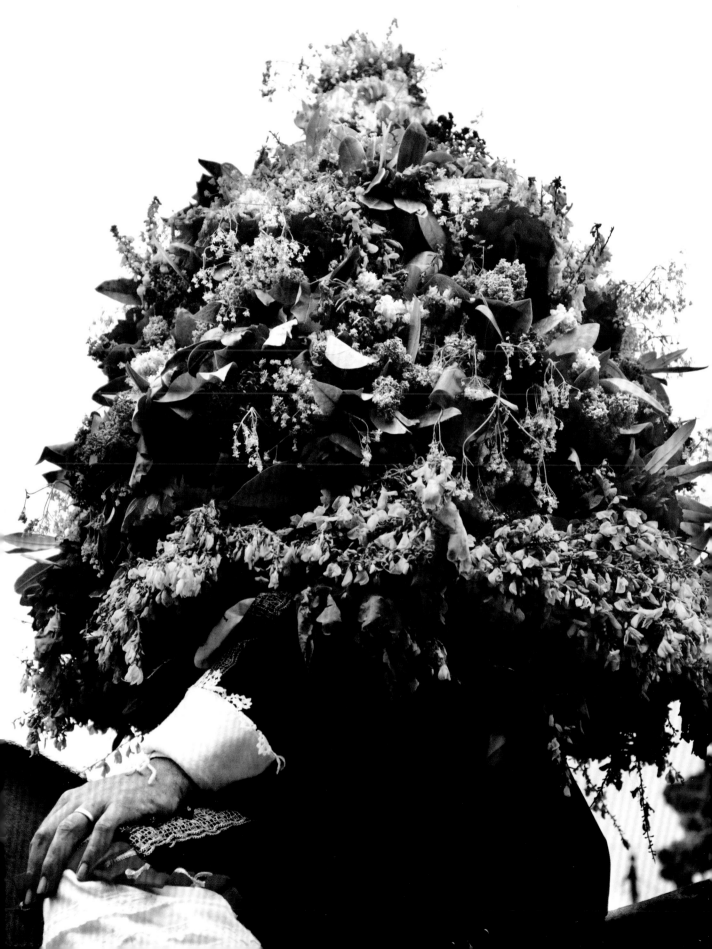

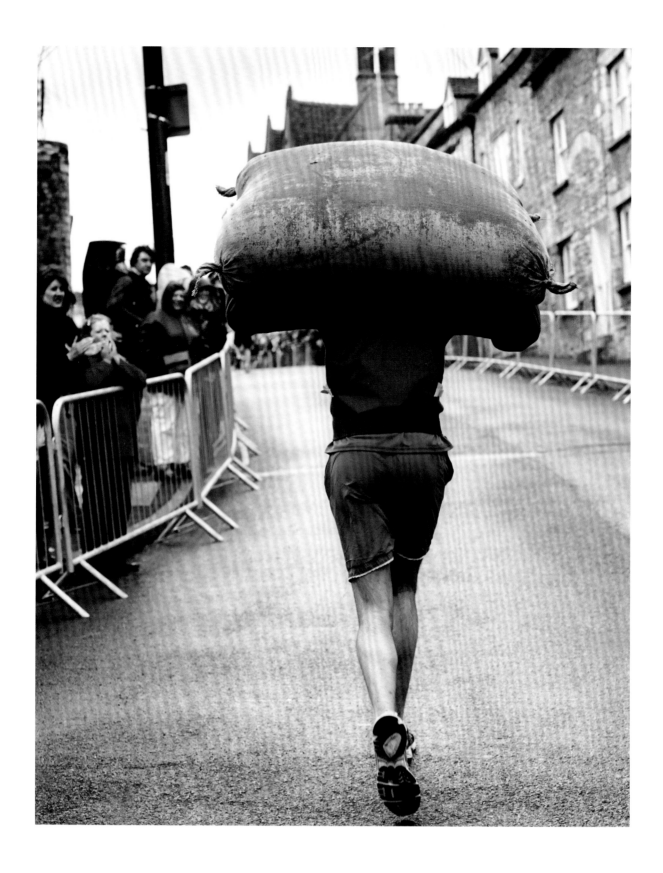

Throughout the year many similar ceremonies take place around the country. Not all involve flowers, but all involve strange customs. What links these colourful ancient rituals (other famous ones include the Haxey Hood, Hallaton Hare Pie Scrambling and Bottle Kicking, Cooper's Hill Cheese Rolling, the Hunting of the Earl of Rone in Combe Martin, and St Briavel's Bread and Cheese Dole) is that they are all forms of congregation or excuses for rural communities to celebrate their collective memories. They are often eccentric, and the particular local details of each ritual are performed with enormous care, with all generations participating with equal enthusiasm. As with so many other country activities, an important part of the celebration is to raise money for charity.

Castleton Garland Day is no exception. Its origins are obscure, but may be similar to those of the Jack-in-the-Green Awakening that precedes the Rochester Sweeps Festival. Whereas that is linked to May Day, this is linked to Oak Apple Day, on 29 May, which commemorates the restoration to the throne in 1660 of Charles II, who hid in an oak tree when he was on the run from the Roundheads nine years earlier. This tradition also used to be known, in places, as "Pinch Bum Day", on the basis that anyone not wearing a sprig of oak was liable to have their bottom pinched.

In Tetbury, Gloucestershire, we stood in squalling rain to watch runners of different ages take part in a series of races along the 220m (224yd) wet road that separated the Crown Inn from the Royal Oak. Watching was made hard by a fierce umbrella-breaking wind. Running was made even harder by a one-in-four uphill slope and the carrying of huge sacks of wool weighing, in the case of the men, 27kg (60lb). For the women's races it is 16kg (35lb). Despite that, scores of runners, some fitter-looking than others, felt sufficiently enthusiastic to give it a go in both individual and team races. The all-time record is just under a minute.

There is, as ever, a story behind the ritual. Tetbury was largely founded on the wool trade, which flourished there in the Middle Ages. By the nineteenth century, the trade had gone into decline, and brewing had filled much of the gap. The woolsack race celebrates both traditions. A pint or two of local beer has helped to persuade many a local that a fully laden uphill sprint might be a good idea. The day is an excuse for thousands of people to have a fun day out and, yet again, to collect money for local charities.

Country life would be unrecognizable without such idiosyncratic traditions. Although we sometimes speak of the countryside with no more in mind than green fields, woods and hills, the country we love is as much a human phenomenon as it is a geographical one. It would be equally misleading to think of those customs as exclusively

community-focused. Our rural celebrations invariably involve the physical fabric of the local countryside, whether it is a particular field or hill, or the wool of the local sheep, boughs of local trees or, most often, locally grown flowers.

In Bisley, in Gloucestershire, villagers produce a dazzling range of wreaths for an annual "well-dressing" festival. In St Neot, Cornwall, the annual flower festival includes a huge carpet of flowers. And in Wiltshire, at a place called Pop's Farm, I was intrigued by an auricula theatre. Auriculas were the height of fashion in the eighteenth and early nineteenth centuries, when they first began to arrive in Britain from Continental Europe, and enthusiasts, often in stately homes, used these tiered "theatres" to display their prize plants to their friends. The plants are more common now; there are no fewer than three national societies.

IN WEST SUSSEX, I WENT TO SEE RUPERT AND JAN GREY, friends who live in a remote thatched cottage on the edge of the South Downs. Rupert was a boy of seven when his parents bought the cottage in 1955, for £250. It was a "complete wreck" with "no water, no electricity and no telephone", and the journey from London took 4 hours. The A3 was a country road then but today, two decades after Rupert and Jan moved there, the cottage is set in a hamlet of five thatched buildings.

The cottage lies in a secluded corner of Sussex, half-buried in a comforting fold of the rounded downs which Kipling wrote about so eloquently. London, a mere 100km (60 miles) away, is a world apart. From the rose-clad cottage and the raised herb beds in the kitchen garden, to the washing hanging on the line and the low-ceilinged kitchen where Jan prepares home-grown vegetables, there is a consistent echo of the romantic "rural dream".

In some respects their way of life is very traditional. They have no television or central heating, save in the magnificent oak-framed library they built 20 years ago, just as nothing in the fabric of the building is made out of plastic. They work tirelessly to manage their ten-acre plot. "We always have some project on the brew," says Rupert. "Hedging, ditching, fencing – whatever needs doing. We're not yet self-sufficient, but we are moving in that direction."

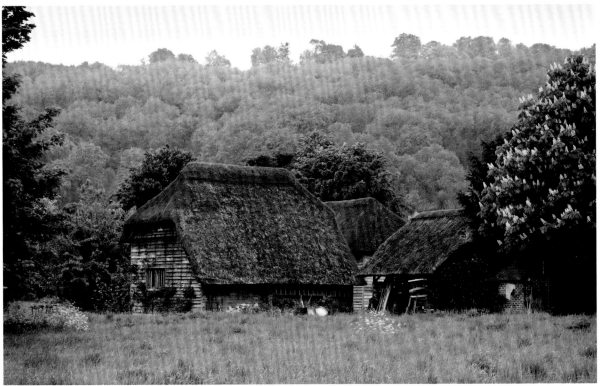

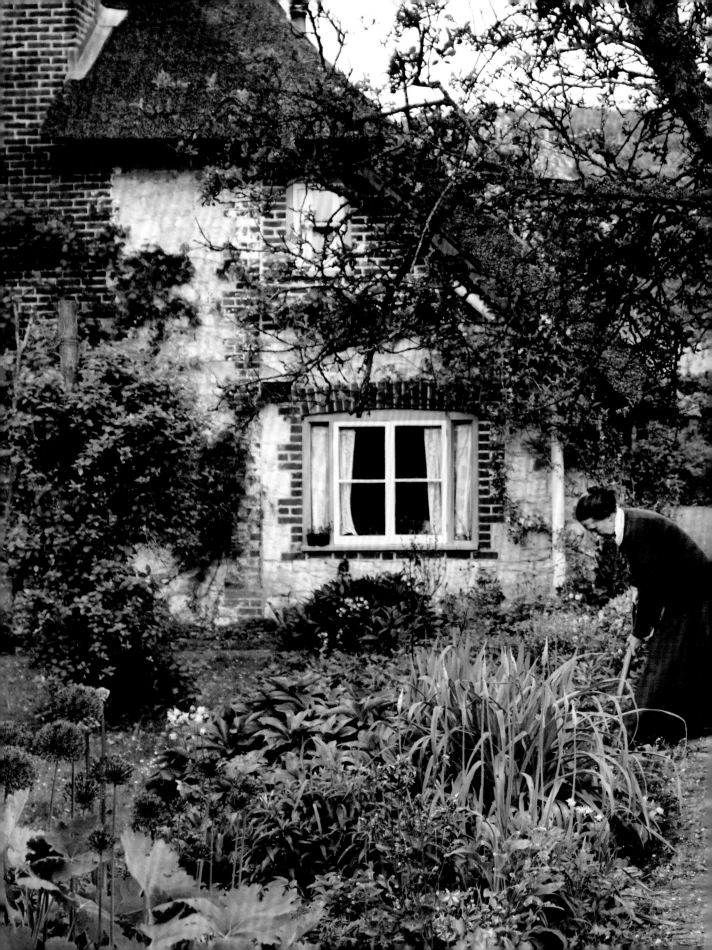

But this is a home which serves a very contemporary lifestyle. There is here a balance, an alliance, between the demands of professional life and the discipline imposed by the seasons, the planting and the harvesting. There is a sense that the transition between the two is natural and straight-forward and that one compliments and enhances the other.

There are those who might see the chopping of firewood and tending the coppice as chores, but for Rupert and Jan they are "magical", and their three children seem to agree. "They're always coming back," says Rupert. "I think they see the magic of it, too." It is, he adds, "an extraordinarily beautiful place. Every morning I go to the top of the Downs. I can walk there in 15 minutes, and when I look down it makes me feel warm in my belly." Afterwards, he comes down to the dandelions and long grass at the end of his garden, where, near a garden gate, he takes a bath.

"It used to be in the cottage and, when we were restoring it, we threw the bath out. It sat in the garden for ages until I suddenly thought, 'Let's run hot water to it.'" Now he bathes there every morning,

immersed in his rural paradise, ruminating on "whatever the issue of the day happens to be. It's a great place for meditating, and problems often solve themselves while I am bathing. Sometimes a robin comes and sits on the tap by my foot. It's wonderful. I could never tire of living here."

Is this romantic way of life typical of the country? Of course not. It is perfectly possible to live in the country and enjoy a lifestyle scarcely distinguishable from that of the towns and suburbs. Indeed, that's what many people choose to do, but I know that Rupert and Jan are not unique or even particularly unusual in living as they do. The essence of their life is not that it is traditional (in some ways, it isn't), but that it is rooted in the way in which they engage closely with the environment.

Countless others do the same, each in their own particular way, which is why communities within the countryside, like the landscape, are still a variegated tapestry in which many quite different people enjoy their own, often quirky, enthusiasms.

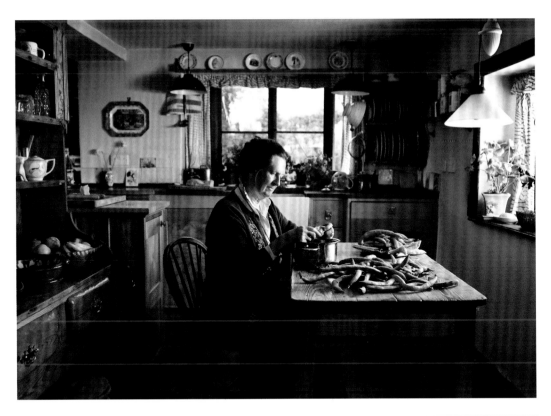

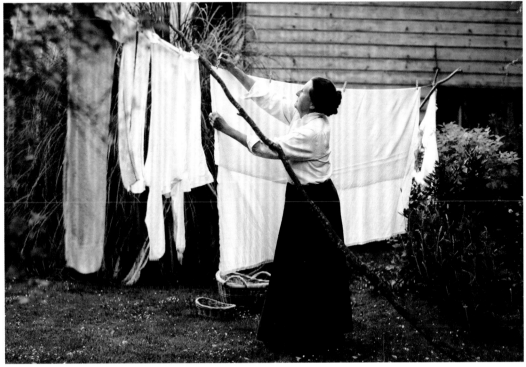

A FEW DAYS LATER, I FOUND MYSELF IN Poyntington, in northwest Dorset. The biennial flower festival was in full swing and the village filled with people and plant stalls. Enthusiasts bustled around looking for bargains, and the air was thick with horticultural expertise.

What really lifted the spirits on a typical summer's day of alternating sunshine and rain was a sense that a whole community had come out to play and had no intention of allowing a few showers to dampen its enjoyment. Teenagers messed around at the coconut shy and wellie-throwing, while smaller children enjoyed face painting and a plastic duck race in the river. There were teas and deck chairs on the manor lawn, and a marquee in which a brass band (the Sherborne Town Band) was playing music cheerful enough to brighten the greyest day. At the village crossroads, a team of young Irish dancers in embroidered costumes skipped and hopped with remarkable skill. They came from nearby Yetminster, where Sharon Sandon,

who used to live in Ireland and whose mother also taught Irish dancing, trains children in this notoriously difficult traditional skill.

The defining characteristic is not that the traditions are old, but that people enjoy them. Is it old-fashioned to make your own jam or practise a traditional craft? Is it nostalgic to hope your children will play Swallows and Amazons, rather than computer games? I don't see why. It has nothing to do with modernity. It is simply to prefer simple, active pleasures over expensive, passive ones. It may have

something to do with living in the country; it is there you are most likely to find people enjoying themselves in time-honoured ways.

Julia Locke, manager of the Sherborne Town Band, is worried that too few young people are taking up brass instruments for her band's future to be assured. "There are so many other activities for children to become involved in." Yet the playing and the dancing brought so much obvious pleasure to those involved it is hard to believe that a child or two will not have been inspired.

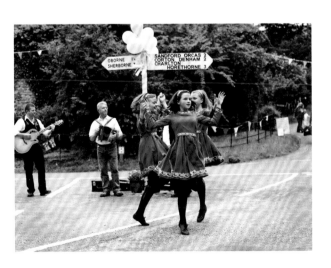

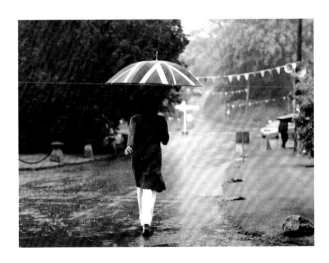

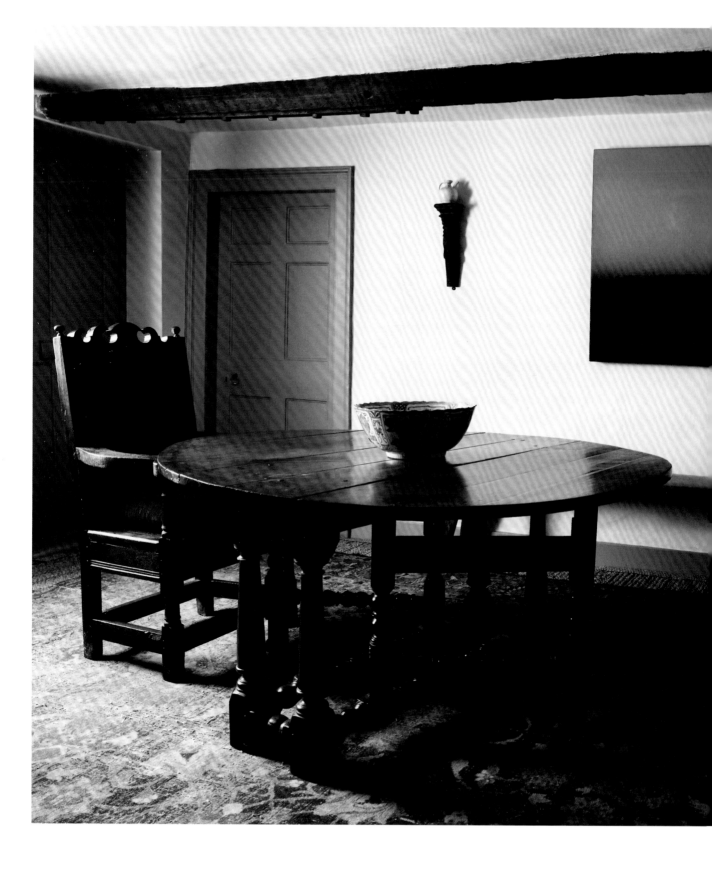

I WOULD BE HAPPY TO BET THAT IN 50 years' time Poyntington will still be celebrating its flower festival in much the same way it does now. People who live in the country are slow to discard, whether that is traditions or possessions. There is a spirit of make-do-and-mend, as well as a respect for objects that still have plenty of life left in them. That may be partly a question of expense, but it is also a question of attitude. There is not the same pressure to move on from the past. That's why the photographs in this book are full of old things: old tools, old furniture, old jam jars, old garments patched together. They do, after all, show life as it is lived today, but old does not yield to new; rather, the two coexist comfortably.

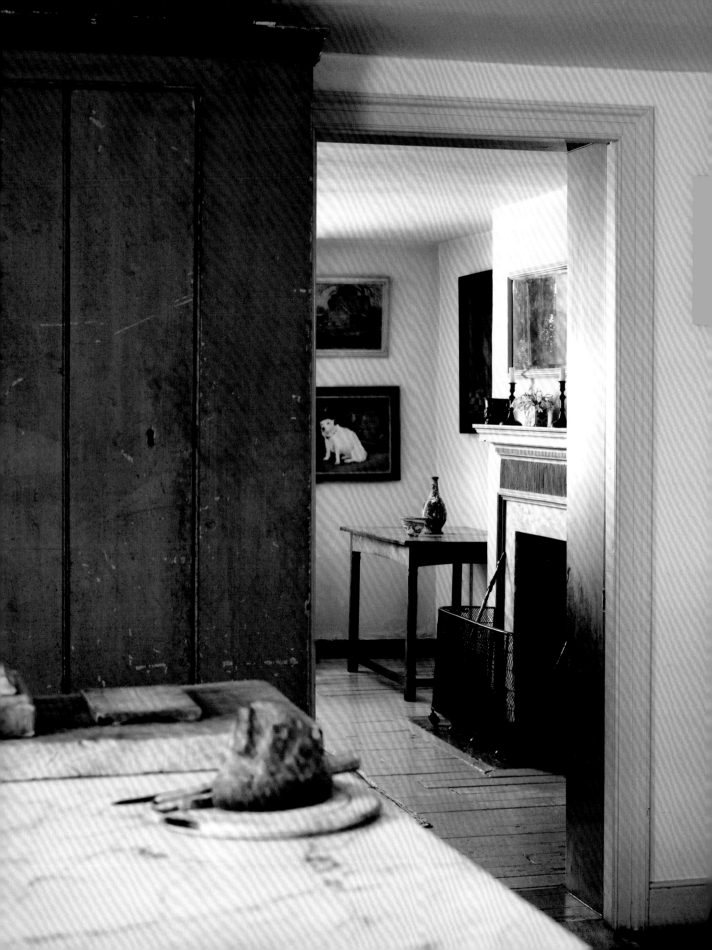

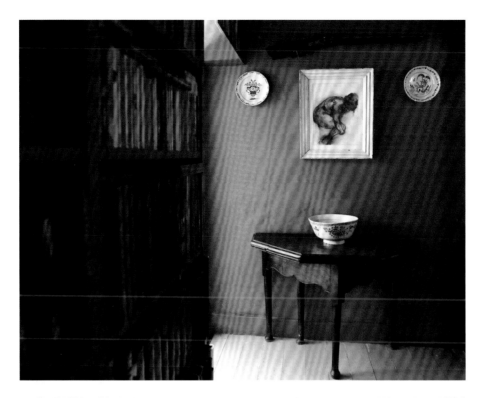

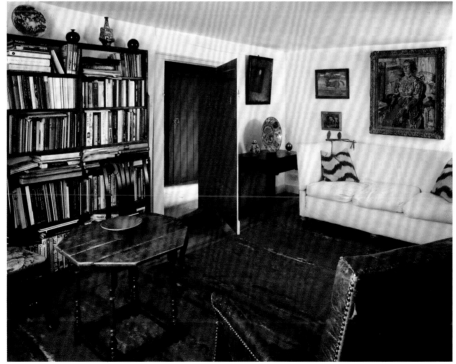

Look inside a country home, such as the one in Coombe Bissett mentioned earlier, and you may notice two things. Rather than being glamorous, the interior will often be not so much designed as found and modified. The furniture and decorations might come from more than one period and style, but will err on the side of function and robustness, and, while the design of the rooms may well be inspired, more often than not it will be tempered by practicality, with flagstones taking the place of fitted carpets, and a preference shown for dark furniture. (You can have white sofas, or you can have dogs and children, but you cannot have both.) The spirit of living in the countryside embraces the outdoors as much as the indoors, and the constant comings and goings mean that you cannot be too uptight about mud.

There is a sense, too, in country houses of the ghostly presence of previous inhabitants and past incidents. A room can be empty yet still seem filled with people and the echoes of their lives. Look at some of the interiors on these pages – the old furniture, worn floorboards and the slight unevenness to the angles of the beams and ceilings. Who could look at these rooms without imagining their stories?

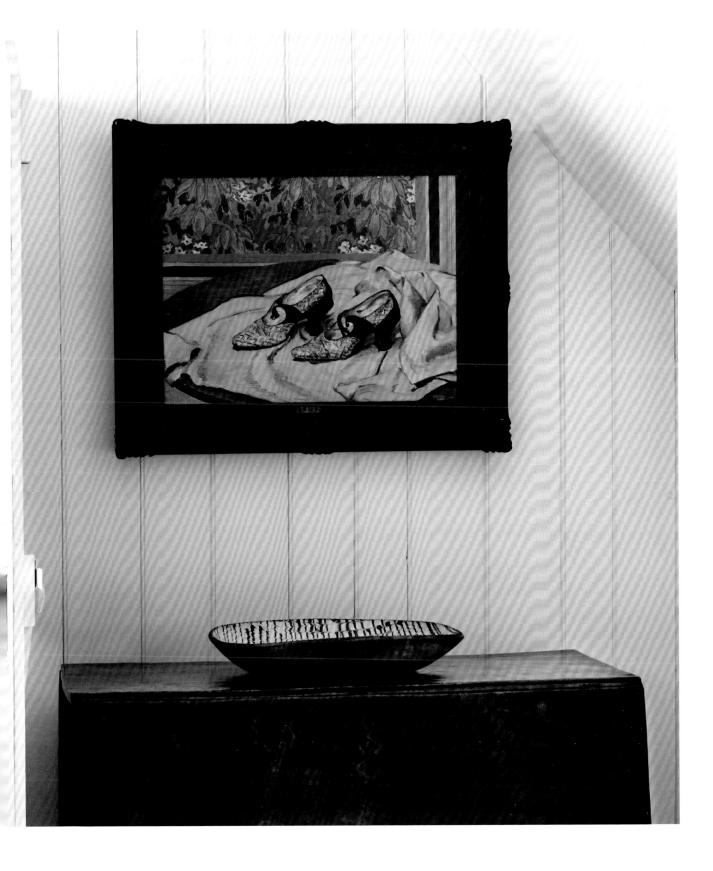

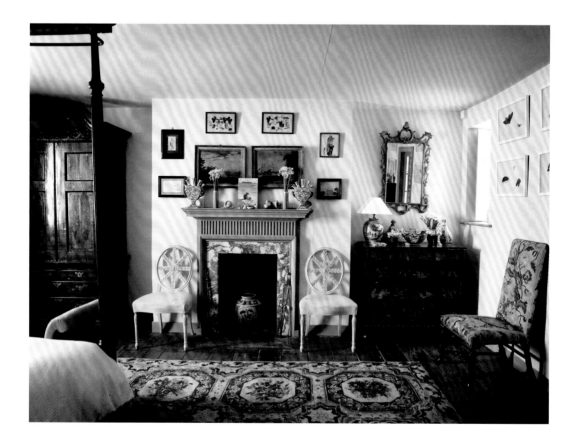

The very word "country" evokes all the life cycles of nature: the plants, the animals and the length and warmth of the seasons and days. It also evokes the life cycles of generations who have tended the same fields, lived in the same houses, raised children in the same landscape and are now buried in the same churchyards. One of the defining characteristics of country life is the sense that people and place share the same past and that our memories can rarely be entirely separated from the physical environment.

Perhaps that is what feels so special about the photograph opposite, a simple scene from a family holiday that has been captured for ever in a painting (by a friend) and placed on a bedroom mantelpiece next to shells collected from the beach. My favourite houses are homes that are filled with special memories such as this and recollections of happy times, in which people have left something of themselves – and to which they may sometimes return again to find something of themselves.

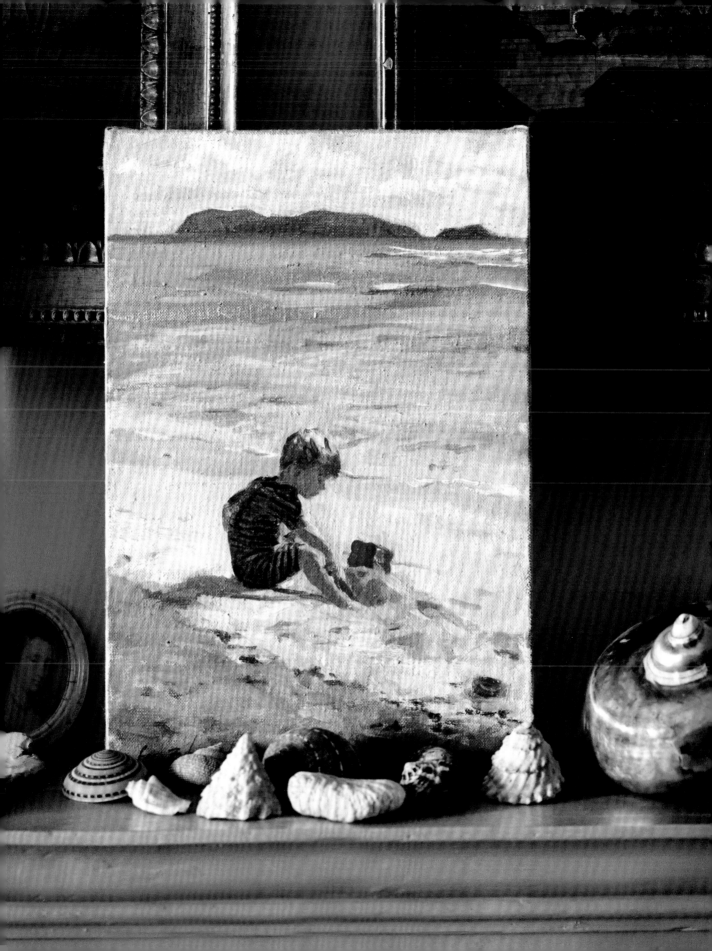

THERE ARE PUBLIC HOUSES, AS WELL AS private ones, where memories are celebrated. In the Wiltshire village of Charlton St Peter, there is an annual celebration of the life of a local grain thresher, Stephen Duck, who in the eighteenth century briefly became a celebrated poet (thanks to such works as *The Thresher's Labour*), before coming to a tragic end. In 1834, one of his admirers, Lord Palmerston, bequeathed an acre of land to pay for an annual "Threshers' Dinner" in Duck's honour in the village pub, the Charlton Cat. It has been held there ever since. It is a struggle these days to muster the requisite dozen local labourers, and readings from Duck's poetry can be a bit of a struggle, too, but a good time is generally had by all. As one long-standing "duck", Tim Fowle, puts it, "I'd hate to be the person who said we're not doing it any more. More than 275 years of history down the drain just because we can't be bothered."

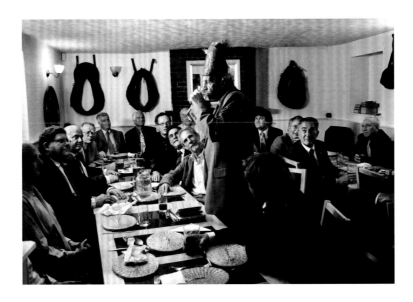

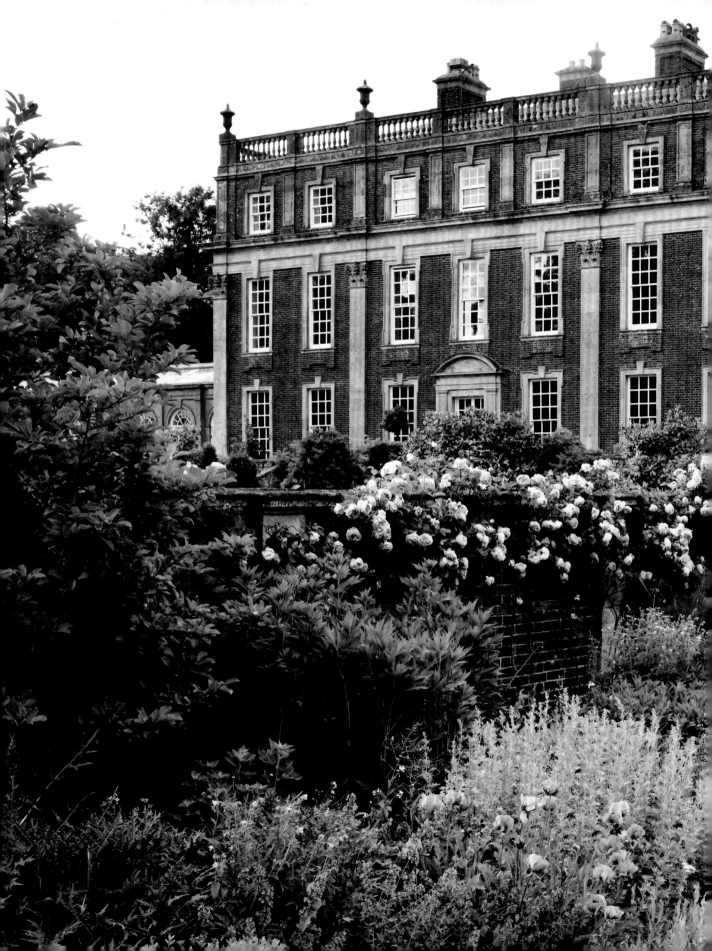

OTHER VILLAGES ARE NOT AS LUCKY AS CHARLTON St Peter. Thousands have lost their pubs in recent years as they close at a rate of five a day. For the first time since 1066, villages that do not have pubs outnumber those which do.

This is sad. A good village pub is one of the best ways in which a rural community retains its sense of collective self. People go to the pub to share stories – not simply the latest gossip, but also the past events and legends that help to give each village its unique character. As Dr Johnson put it: "Nothing has yet been contrived by man by which so much happiness is produced as by a good tavern or inn."

There are other traditions that inspire happiness and the warmth of communication, including our shared passion for gardening. The dazzling herbaceous borders and lovingly mown lawns glimpsed behind so many village hedges are usually private creations, but their owners

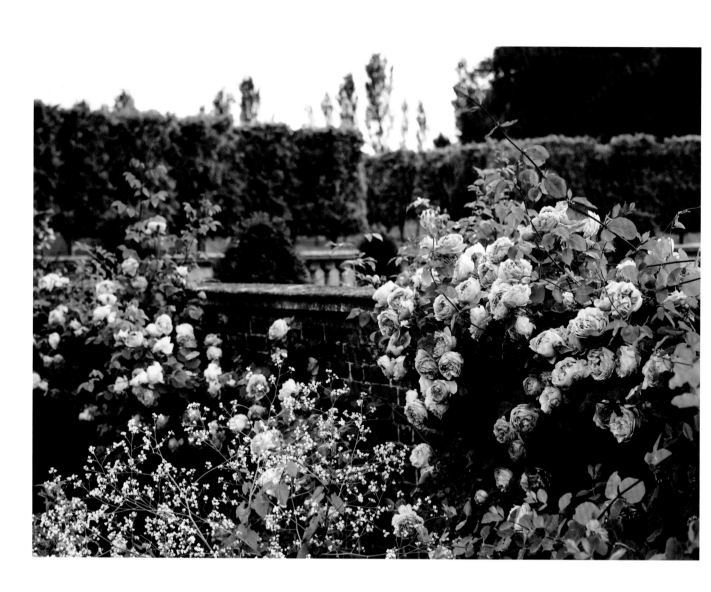

are often pleased to share their achievements. Indeed, one of the main points of the exercise is to show others what you have nurtured, hence the popularity of flower shows, prizes for produce, gardening clubs and, increasingly, open garden weekends. The typical country garden is a haven of seclusion, but it is also a place of gentle sociability in which we can share our wonder at the beauty that nature, with a little help from humankind, can conjure from the earth.

Some of the best days out in the country involve visiting gardens, and the tradition of open gardens, both small and grand, brings pleasure to many over summer weekends. For many of us, flowers really are the stuff of life. We nurture them, study them, collect and share them, delighting in their beauty.

What could be a prettier sight than that of pale pink roses spilling over a crumbling, eighteenth-century wall or starched white ox-eye

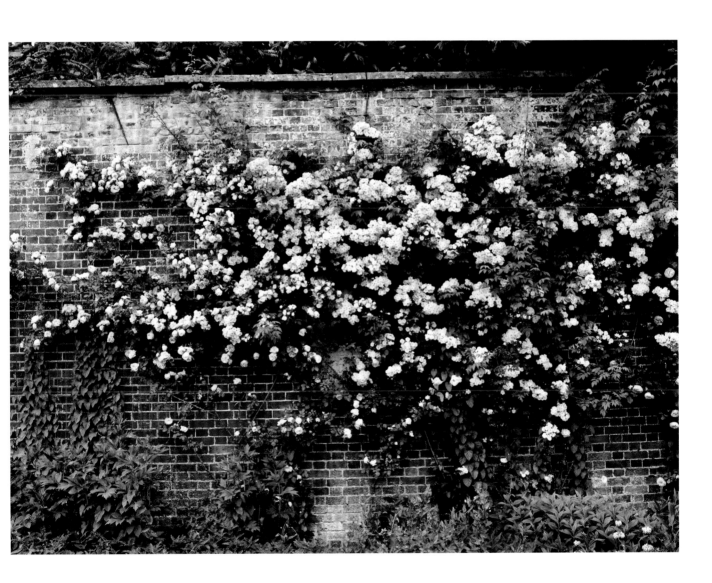

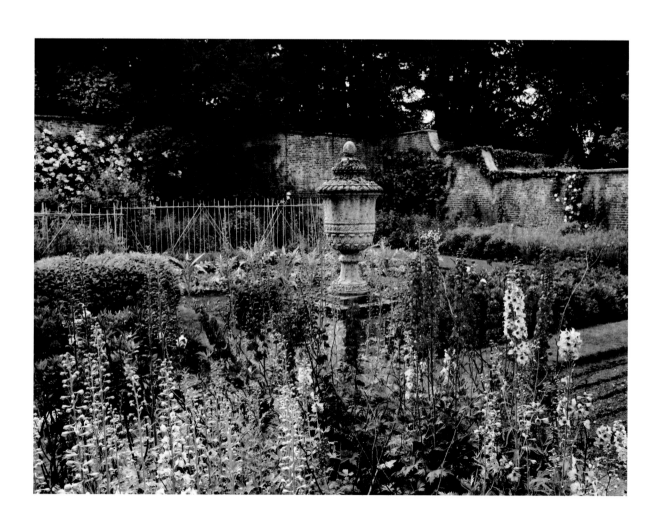

daisies swaying in a warm breeze? There are as many kinds of floral beauty as there are flowers, and its greatest joy is its ability to surprise. The roses and delphiniums in my garden blossomed overnight into intricate arches of colour and stunning pattern. One moment you are wondering if your flowers are ever going to blossom; the next, almost while your back is turned, they have burst into spectacular colour.

One should not underestimate the amount of love that is to be found in a garden. The capacity to take pleasure in beauty and our willingness to share it are important elements in the local community, which, like flowers, takes time to open up. Left to ourselves, we are inclined to potter in the privacy of our gardens or seek quiet solitude among remote woods and streams.

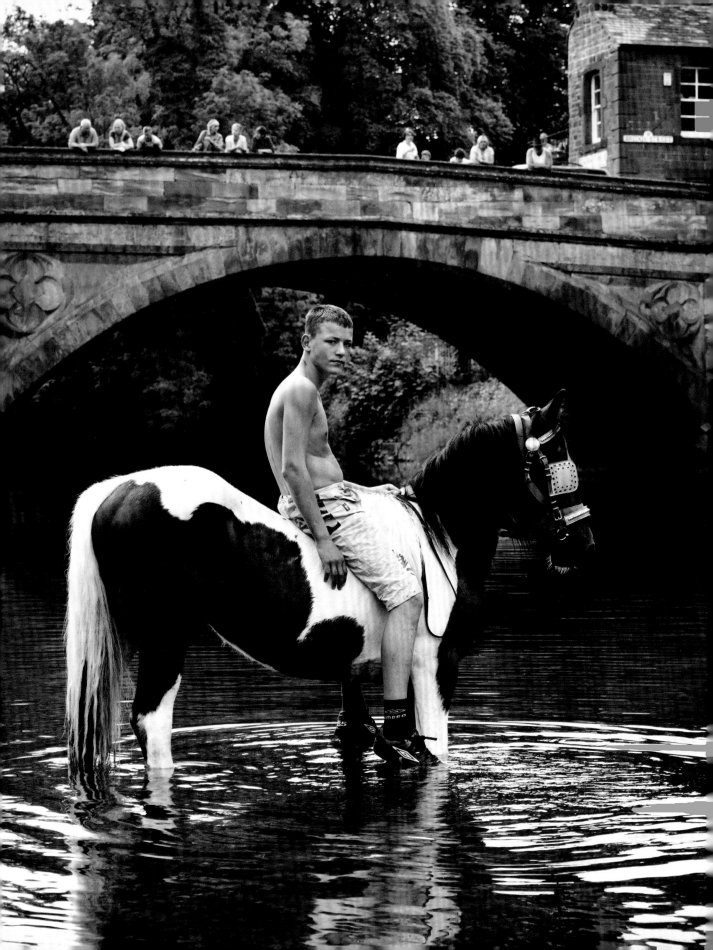

RAMBLING THROUGH THE ENGLISH COUNTRYSIDE north, south, east and west, you can never go far without encountering some sight or experience that floods the heart with hope. It could be a breathtaking view, a wonderful smell or a snatched glimpse of a wild creature; perhaps, even, a beautiful house glimpsed suddenly from an unexpected angle. It's all there just waiting to be discovered. I suspect William Wordsworth had those discoveries in mind when he wrote: "Pleasure is spread through the earth in stray gifts to be claimed by whoever shall find."

Whether you are in the farthest corners of the country or your own back yard, there are always surprises lying in wait. I thought I might see gypsies in Appleby in June (I mentioned earlier that they have another horse fair) and expected them to be showing off their horses, but not in a deep, fast-flowing river. Yet there they were, at a bend in the Eden, casually riding their mounts into the deepest waters to prove their horses were strong enough to swim with riders on their backs. There are those who disapprove of this practice, but it is dramatically evocative of a culture very different to the mainstream hi-tech so many of us assume is the only reality. It was a glimpse of a wilder world, both unsettling and stunning at

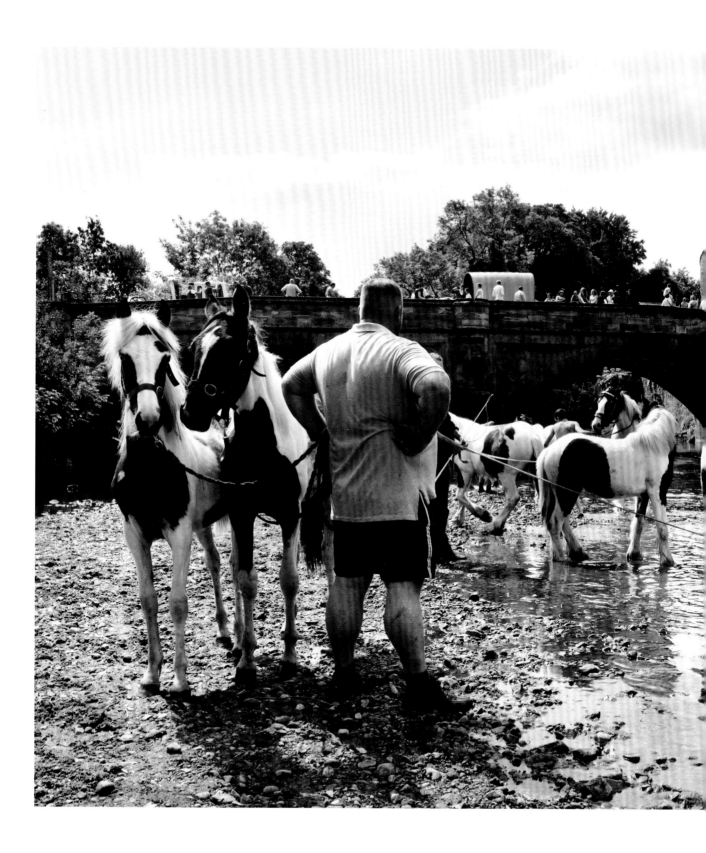

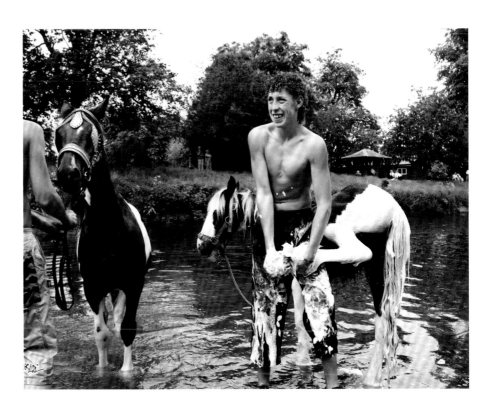

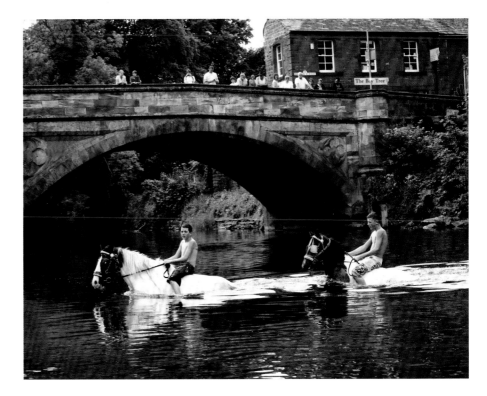

159

the same time. One young man seemed centaur-like in his effortless rapport with the horse beneath him, while the whole scene – bridge and boy reflected in the cool waters as the old trees cast mysterious shadows around them – looked like some kind of Pre-Raphaelite painting.

In a similar sense of surprise, you might expect to see poppies in the countryside and fields brimming with ripe wheat, but you do not necessarily expect to find a field overflowing with both. That was the scene in Somerset, near Castle Carey, where brilliant scarlet and bright gold was scattered beneath grey menacing clouds so low that they seemed to be touching the field, in a scene (see overleaf) that felt like a surreal conflation of Monet and Van Gogh. The sense of the abundance and immensity of nature was overwhelming but, on a more mundane note, there is the cheering thought that if poppies are returning to our wheat fields, farmers must be using fewer pesticides.

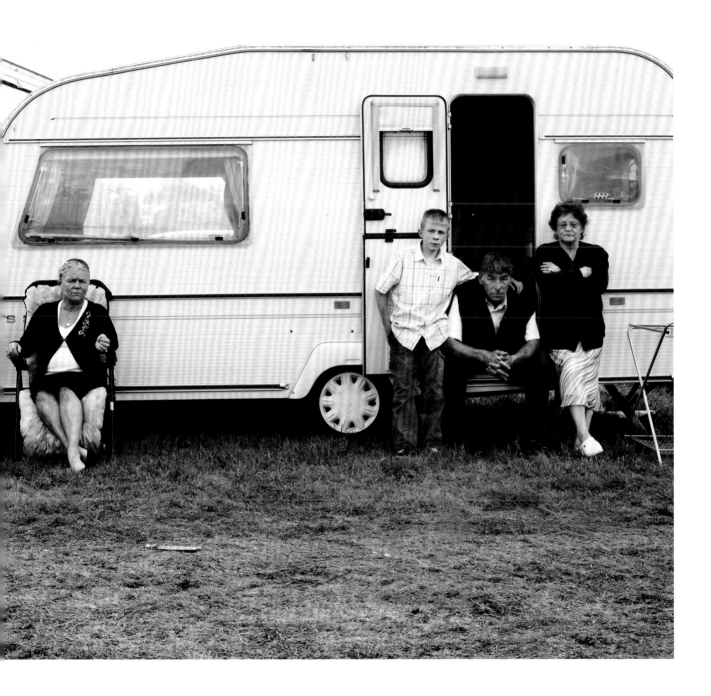

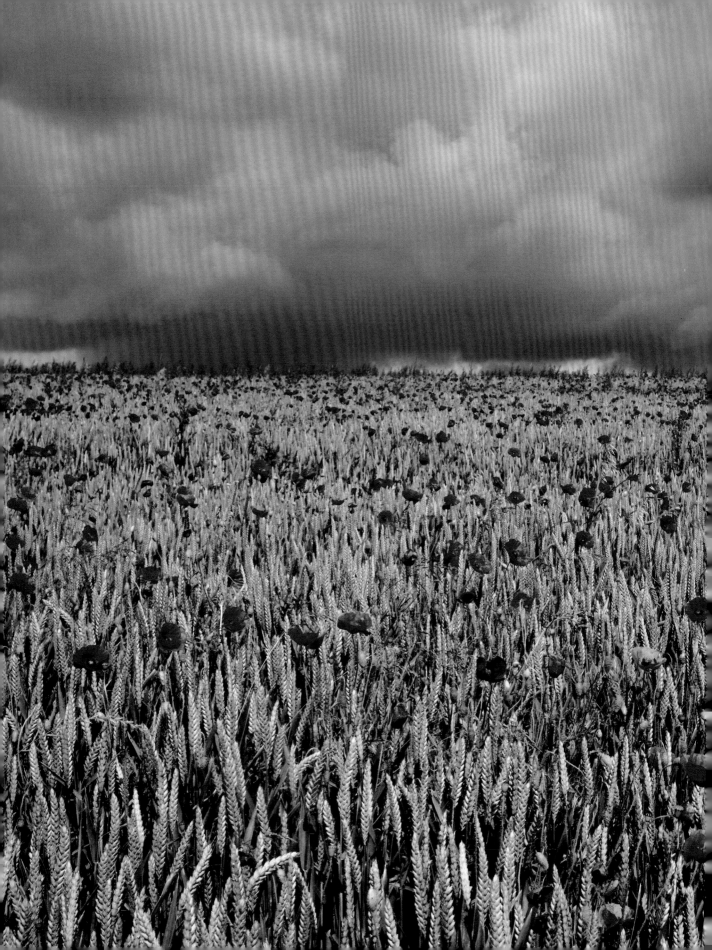

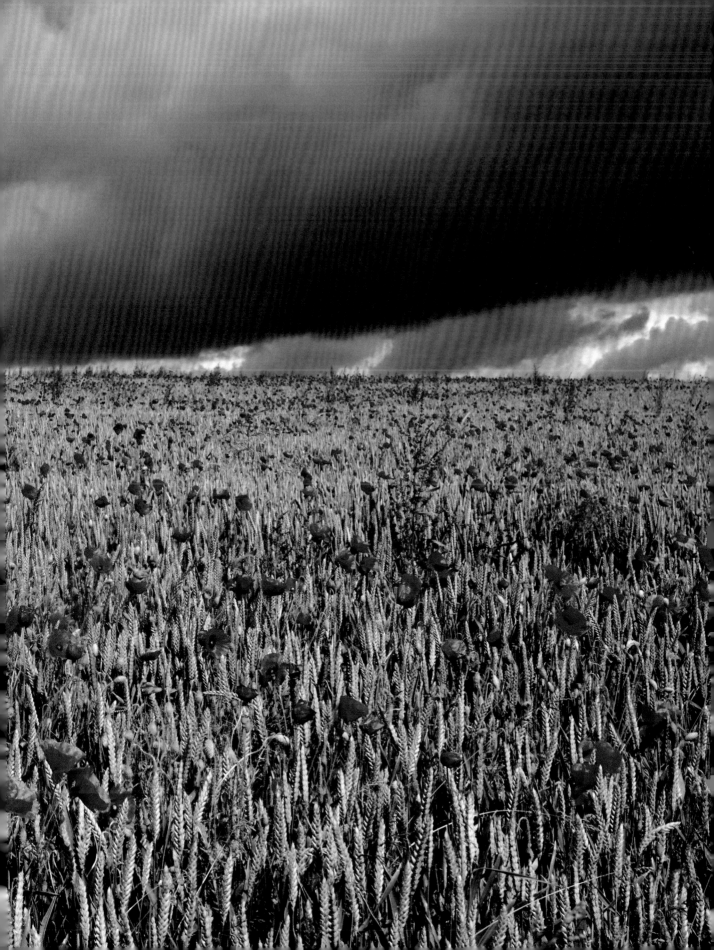

FARTHER WEST, NEAR STITHIANS in Cornwall, I was amazed to find villagers of all ages enjoying a vast but apparently gratuitous bonfire. It was Midsummer's Eve and part of a very ancient ritual. Similar fires are lit over much of Cornwall, along the same chain of high beacons that was used to warn of the approach of the Spanish Armada in 1588. This is a much older ceremony in honour of the sun, dating back to pre-Christian times and later reclaimed as a celebration of St John's Eve, which spread to other parts of Britain before dying out, even in Cornwall, in the late nineteenth century. It was revived by Old Cornwall enthusiasts in the late 1920s and early 1930s, and shows no signs of losing its popularity.

There is not a great deal to it. Imagine Bonfire Night without the fireworks, but with some colourful costumes and dancing thrown in. Really, it is no more than a charming excuse to gather together and raise some money but, when the fire at Stithians was lit and herbs were thrown into it as an ancient incantation was chanted in Cornish, it was difficult not to feel the hairs on the back of your neck stand on end.

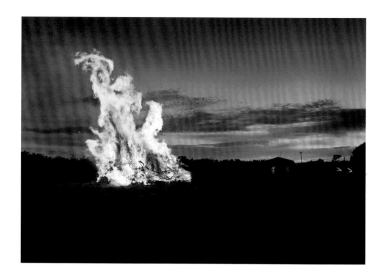

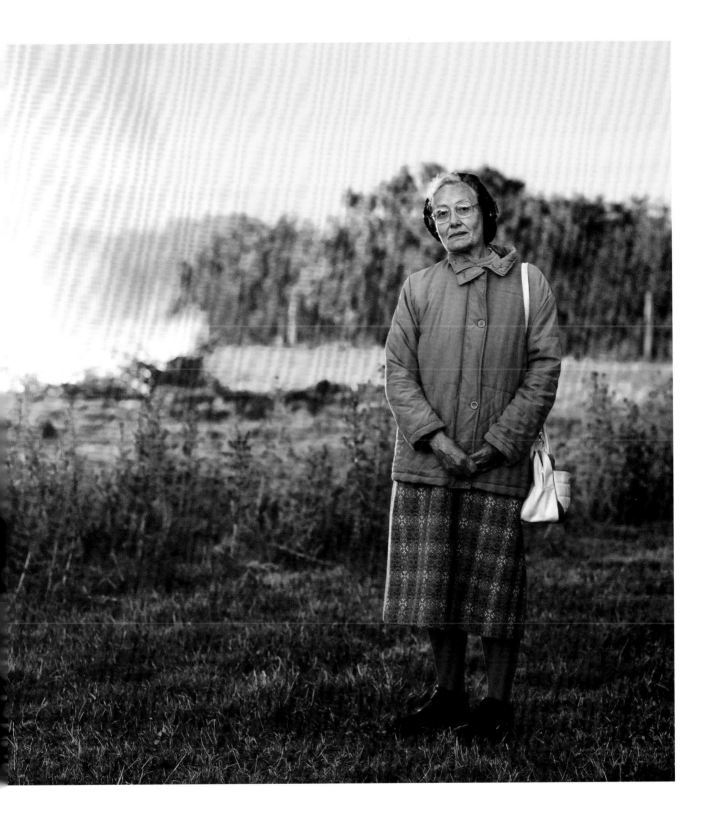

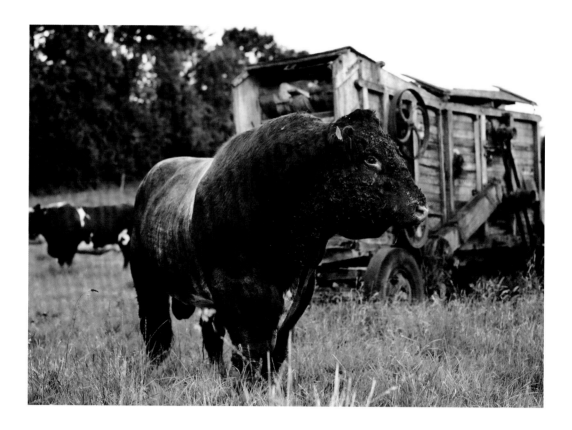

ONE DAY, NEAR SHERBORNE, I noticed some very curious-looking cows on a hillside. We went to investigate and found that they were indeed unusual. Strangely square, they had disproportionately large bodies, just like the two-dimensional farm animals depicted in naïve English paintings in the eighteenth century. They were, we discovered, Beef Shorthorns, descendants of the Durham ox, and belonged to a local doctor, Dr Simon Cave, and his wife, Penny, who keep them for a hobby. There were six cows in all – "Bricks on legs," said Penny – as well as two calves and a huge brown bull called Colonel.

It was good to know that such a relatively rare breed was being nurtured and reassuring to hear Penny say, "There is nothing to fear from Colonel." With his huge shoulders, deep chest and knotted brow, Colonel looked like some sort of prehistoric monster. He was, insisted Penny, a gentle beast, but she did also say: "You would come off the worse for wear if you got in his path once he had made up his mind he was going somewhere."

Shortly afterwards, the cows wandered off to a different part of the field, and Colonel, after a few moments' thought, made up his mind to follow them. We leapt out of his path, and watched his great brown frame ambling into the distance, while the earth seemed to tremble beneath him.

Such strange, unorthodox encounters seem to me to capture the essence of the countryside, as do the ramshackle sheds, trailers and unkempt nettle patches with which the Beef Shorthorns share their field. It is the same lovely disorder as a meadow of wild flowers or a rambling garden, which is one of my favourite rural sights. I remember a cottage near Ashmore, in Kent, where the front garden was so overgrown you could hardly see the house for a riot of colour and poppies growing as high as the eaves. The scent was intoxicating, and the overall effect, including a moss-matted roof and lichen-dappled wall, was of a building rising organically from the local landscape.

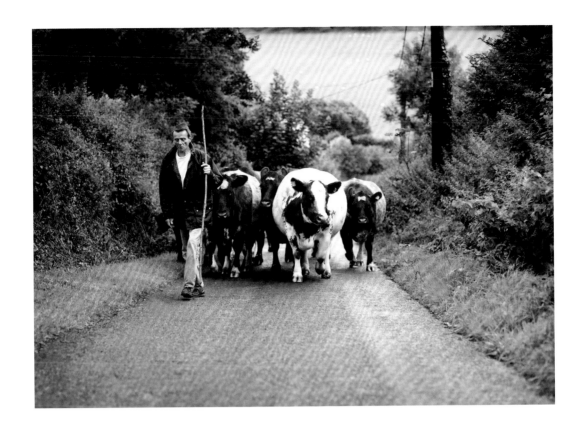

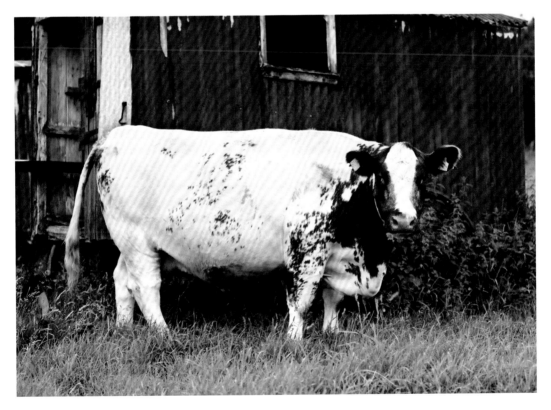

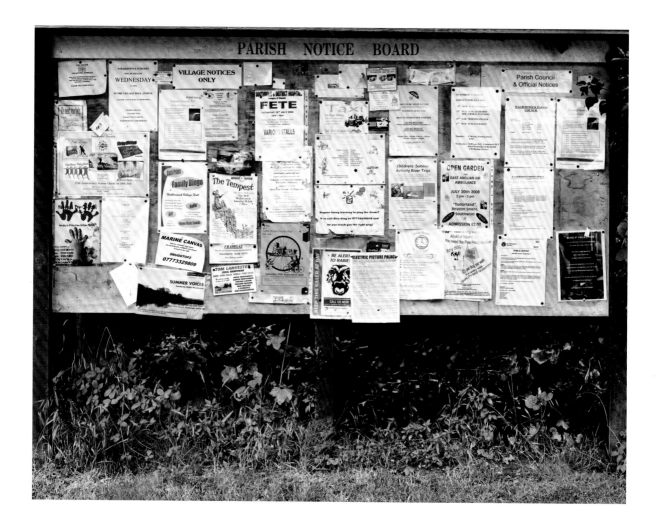

"Glory be to God for dappled things …" wrote Gerard Manley Hopkins more than a century ago. "… All things counter, original, spare, strange." In today's world, the ungovernable exuberance of nature is more valuable than ever. Nor is it just in nature that such inspiring disorder can be found. Many villages have evolved and many cottages sprung up in just such an unplanned, ramshackle way. It is part of the same charm that is to be found in messy old notice boards on many village streets. The handmade notes, some weather-beaten, some out of date and some misspelt, each tell a story, perhaps about the fête committee or the parish council, perhaps advertising a playgroup, a dog walker or a local handyman. The voices of half the village are there.

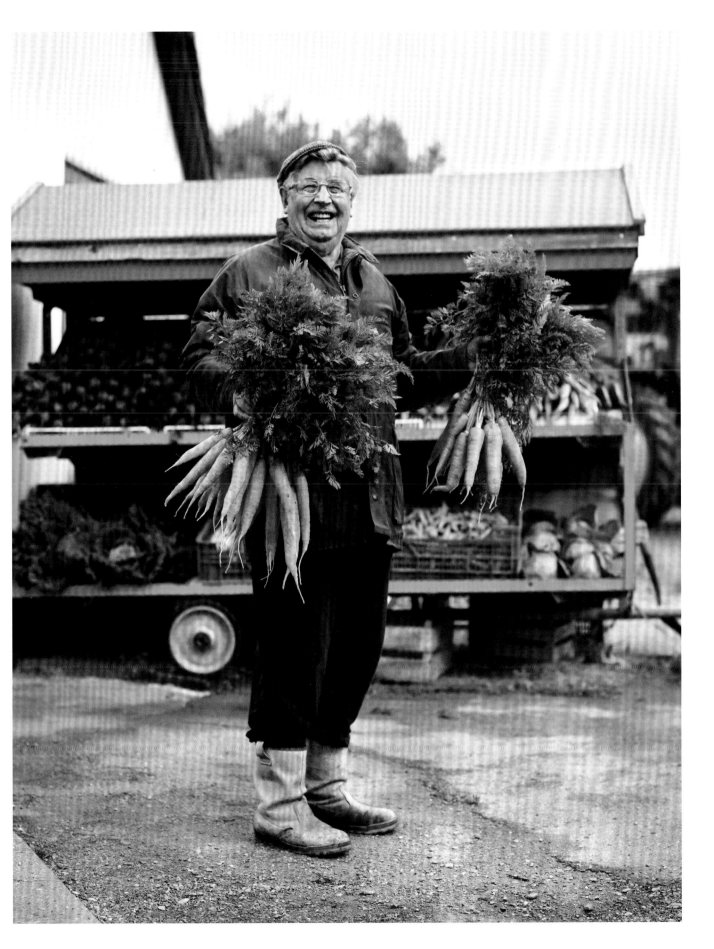

THERE'S A SIMILARLY ENGAGING QUALITY TO those handmade signs you see on country lanes advertising such delights as "fresh eggs", "honey" and "logs", as well as the ever-inviting "pick your own". To me, they feel like welcome signs. They are not simply a refreshing contrast to the bossy street signs haranguing us in built-up areas, but also a very human way into the landscape. They tell you about local foods and offer little clues (in the handwriting, the spelling, the jokes) to the character of the person who made them.

In the Suffolk village of Carlton Colville, a hand-drawn sign for carrots led us to William Boon, a 76-year-old smallholder who has lived in the area all his life. He had a healthy crop, not just of carrots, but of swedes, parsnips, turnips, onions, sprouts and cabbages, too, most of which he sells to passers-by. He is delighted to be working so far past retirement age, partly out of a sense of family tradition – his parents and grandparents worked the same land – but mainly because of the sense of independence it gives him. "It's not much of a way of earning money," he said. "But it is a way of life."

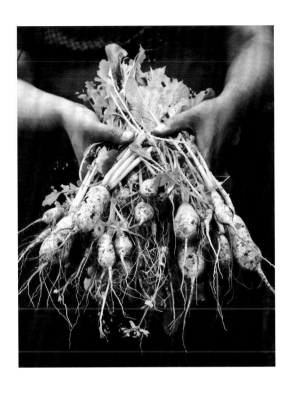

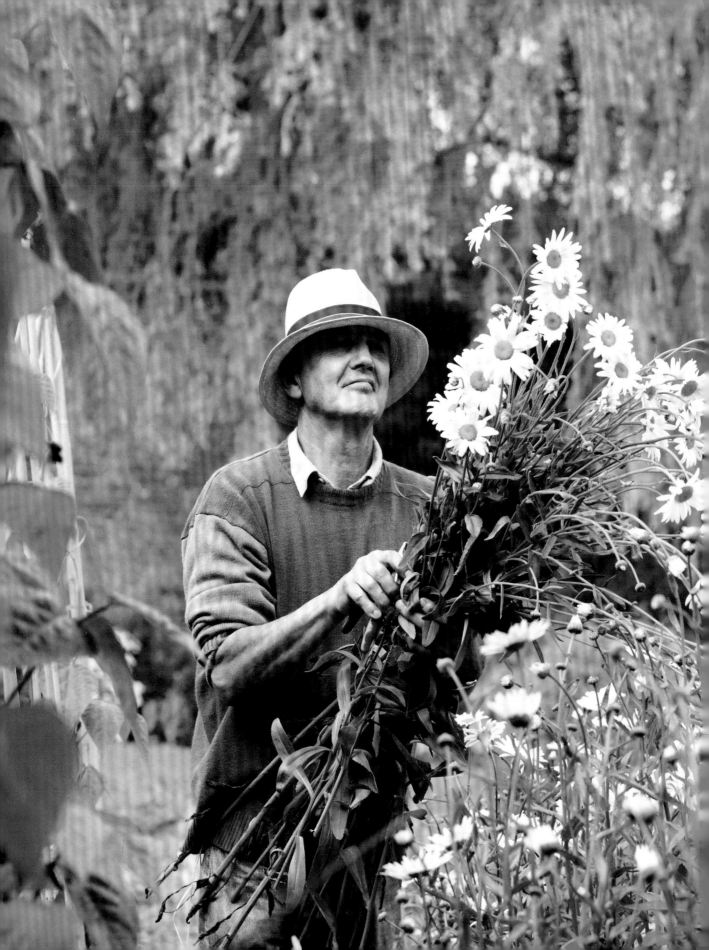

THE URGE TO GROW FOOD IS primal. Even people without access to land feel it, hence the continuing popularity of allotments, pick-your-own and crop-sharing schemes. City dwellers once saw a fruit-picking trip to the countryside as a way of combining cheap food with spiritual refreshment. Country folk with only enough land and time to grow a small proportion of their food still enjoy the pleasing sense of self-sufficiency it brings. It is, after all, a lot more fun than traipsing around a supermarket and much more reassuring to know where your food comes from.

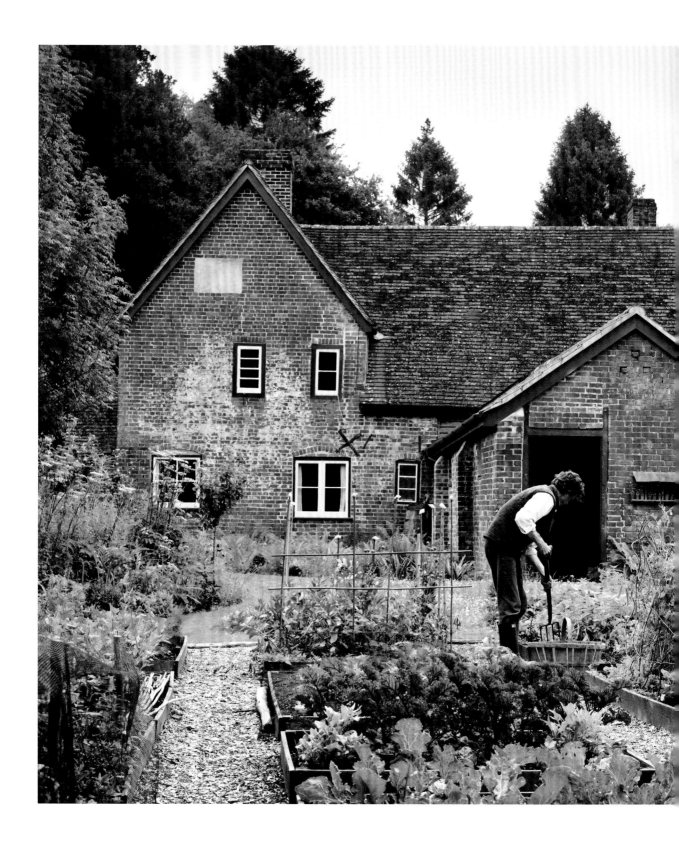

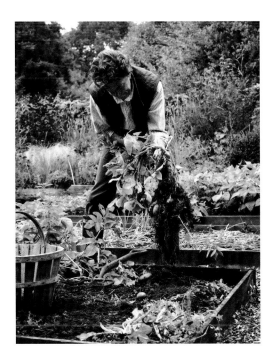

FOR SOME PEOPLE, GROWING FOOD IS AN altogether more serious business. My friend Marwood Yeatman lives in an idyllic old house, a former pub, near Fordingbridge, on the edge of the New Forest. Marwood is one of the great rural idealists. He believes passionately in growing and cooking food in the traditional way. He wrote the acclaimed book *The Last Food of England*, and lives according to his ideals eating nothing but organic local food, most of which he grows himself.

His kitchen garden is an intricate, perfectly tended natural store cupboard in which every imaginable vegetable and herb is grown for the kitchen. What little his garden cannot supply (such as meat or dairy products), he buys from local sources. For him, it is a matter of social responsibility as much as convenience. "If you buy Italian olive oil instead of someone's locally made butter, they go out of business," he says simply.

He cooks in traditional ways, burning only "cordwood" (dead or fallen wood gathered from his own land) and using the fireplace for home baking. He brews beer, makes yogurt, pickles onions and hangs hams on hooks in the ceiling – as well as managing a wild-flower meadow, a significant number of fruit trees and an acre-and-a-half of woodland.

It is a more-or-less full-time job, but Marwood genuinely loves it. He does everything with the quiet confidence of a man in touch with his environment and an energy fuelled by unfailing enthusiasm.

A meal at Marwood's house is an unforgettable experience. "We have a good life here," he says. "It is fashion-free, celebrity-free … The house is the last in the area to retain its original interior. I can't see the reason in buying an old house and making it like a new one. I found out what the Old Ship wanted, and honoured it." In the garden, he and his wife, Anya, a photographer and graphic designer,

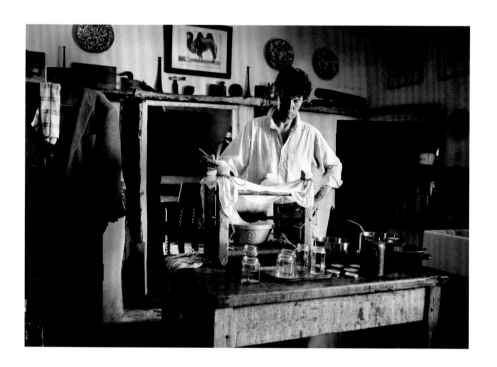

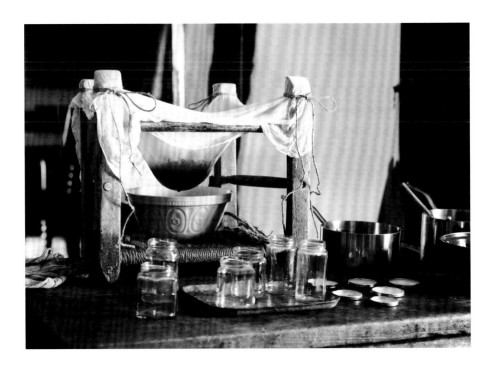

did the same thing: "We found out what the land wanted and honoured it."

There are flowers in the garden, and Anya is particularly adept at arranging them, but the emphasis is always on growing things that can be eaten. There are, after all, plenty of herbs that look attractive, as well as an inexhaustible supply of wild flowers in the surrounding woods.

Some might consider Marwood eccentric, but he challenges the idea. "To salt pork for the meat hooks, put distemper on the walls and burn cordwood on the fire is common sense. It gets the best out of resources, means something and fuses connections deep inside you." What he doesn't add is that, without people like him, we may all end up eating nothing but plastic-wrapped food from supermarkets. The widespread move towards more natural ways of feeding ourselves by eating organically, counting food miles and buying local produce from farmers' markets is largely down to "eccentrics" such as Marwood.

He lives as he does partly to prove it can be done and partly from a deep desire to live in an authentic and sustainable way. He also takes enormous pleasure from it and has, like so many others, his own vision of what country life should be. And he is lucky enough to be living it.

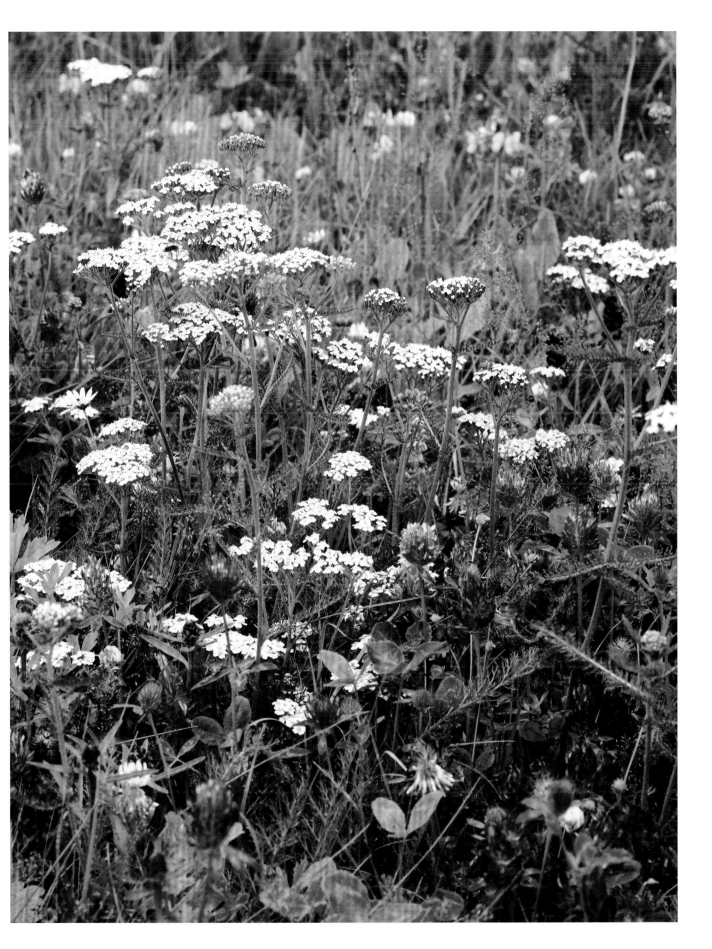

ONE MISTY SUMMER'S MORNING, AT A willow-fringed bend in the Great Ouse in Bedfordshire, I went to watch my friend gathering bulrushes from a punt. She looked like a river goddess who had just emerged from the green waters. In fact, her name is Felicity Irons, and she was engaged in the ancient craft of rush harvesting. Using a 2m (6ft) pole with a long, sharp blade on the end, she leans into the rushes, slices them away at riverbed level, waits for them to float to the surface, then gathers them onto her 17ft punt. She has, she says, been doing it for years, having learned from an old harvester who used to work this same stretch of river. She is one of the last practitioners of the craft in England and spends most of the summer harvesting and storing the rushes in an old barn, then devotes the rest of the year to turning them into wonderful sweet-scented matting and other products.

"I love it," she says. "You see the most extraordinary things – kingfishers diving past, grass snakes swimming – and at the end of the day you have that wonderfully satisfying feeling of knowing you've done a really good day's work. I can't imagine ever wanting to stop."

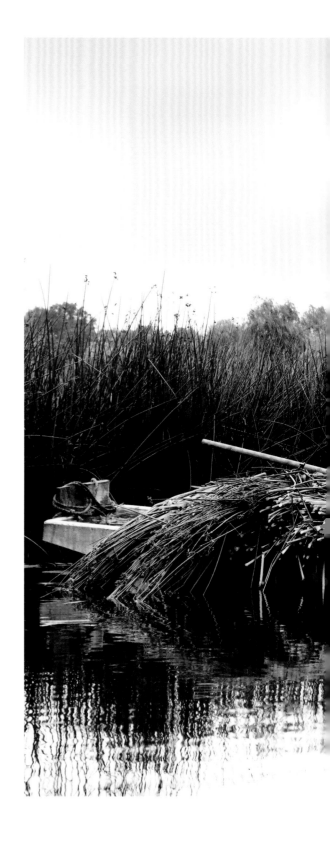

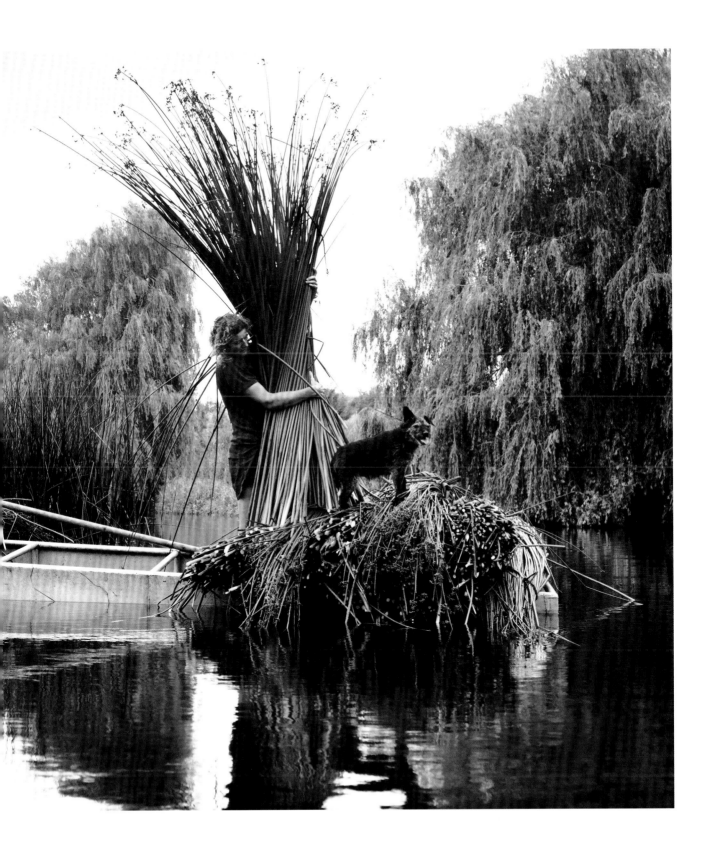

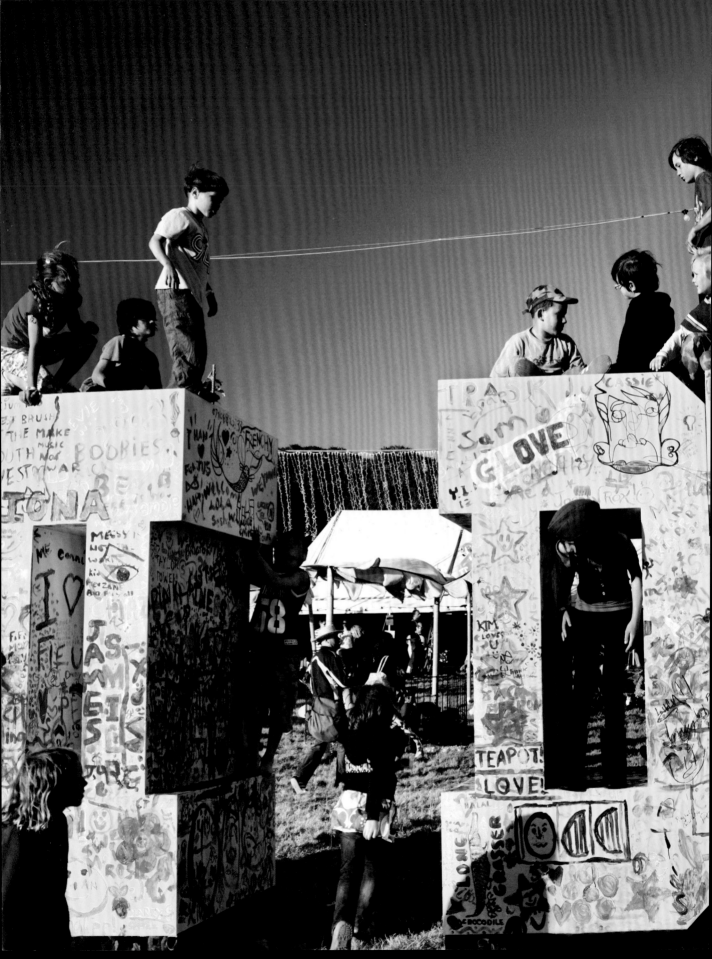

I HAVE GREAT RESPECT FOR PEOPLE SUCH AS MARWOOD and Felicity who preserve strands of rural life that would otherwise have vanished, but I also admire those who create new traditions, including noisy, garish ones, because those, too, are part of the fabric of our countryside. I found a good example of this at Lulworth Castle. It overlooks the most famously romantic cove on the Dorset coast and is where John Keats spent his last hours on English soil and Thomas Hardy set a climactic scene in *Far from the Madding Crowd*.

Once a year it is transformed into the location for a wonderfully exuberant music festival. Camp Bestival, as it is known, is described by its organizers as the "younger sister" of the better-known Bestival, which takes place each summer on the Isle of Wight. Camp Bestival is young both because it is new and because it is aimed at families and children. It certainly seems to be meeting a need. More than 10,000 music-lovers gather there for three days in July for an explosion of music, entertainment and general high spirits. Imagine a cross between Glastonbury and Center Parcs, and you will get the general idea. For every adult music-lover, there is at least one wide-eyed child; for every musical act there is a storyteller, face painter, juggler, Insect Circus or an All Singing Kids' Summer Party, not to mention any number of things to climb on or bounce off or generally mess around with. Families sleep in tepees, yurts, bivouacs, pod pads and old-fashioned tents, and feast on barbecues and spit roasts made from local food. There is also a small farmers' market and a WI cake stall. The dancing goes on past dusk and, for some, until dawn.

It is probably not what the Weld family had in mind when they bought the Lulworth Castle estate in 1643, but for their descendants it is a good way of keeping the estate viable. English Heritage also helps by looking after the castle itself. I find it hard to believe that anyone could move among that sea of happy faces – young, very young and occasionally middle-aged – without feeling this is as vital and authentic a part of country life as any point-to-point or agricultural show. Festivals such as this have nothing to do with the clichéd Miss Marple image of an unchanging countryside locked in the past. There is genuine rural charm to them and great hope in their growing popularity.

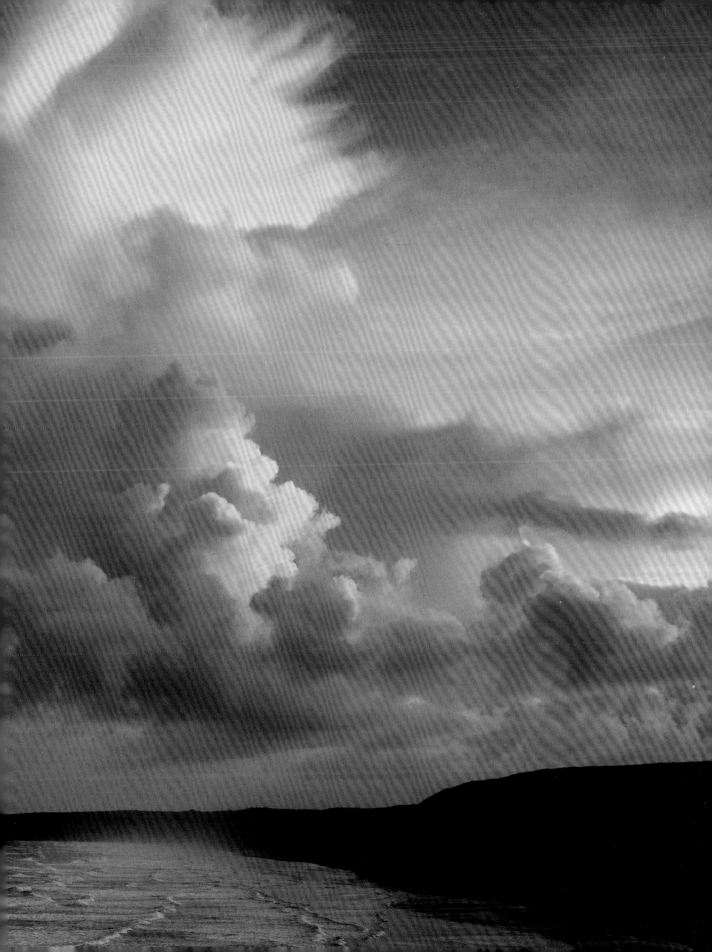

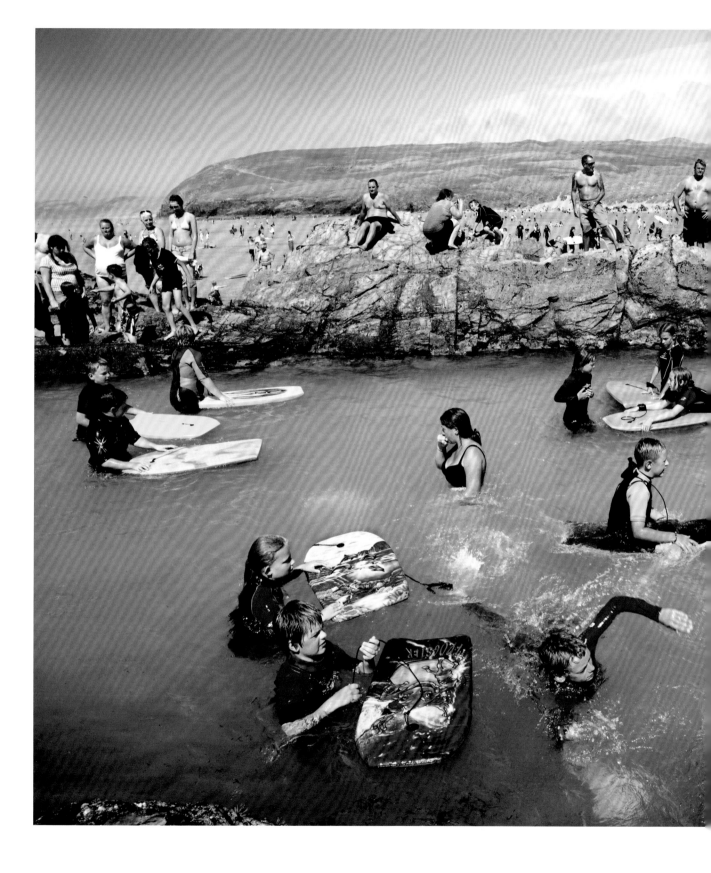

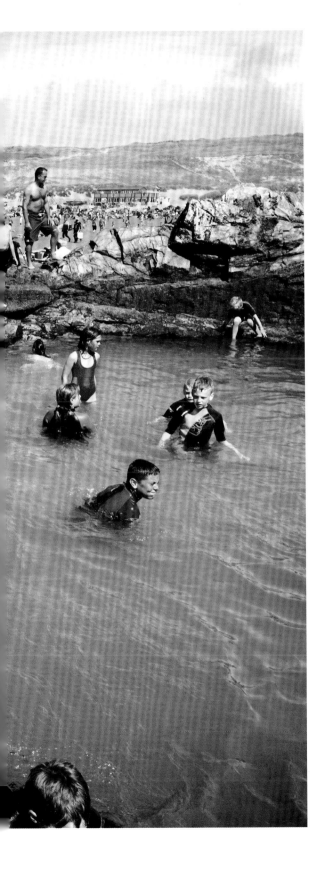

NO MAN-MADE CREATION CAN take the breath away quite as emphatically as the everyday spectacles of nature. Early one summer morning, standing on a grassy cliff top near Perranporth in Cornwall, I was drawn to the splendour of sun, sea, land and sky. The huge, shining glory of the ocean, the dazzling golds and blues of the sky, the clouds that towered and tumbled and the fresh scent of grass made mere human concerns seem insignificant. In the words of Richard Jefferies, the Victorian nature writer: "If we had never before looked upon the Earth, but suddenly came to it man or woman grown, set down in the midst of a summer mead, would it not seem to us a radiant vision? The hues, the

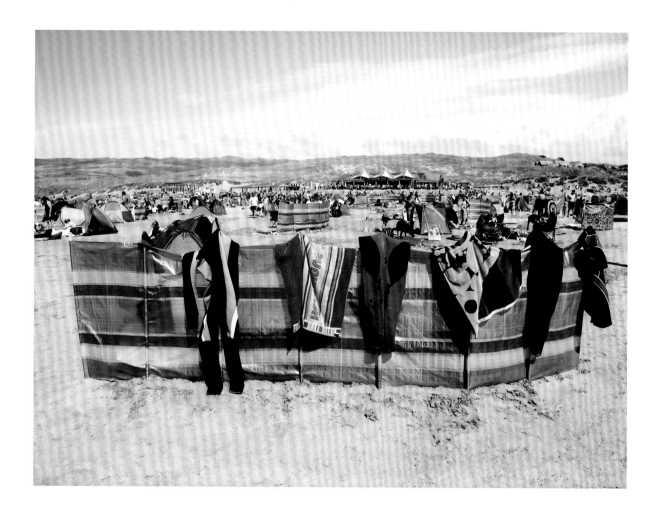

shapes, the song and life of birds, above all the sunlight, the breath of heaven, resting on it; the mind would be filled with its glory, unable to grasp it, hardly believing that such things could be mere matter … too beautiful to be long watched lest it should fade away."

And yet, despite the overwhelming majesty of nature, particularly the ragged, untamable border between land and sea, we approach even the most spectacular stretches of coastline with irreverence, calling them "seaside" rather than "coast", and happily disturbing their dreaming tranquillity with the sounds of slot machines and bumper cars, the smells of sunscreen and deep-fat frying and the garish clown colours of the funfair.

We are drawn there year after year in search of the simple, silly, childish joys of the beach. There are many rural activities that bring generations of people together, a quality I particularly like about Camp Bestival, but the best of all for breaking down

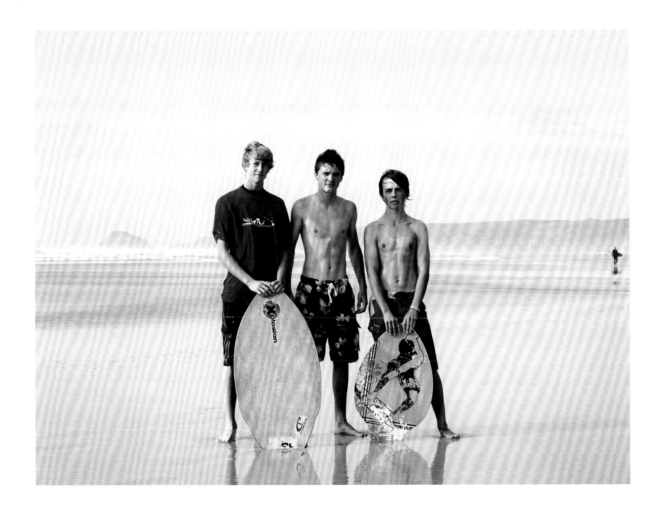

the barriers between generations is undoubtedly the seaside. It brings out the child in us all – not just in the obvious sense of messing around on the beach, but also in the more serious sense of making us see the world with a child's wide-eyed wonder.

I saw this again and again, from the farthest tip of Cornwall to the easternmost edge of Norfolk; grown men and women prancing around semi-naked, getting sandy, salty and sunburnt, playing games, building sand castles and attempting inadvisably athletic feats with surfboards – partly, no doubt, because they wanted to share with their children the remembered fun of their own childhoods, but also, I think, for the thrill of abandoning adult moderation. And the world was a better place for it.

One of the things I love about the seaside is the touching sight of young and old reaching out to each other. In Walberswick, in Suffolk, I saw a group of tough-looking men

teaching their children how to catch crabs from the harbour wall and explaining, with seemingly inexhaustible tenderness and patience, as the children listened with rapt attention. In Perranporth, two ladies pretended not to notice the iciness of the sea so as not to disappoint their children; a man made up for the lack of surf by pulling his son's surfboard through the shallow waters. Near St Ives, still farther west, two families struck up a friendship as they shared a beach game; a young girl patiently taught a far-from-athletic mother to balance on a surfboard, and a young man who had not hitherto seemed in possession of much poetry in his soul stood motionless in the cold waves, gazing out at the golden magnificence of an Atlantic sunset.

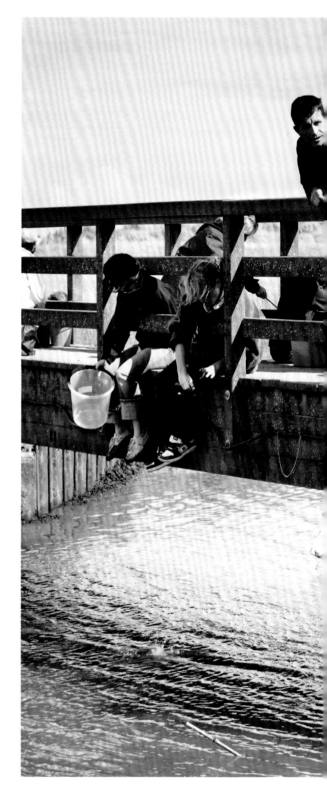

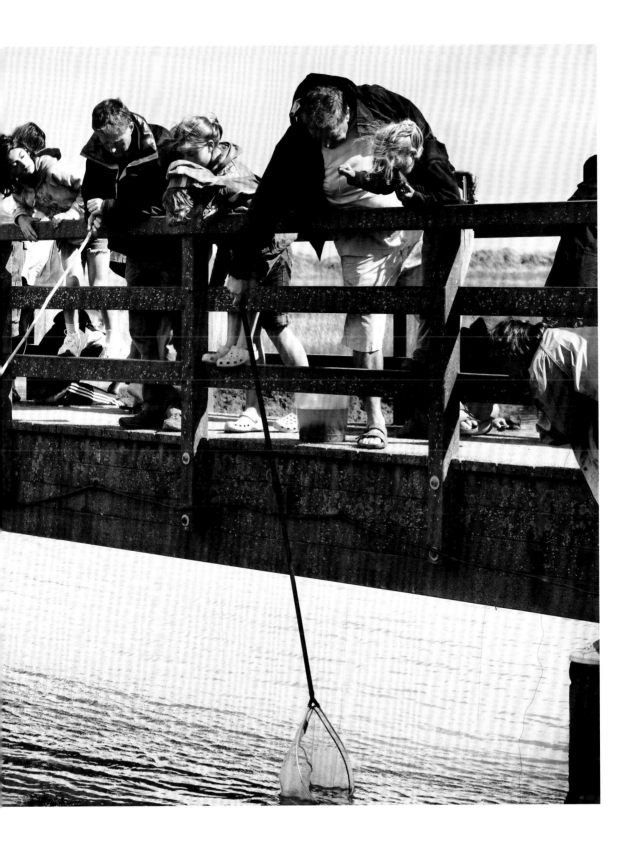

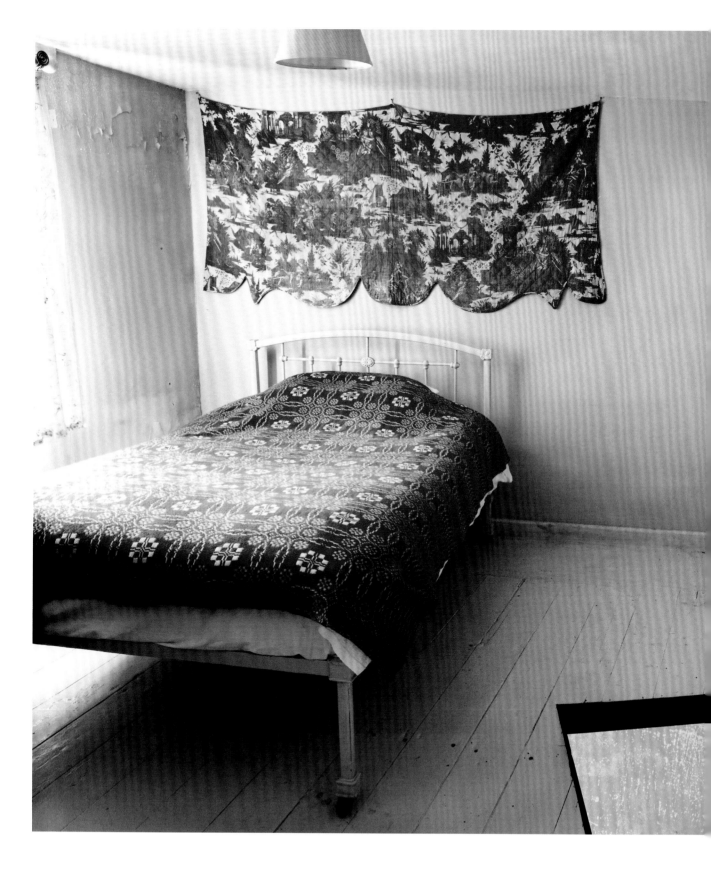

Furthermore, even when the day is ended and the games are over and tired families have dragged themselves back to guesthouses, bed-and-breakfasts and rented cottages, a new kind of mood descends. Who could mistake the atmosphere of a seaside holiday cottage, a guesthouse or hotel; the faint suggestion of sand and seaweed, piles of well-thumbed old books, and plain bedrooms where children dream about the adventures of a new day?

Perhaps those who grew up in the years before cheap flights and easy foreign holidays, when the annual trip to the seaside was as big an adventure as the world had to offer, recall those trips through rose-tinted spectacles. We romanticize our memories and edit out the discomforts of all-day car journeys on narrow, bumpy roads, grim picnics in lay-bys, run-down guesthouses, rainy weeks with nothing to do and sand between the sheets. Can it really have been as idyllic as we like to believe? Of course not.

Even so, there is some truth behind our memories. Those old-fashioned seaside holidays belong to an age when wealth was scarce. Few could afford to jet off to the latest fashionable overseas destination, while the idea that lives would be incomplete without the latest must-have gimmick had scarcely begun to take hold. Having fun was a simple activity and all that mattered. All that was needed was a bucket, a spade and a few square yards of sand.

The modern age is richer, but sometimes I wonder if we are poorer for forgetting how to enjoy ourselves in simple ways. Part of the fun of a seaside holiday is in recapturing a natural, active approach to pleasure. Enjoying yourself on the beach has nothing to do with consumption or status. It is to do with being human and responding to the joy around us.

I think it is what I find so evocative about these photographs of seaside interiors. They are simple; not in a crude or unsophisticated way, but in the sense of addressing basic human needs. The implication is that all the really interesting stuff is outside and, indeed, you can almost hear the distant rhythm of the ocean's

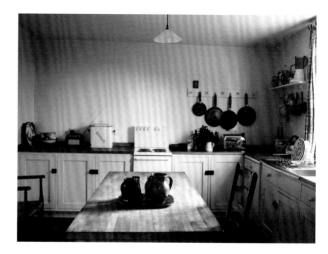

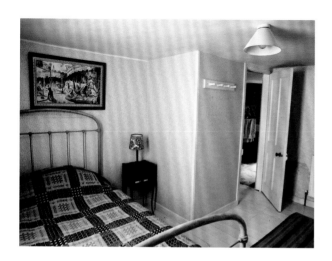

ceaseless roar somewhere beyond the windows. Everything feels different at the seaside: the huge skies, the wild scent of the sea air and the strange formations in rock pools, cliff faces and seaweed. If you are interested in texture and pattern, the inspiration is limitless.

It is a fact that sea air restores both physical and mental health, encouraging the deep, restful sleep that many adults seem to find so elusive, but perhaps the best thing of all is that, like all the best country treasures, the seaside is available to everyone and anyone who chooses to enjoy it. There is much to be said for flying away to holiday abroad, but what about the exotic worlds in our own back yard? There is much to discover and not only on the coast, but also in our great national parks and, just as rewardingly, in the many still-neglected highways and byways of our less-celebrated tracts of countryside.

As economic and environmental concerns persuade people to think twice about travelling abroad, more of us might discover the joys of "holidaying at home". Our countryside is an amazing free and accessible resource.

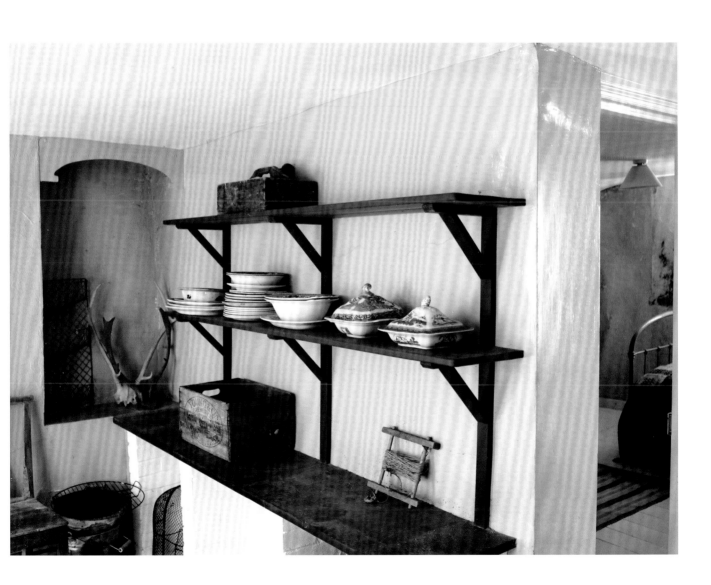

HOME IS IMPORTANT TO THE MONIES
family, members of which have been farming the same
Cornish fields at Tremedda farm, in Zennor just outside
St Ives, for more than a century. Every Sunday they get
together for lunch, just as they have always done. There
were eight at table when we visited, all variously living in
the main farmhouse, an adjoining cottage and a converted
barn, with an elderly aunt and uncle (seen relaxing here)
in a cottage just up the lane.

Bridget Monies (at the head of the table overleaf) is the
current matriarch. Her eldest son, Nicky, now runs the
farm, and her five other children are either yet to leave home
or have left and come back. "There's something special
about Tremedda," says Bridget. "It's always been a place
people want to revisit. Even people who just come to stay
seem to keep returning. I remember my father telling me
that it was the same with the evacuees who came here during
the war. They all wanted to come back."

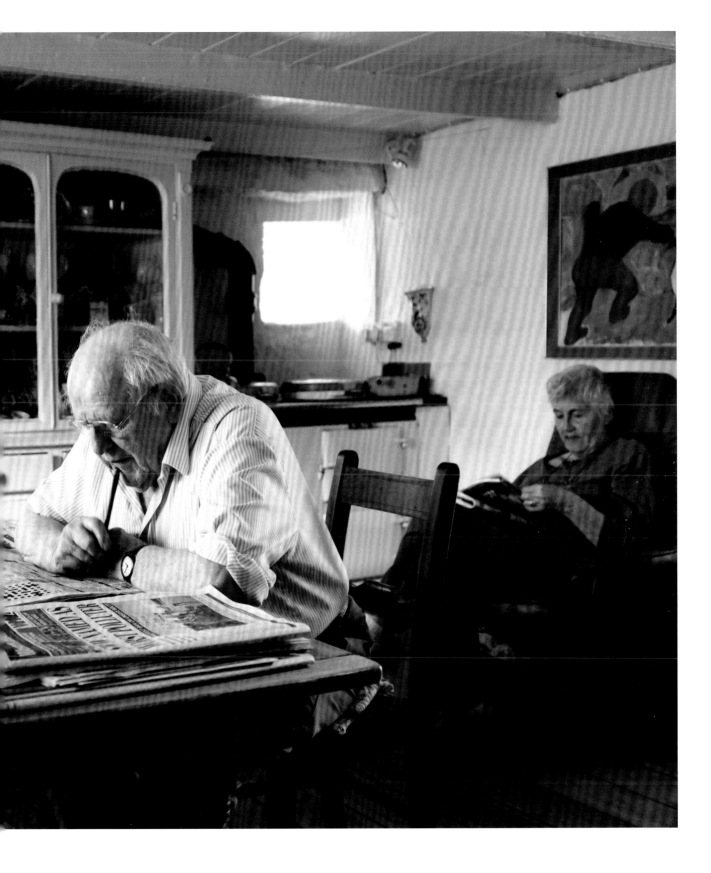

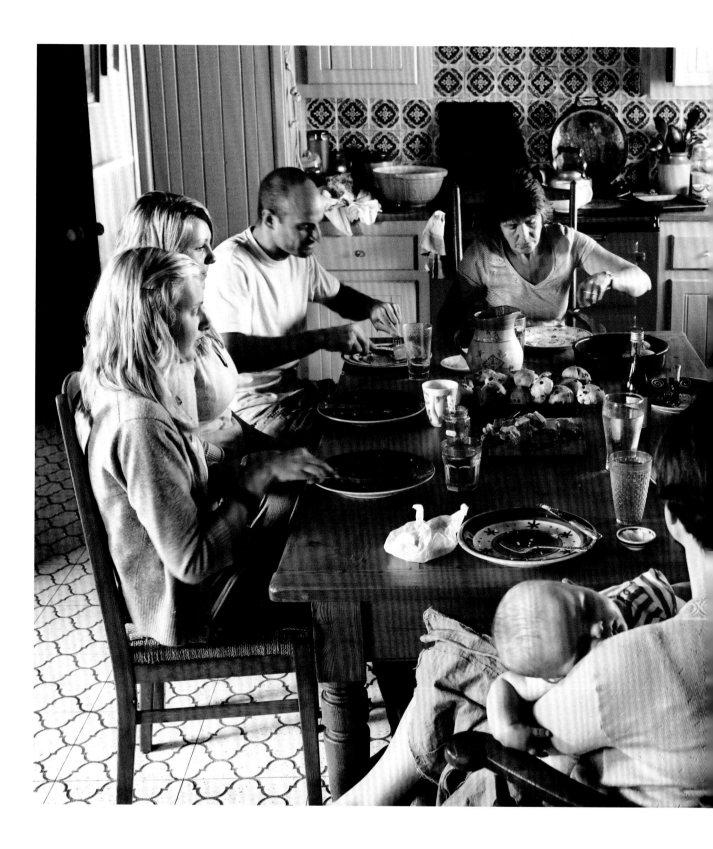

That is partly because of the sheer beauty of the place – 200 emerald-green acres overlooking the Atlantic – but it is also down to the warmth of the Monies family. "I think a lot of people don't realize how much support families can give each other," says Bridget. "Just being there for each other can make a huge difference. If something needs doing, everybody mucks in. And whatever happens," she adds, "at some point in the day we always sit down round the table and have a meal together."

Like most dairy farms, Tremedda has had a tough time making ends meet in recent years, but a couple of years ago the Monies were innovative enough to branch out into ice-cream making. "The idea was that, if any of Nicky's brothers or sisters did want to come back, there wouldn't be enough work from the dairy farm to employ everyone." It has been a great success, bringing more than enough work for

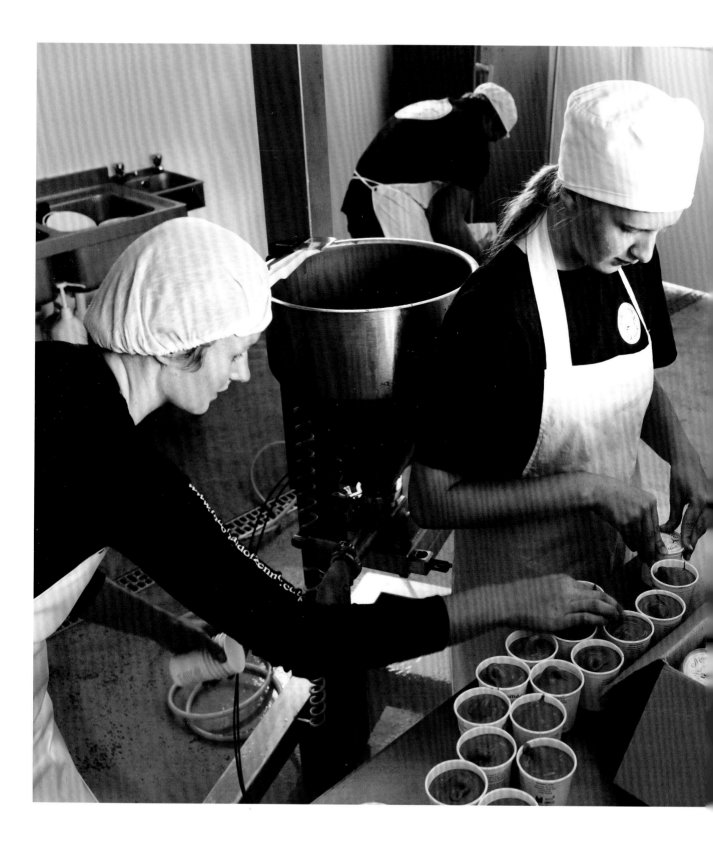

the whole family, from manufacture to marketing: "I don't think we quite realized just how much it would involve."

They sell their products, called Moomaid, all over western Cornwall, in farm shops, restaurants, pubs, hotels and even on the beach. Their herd of Holstein Friesians provides the milk; the younger children lend a hand with packaging, and everyone chips in with suggestions for new flavours. They recently added a Christmas pudding flavour as a seasonal special. "It's a lot of work," says Bridget, "and it didn't help when we had two wet summers on the trot, but it was definitely the right thing to do, and it's lovely having everyone around."

Watching the Monies gathered together at the table, seeing the lovingly assembled family photographs or the children diligently at work in the ice-cream parlour – even watching the cows grazing contentedly on their high green pastures – you cannot help but sympathize with those who want to keep returning. As Bridget puts it, "It's a nicer way to live."

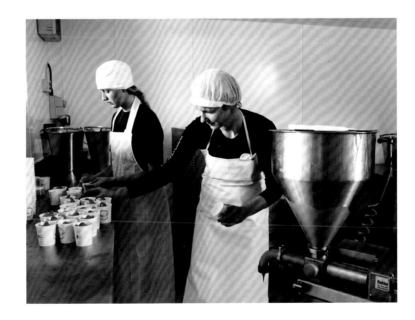

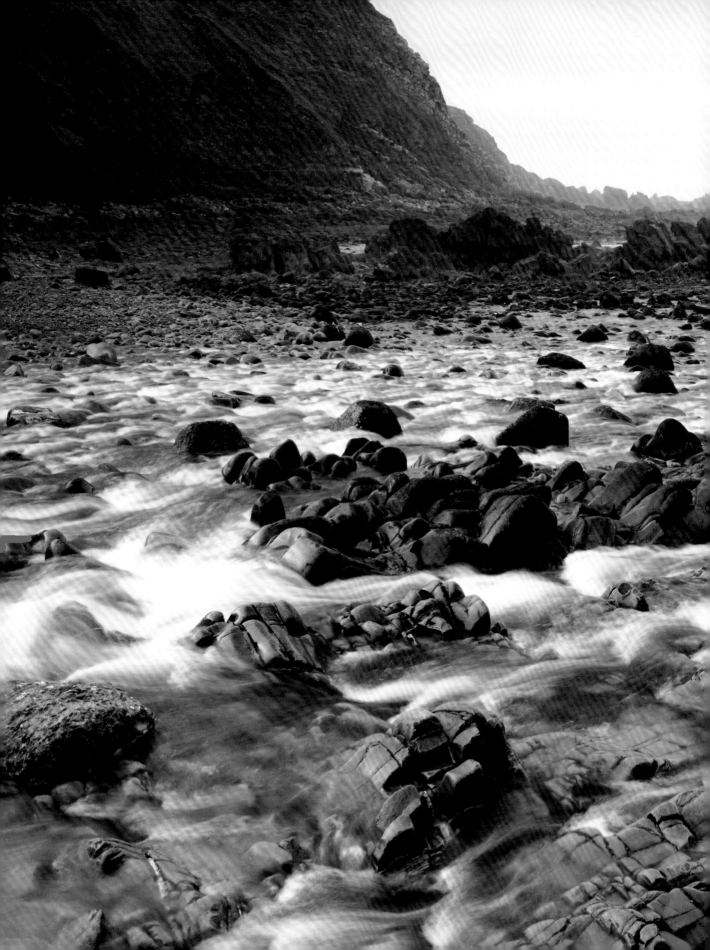

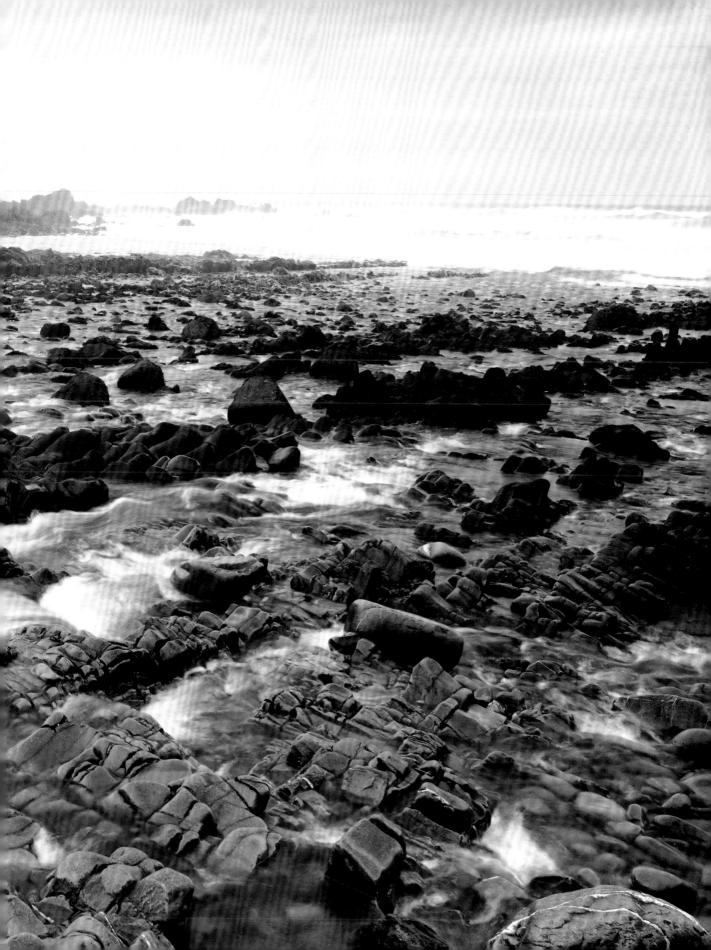

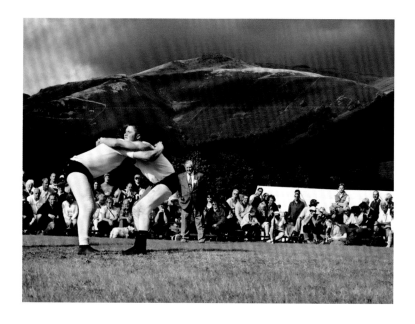

OTHER PLACES CALL YOU BACK. The romance of the Lake District has scarcely been dulled by two centuries of tourism. As well as the wild hills there are local traditions, such as Grasmere Sports, where thousands gather each August to witness a range of contests such as fell races (runners race at suicidal speed to the crag on the horizon and back); hound trails (sweet-natured hounds lollop after a human-laid scent over several mountainous miles); and Cumberland and Westmorland wrestling, in which pairs of young men shuffle and circle in a "two-man scrum" until one of them, for no discernible reason, is abruptly thrown on his back. It is idiosyncratic and enthralling, and the crowds return year after year, just as they have done since pre-Victorian times.

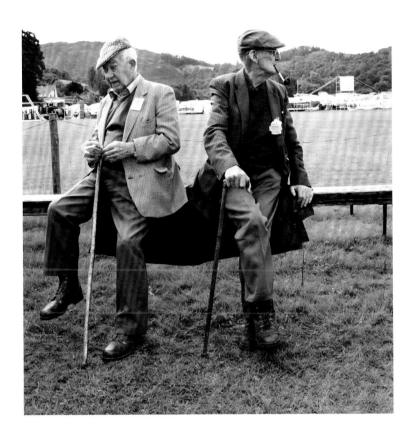

WORDSWORTH CALLED GRASMERE the "loveliest spot that man hath ever found". He may well have been right, but there are other challengers. At times it is hard to imagine anything more captivating than the empty southern stretches of the East Anglian coast. On long summer days, there is a wonderfully weather beaten quality to the landscape; everything appears washed pale by sun, wind and sea. This was particularly evident at a spot near Dunwich, where a great medieval city once stood. It was lost to the sea in the thirteenth and fourteenth centuries, and in its place there is now a quiet fishing village. The colours and textures of the upturned boats and deserted fishermen's huts are reflected in the weathered stone of the village and its ruined abbey, as well as the eroded sandy cliffs and the windswept heath beyond. Everything has been worn away by time.

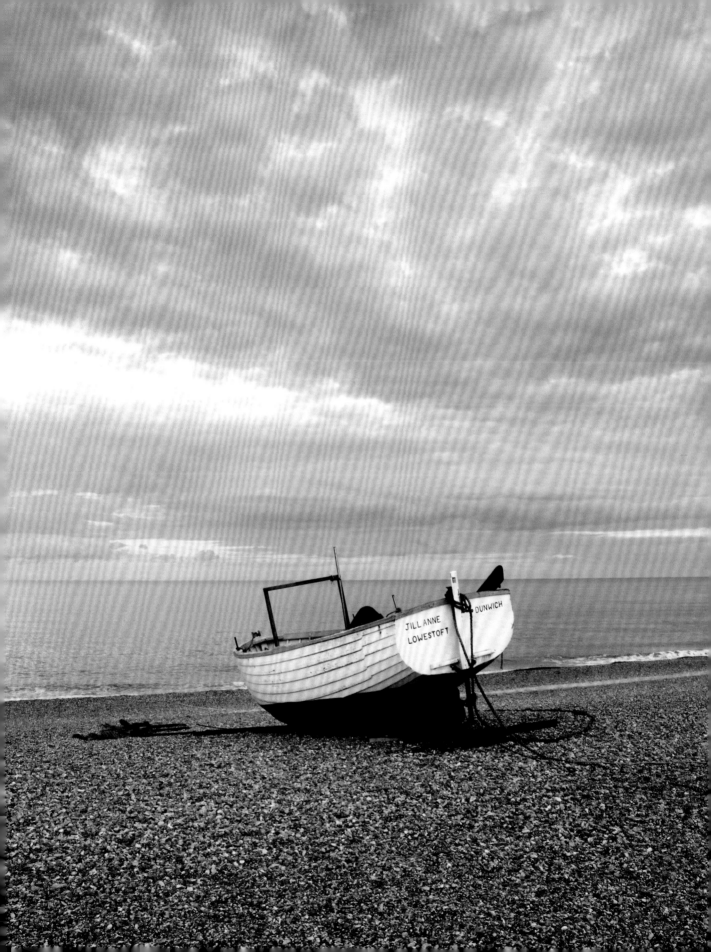

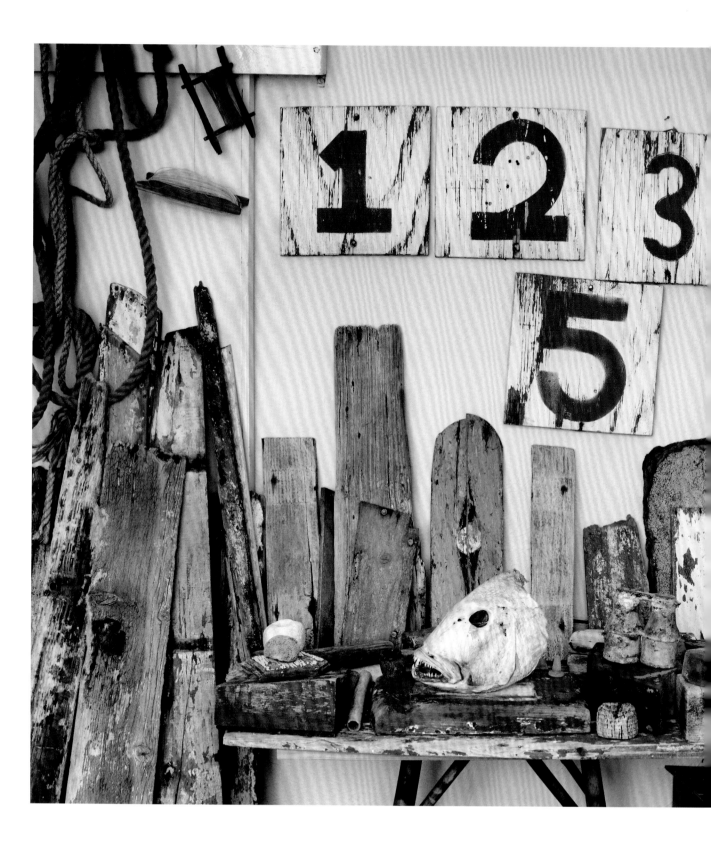

FURTHER DOWN THE COAST, I EXPLORED the ragged Essex lowlands around Mersea Island, where the rivers Blackwater and Colne merge with the cold North Sea. It is wonderful to stand at the muddy mouth of the Colne, listening to the birds' elegiac cries and smelling the dampness in the air. Nearby, at St Osyth, an artist, Guy Taplin, celebrates the area's subtleties of texture in sculptures, mostly of sea birds, made from driftwood. Something of a drifter himself, he was born a cockney and worked in countless jobs, including being a birdkeeper in London's Regent's Park, before discovering a gift for conjuring birds from wood, 30 years ago. The beaches and mud flats of the Essex coast, where he has an extraordinary studio, are a treasure trove of flotsam and jetsam. His birds, particularly his ducks, are widely sought after, but there is a haunting beauty in the studio itself, which is piled high with pale, bleached scraps of wood. Guy calls them "echoes" or "residues" of lives past.

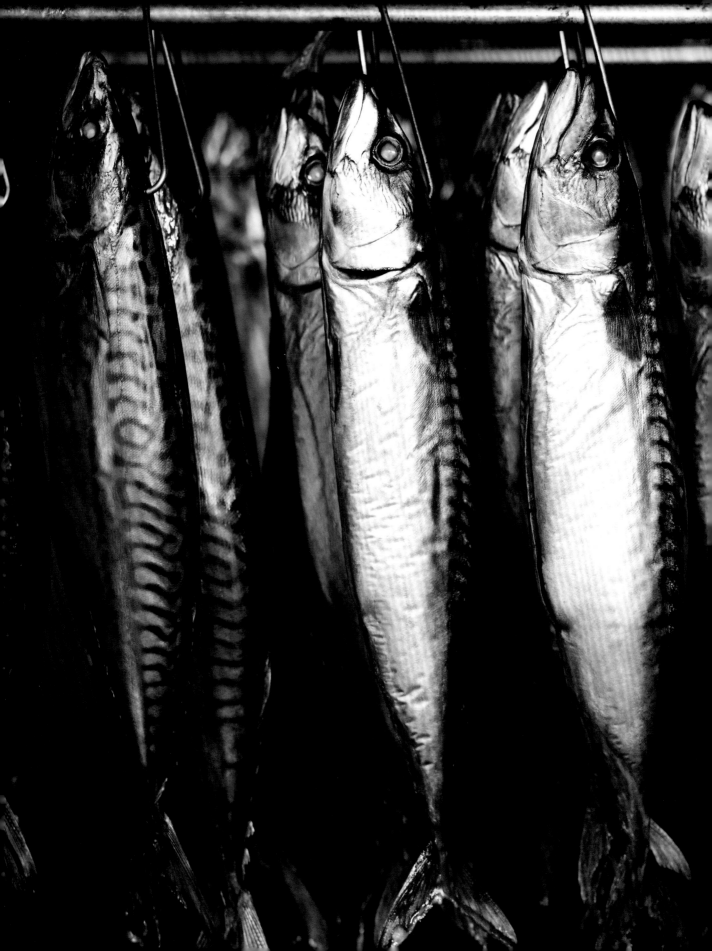

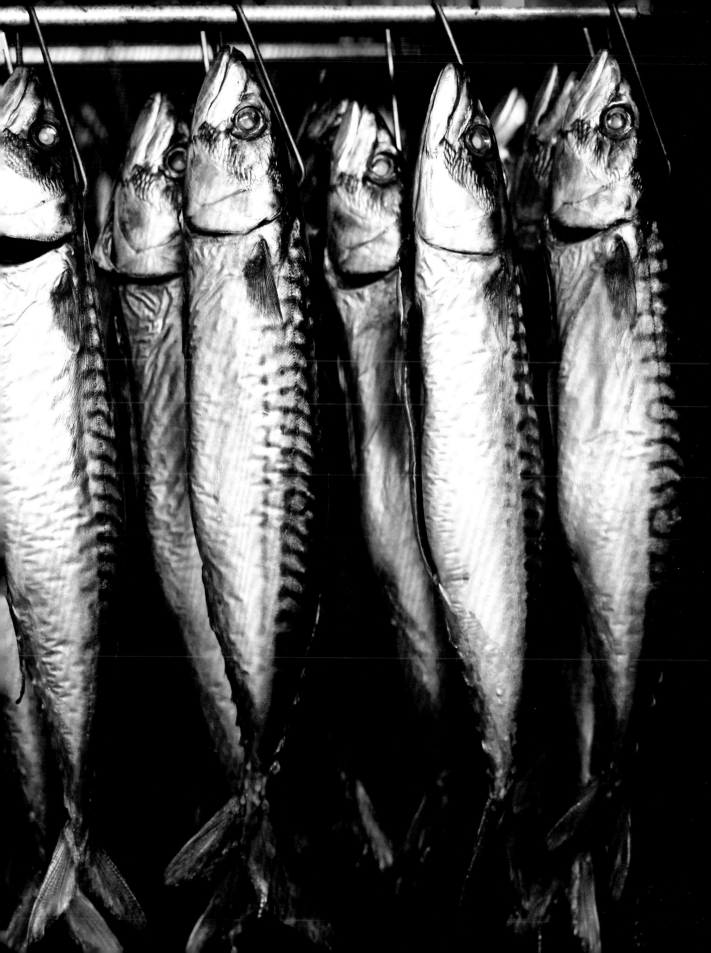

NOT FAR AWAY, IN ORFORD, near Butley Creek, is another dark, time-worn hut, one of many in the area. Inside it is a shadowy world of culinary wonder, where salted fish hang over smouldering oak logs and smoke drips from the ceiling like treacle. The hut is the smokehouse attached to Butley Orford Oysterage, a culinary Mecca founded by another ex-Londoner, Richard Pinney, more than 60 years ago. There have been oyster beds in the vicinity for centuries, but they were abandoned in the mid-nineteenth century. Richard, with a confidence born partly of ignorance, dreamed of reviving them. It took years, but he finally succeeded, and his shop and restaurant are famous, not just for oysters, but also for some of the best smoked trout and mackerel that you will ever taste.

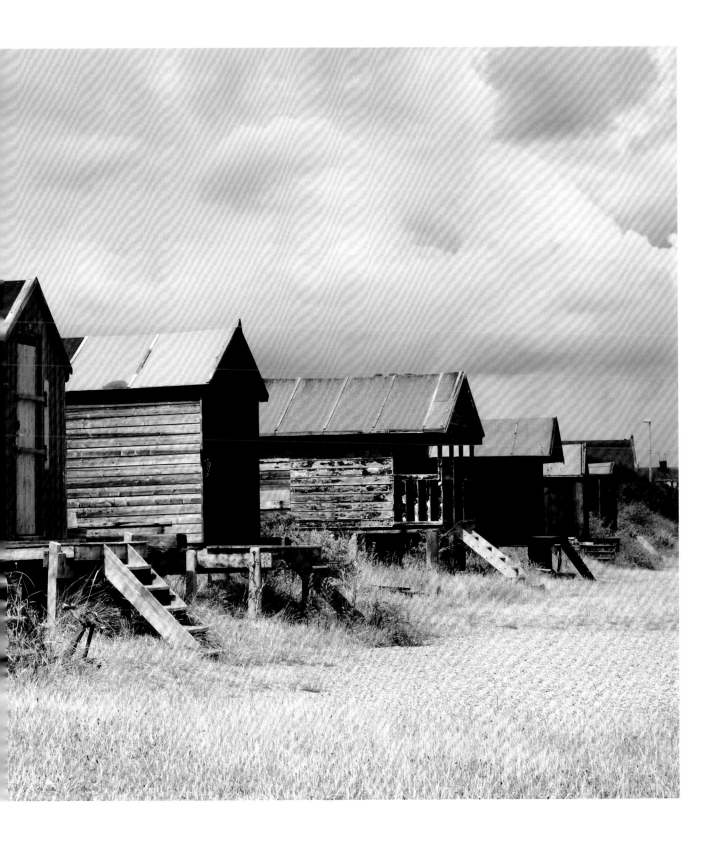

221

AWAY FROM THE COAST, SUMMER takes on a different texture as leaves darken to a deeper green and the wheat fields take on the dry, golden bushiness of a lion's mane. Here, there are wonders still to be found. On a village green near Cheltenham, we came across an old-fashioned travelling circus with a ring of old wagons surrounding a small big top. News of the circus had spread by word of mouth. For every night of its week-long stay, the tent was packed.

I doubt anyone was disappointed. Gifford's Circus is irresistibly exuberant, with acrobats tumbling, trapeze artists flying and amazing displays of horsemanship.

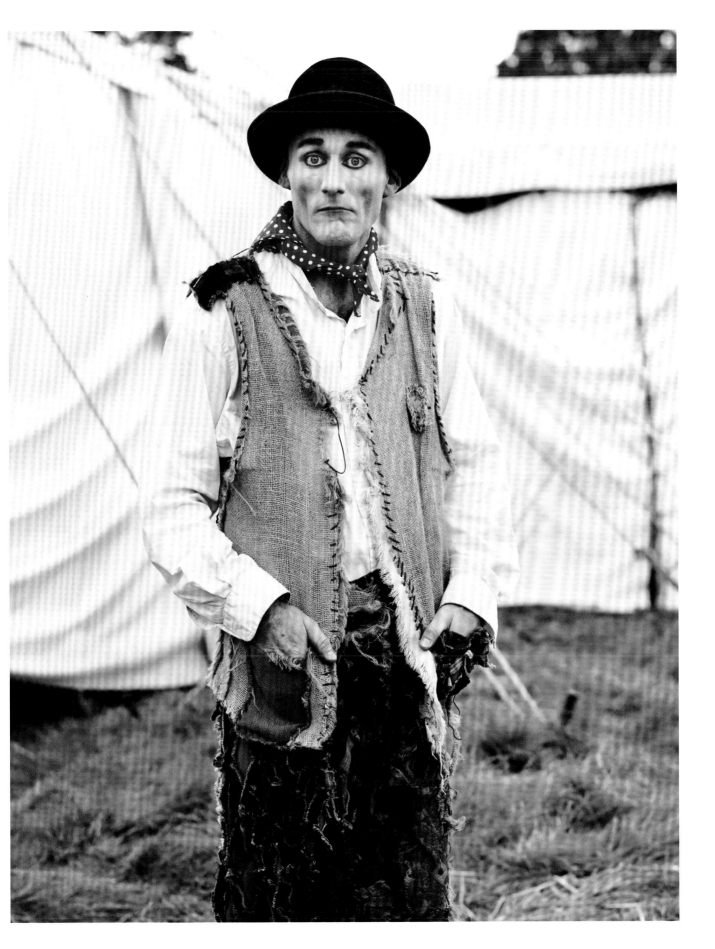

There's a violin-playing loose-rope walker, a breathtaking knife juggler, a genuinely funny clown, an unusual range of performing animals such as geese, ducks, shire horses and a man in a bear costume. It has a deserved reputation for creating show business magic in the depths of the countryside.

There are about 50 performers and crew led by Nell Gifford (on horseback, opposite) who learned her trade in Europe and the United States before creating her own company in the Cotswolds a decade ago. "It's a rural show aimed at a rural audience," she says. She and her husband grew up in the area. "Many of us are country people, and most of the people who come to watch are country people. In the circus, we have farmyard animals and a tractor too." In winter, the core of the troupe retreat to a farm near Stow-on-the-Wold, where they transfer their skills to agriculture.

It's a tough life. They travel constantly, pushing themselves to their physical limits, often painfully exposed to the weather. "If it's hot, you boil," says Nell. "If it's cold, you freeze. If it's wet, you drown." It is worth it for the buzz that surrounds them each time they arrive in a new village and the hugely appreciative audiences. "I can't see the attraction of playing in a huge, empty venue in London when we can have packed houses every night and a real intimacy with enthusiastic audiences."

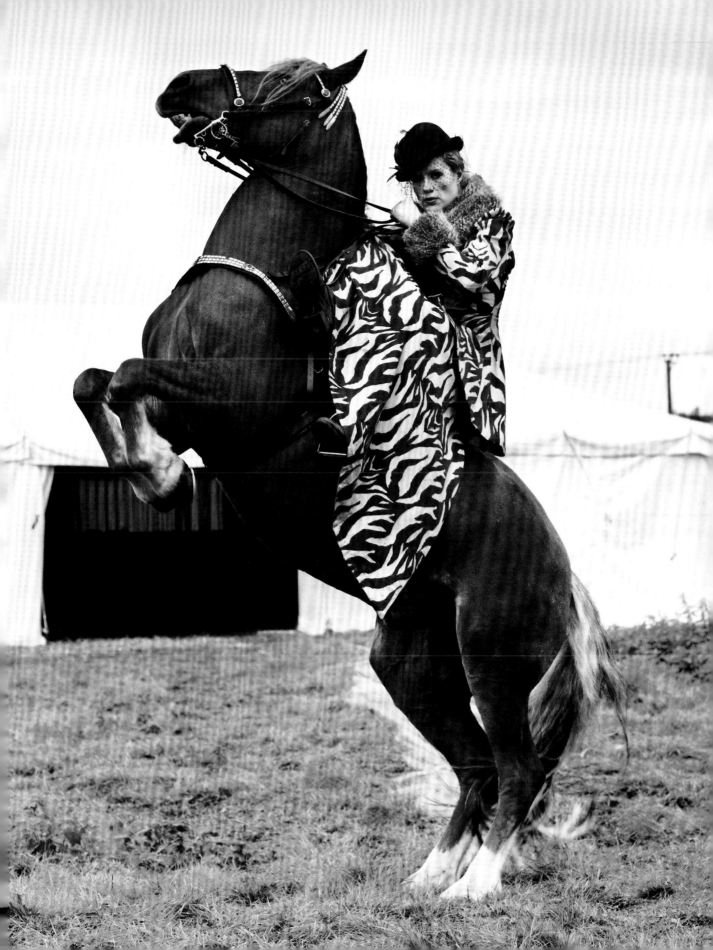

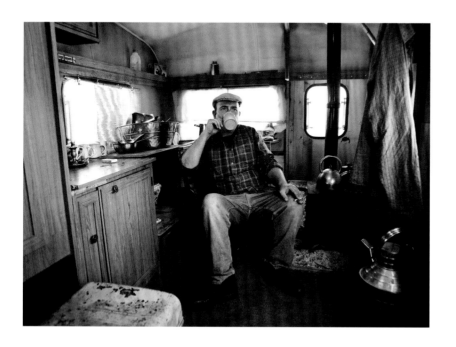

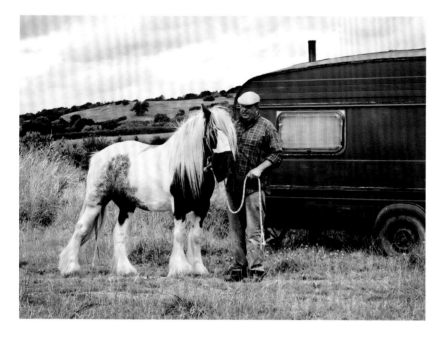

JUST SOUTH OF SHAFTESBURY IS an undulating area of grassland called St James's Common. On it stands an old brown caravan with a short, shaggy horse tethered beside it. They belong to a man called Andy, who is a traveller. "I've always travelled, all over. Scotland, the Lake District, Wales, the southwest. I think my parents were travellers, too, but I'm not sure. The Forest of Dean is my favourite – it's where the people are friendliest – but you go where the work is. I'm a farm labourer. If the work runs out, I have to move."

It is a small caravan, but it is the place where he feels most comfortable and relaxed. Like his horse, Joey, he seems unaffected by the pressures of the outside world. His main stress is the occupational hazard of being moved on. "I usually stick to places where people know me. I've been doing this for 50 years, so I'm known in quite a lot of places."

It can, he admits, be a lonely life. Some of his fellow travellers have settled down and although he "once had a family", he is now separated from them. He still sees his children and tries to spend as much time as possible in Dorset, where they live. "I try to teach them the old ways; how to catch a rabbit, how to make a fire from nothing. How to survive, really. I want them to know all that, and they love it." He did try settling down, long ago – "I bought my own land and lived on a site" – but it didn't agree with him. "I'll always be a traveller. I'll be doing this till I die."

At the Suffolk Smallholders Society Show at Stonham Barns, a big, bushy-sideburned man called Tom Walne proudly shows off his seven-year-old Suffolk Punch mare called Daisy. Such powerful hard-working beasts were once a common sight in English fields, but today, Tom says, "They're rarer than what pandas are." There are, he thinks, about 400 left in the country.

That there are any at all has much to do with people like him. He grew up on a farm in nearby Westerfield and worked with a Suffolk Punch mare as a teenager. In those days, the 1940s, a third of all crops grown in Britain were used to feed horses. With the advent of tractors, breeds such as the Suffolk Punch dwindled to near extinction.

Tom drifted into other jobs, including national service, agricultural machinery and haulage. Then, in the early 1970s, he was able to buy an old Suffolk mare destined for the knacker's yard. "A lovely, kind, hard-working horse", she was the beginning of a hobby that has defined his life ever since. He affectionately reels off the names of the Suffolks he has kept, shown and bred: Nelly, Star, Gertie … Tom also works to support the Suffolk Punch Trust. Numbers nationwide have since doubled.

"It's a hobby, not a job," he says. He lives on the edge of Ipswich and, aged 76, still works full-time, doing odd jobs such as fence-laying and hedge-cutting to pay for his enthusiasm, which is shared by his partner, Sandy. "We don't take no holidays, we don't go to the pub and we work bloody hard."

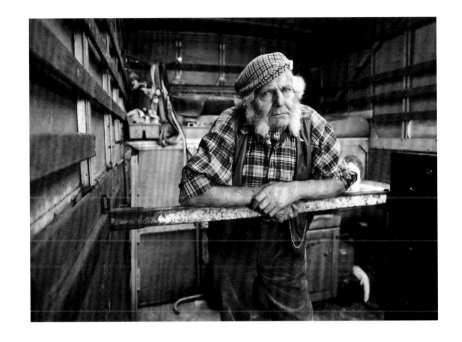

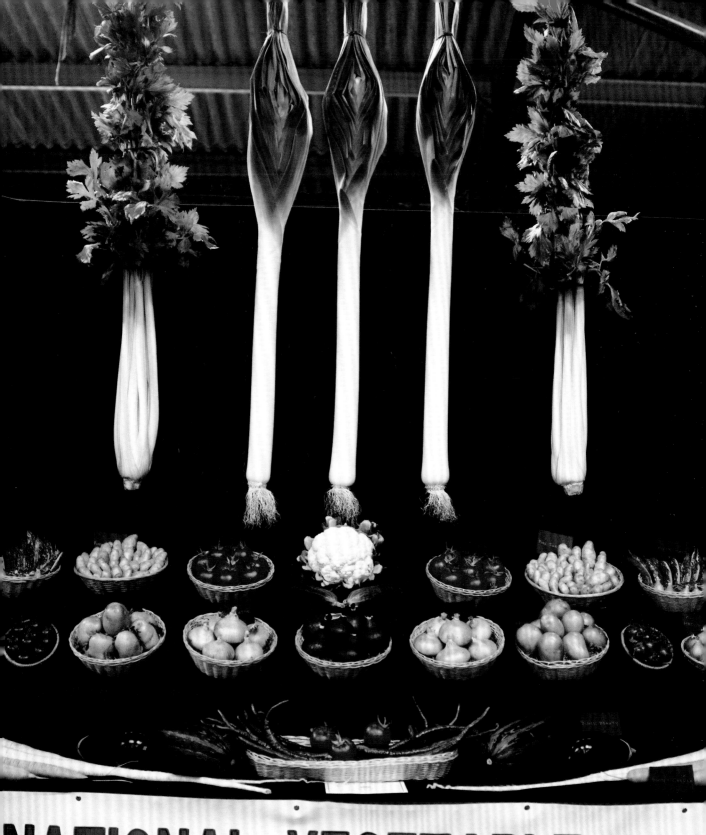

NATIONAL VEGETABLE SOC
harities registration no 108897

MOST OF US WOULD SCARCELY NOTICE IF the Suffolk Punch became extinct, but we are better off for Tom's dedication. Multiply this many thousands of times, and there is a sense of rich diversity made up of ordinary and extraordinary people pursuing many, sometimes idiosyncratic, enthusiasms. Whether it is Morris dancing or jam making, topiary or flower arranging, it is embraced with an enthusiasm that unites local communities and gives the countryside its quiet but unmistakable vibrancy. People talk with infectious pleasure about their "pride and joy". It might be a garden or a building, a foodstuff or a landscape, but it will rarely be a fashionable pursuit. It will, however, be one of real value.

I am most proud of my dahlias; the most joyful of flowers, both extravagant and spectacularly colourful, and each a small,

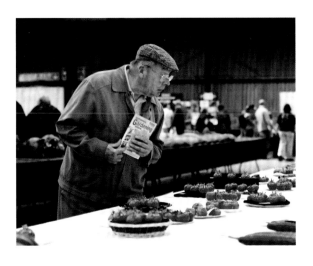

lovely addition to brighten up the world. The enjoyment of seeing them blooming in the garden is matched only by the satisfaction of creating tall, generous arrangements for the house. The sight of a barrowful of freshly cut dahlias excites me as a Christmas tree excites a child. If I was a woman I would wear hats made out of dahlias.

For pride and joy on an epic scale, you need to visit one of the big agricultural shows such as the Royal Bath & West Show held in Shepton Mallet, where farmers, horticulturalists, smallholders and gardeners from all over the southwest come to show off their achievements. It is a huge, happy cornucopia of country delights, vibrant with human and vegetable life. Enthusiastic amateurs rub shoulders with world experts as they inspect an endless category of apples, pears, carrots and tomatoes, earnestly checking each one for the tiniest flaw. Growers glow with visible pride if their onions or aubergines win a prize; losers offer friendly congratulations, while silently vowing to come back the following year with something unbeatable.

It may seem faintly ridiculous that so many men and women focus so much energy and expertise on horticultural perfection, but there are, for me, few things more deserving of such focus. The growing of food and flowers is both life-enhancing and enriching, and it is endearing to see how some people can get worked up about the finer points of a perfect turnip. Of course, it does not matter that the giant vegetable competition was won by a 65kg (143lb) marrow grown by Ken Dade from Norfolk, or that 92-year-old Alf Cobb from Nottinghamshire broke his own world record with a 91.9cm (36¼in) cucumber, or even that a display of vegetable animals includes a cute marrow penguin and a charming butternut squash lion with a mane of parsley. At the same time, it matters very much that an enthusiasm for growing food can still enthral so many.

The Royal Bath & West Show has little in common with entertainment as television understands it. That is its charm. It is real. It is a grand day out (or four days for the really committed), and grand days out are an important part of country life.

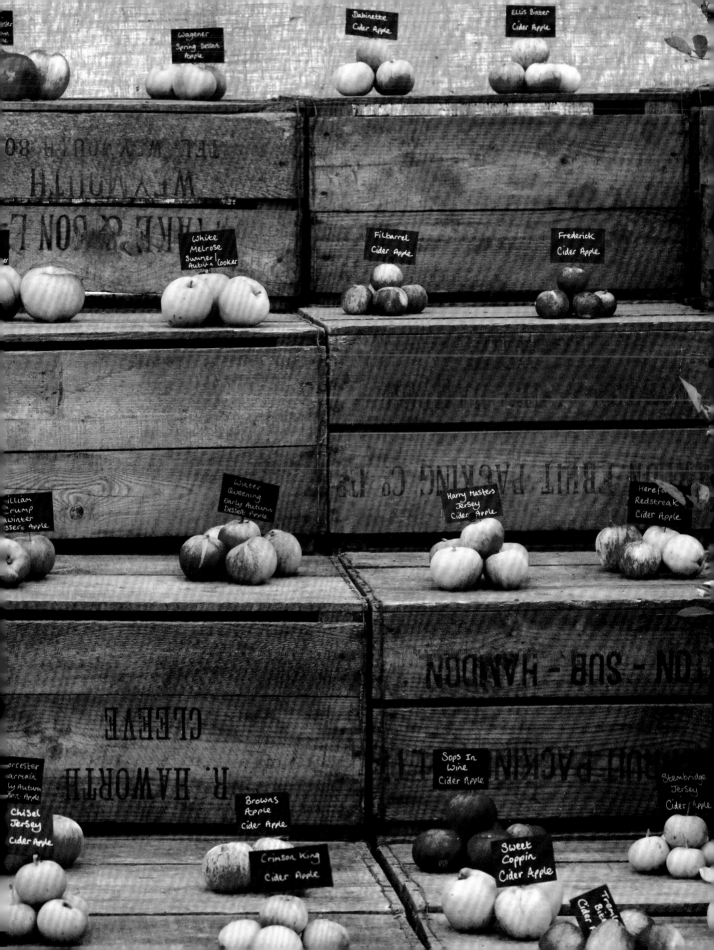

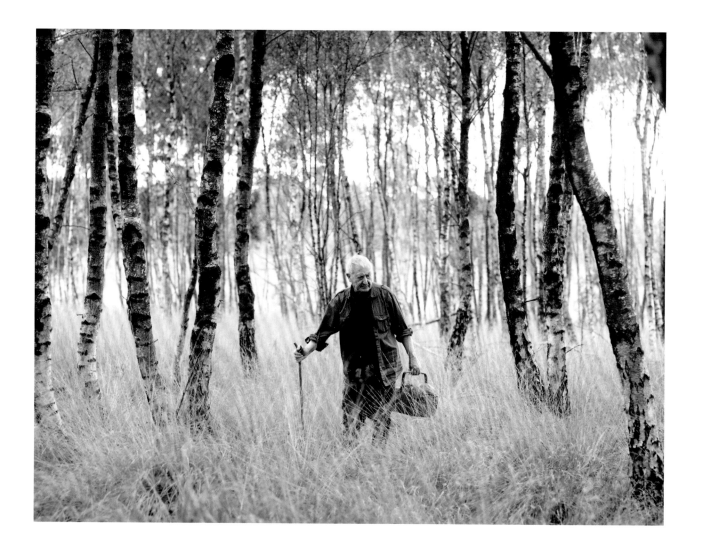

OF COURSE, NOT EVERYTHING THAT GROWS in the countryside is cultivated, and a grand day out need not involve an organized event. Nature has her own treasures, and there are those, with their ear to the ground, who know the secret places where they are to be found.

On a warm autumnal morning in an undisclosed location in Surrey, artist Dante Leonelli showed us where to find penny bun mushrooms, also known as ceps, or *Boletus edulis*. They are the bread and butter of foraging: easy to find, easy to identify and easy to cook – they are particularly delicious sliced and grilled. As well

as mushrooms, which should always be approached with caution, there is plenty more to forage, including nuts, berries, nettles, dandelions, snails, chickweed and sloes. An experienced woodsman such as Dante (or Marwood Yeatman in the New Forest, some of whose dried mushrooms are shown opposite) can amass a whole larder of wild-grown delicacies, particularly in the autumn.

For some people, even a larder is not enough. The most remarkable forager I came across was Anne Misselbrook, who lives on a big and distinctly unrural council estate in Redruth, Cornwall, but spends most of her time travelling and scouring the hedgerows,

woods and cliff tops of western Cornwall for natural delicacies. She has such a reputation that she now supplies many top restaurants in Cornwall and beyond.

Anne was born and raised in rural Hertfordshire and has been devoting increasing time to foraging since coming to Redruth six years ago. She reckons she knows where to find between 80 and 90 different foodstuffs, ranging from leaves, berries and shoots to mushrooms, seaweeds, flowers, seeds and nuts. Favourites include sorrel, rock samphire, sea beet, pennywort, black mustard leaves, ox-eye daisy leaves, alexanders, elderflowers and elderberries, rosehips, sloes, thyme, fennel, marjoram, mint, fuchsia fruits, gutweed, bladder campion, scurvy grass and hottentot figs.

Often, she gathers so much that she needs an old trolley to get it back to her car but, as she says, "It's a really satisfying thing to do. The sheer abundance of nature makes me happy every day. There's always something new to discover, whatever the season. Even if you're not picking it, you're seeing what's in seed and what's in flower. It's about noticing what's right in front of you. It's amazing how much people don't notice, even when it's under their noses."

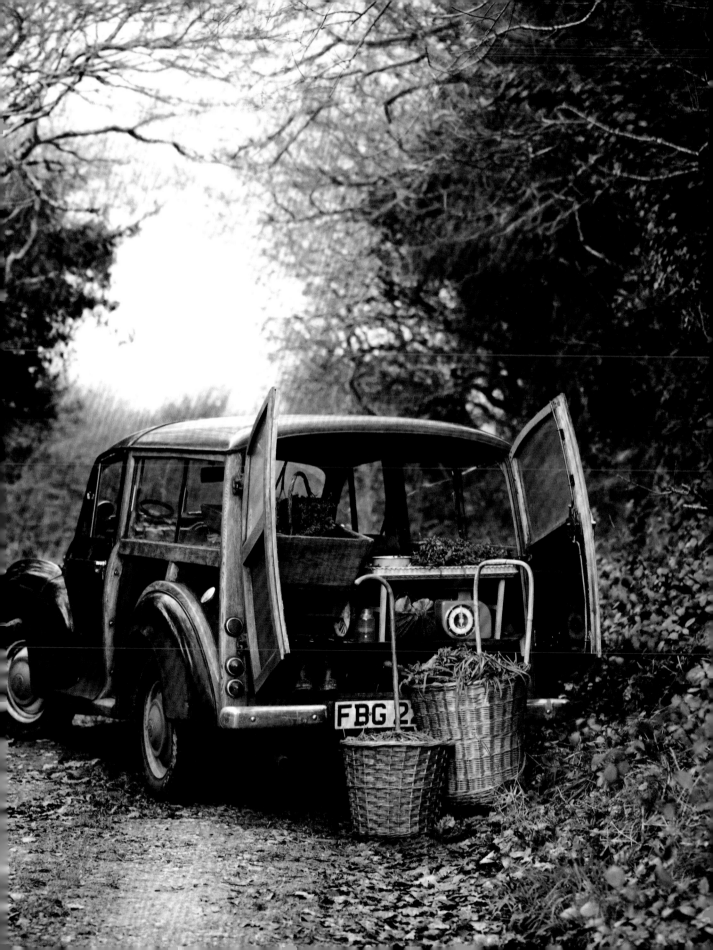

NOT EVERY TREASURE IS EDIBLE.
The countryside has many overlooked marvels. There must be hundreds of millions of dew-spangled cobwebs suspended in the branches of trees every autumn day, but how often do any of us think to stop to look at them? One day I did, and stood until my feet grew numb as I wondered at the infinite complexity of their delicate beauty, a thousand times more wonderful than a string of the richest pearls, and there for free, to be enjoyed by anyone who takes the time.

In the same way, how often does anyone stop to contemplate a cow? A crazy idea, perhaps, but at Rousham, in Oxfordshire, I watched a herd of longhorn cattle standing as still as oaks in misty autumn parkland. There is something magnificent about these ancient, patient beasts. Close up, you realize their monstrous power as they stand, placid, huge and enigmatic, indifferent to cold and rain, or the damp that drips from their hides. The more you ponder it, the stranger and more wonderful the world seems.

Even the most everyday sight such as tree bark, streams, weeds, hares, herons or rainwater running in rivulets down a stony path are reminders of nature's bounty and all are freely available, nature's gift to us all.

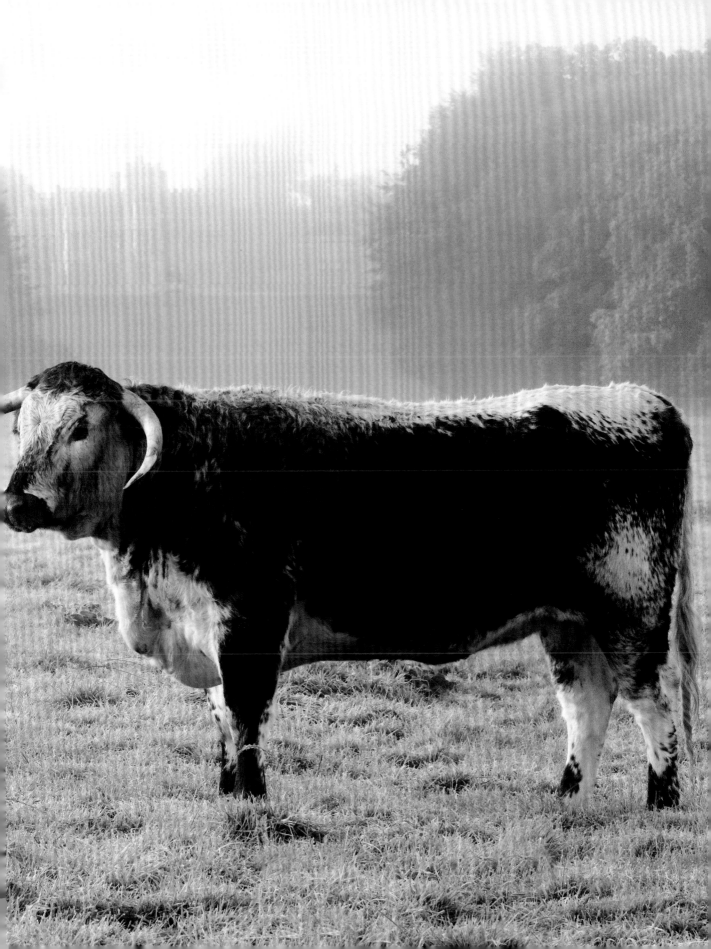

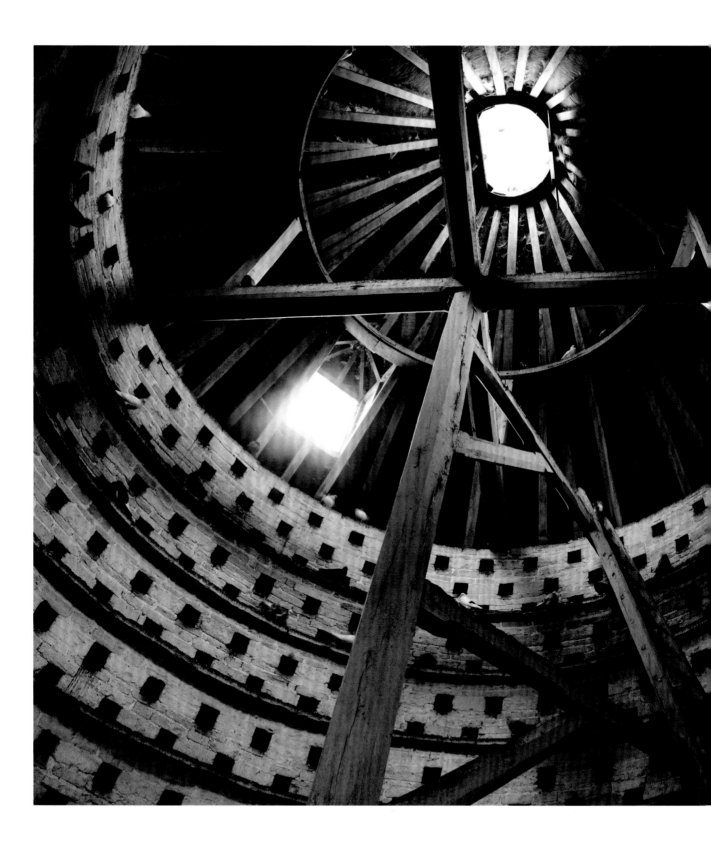

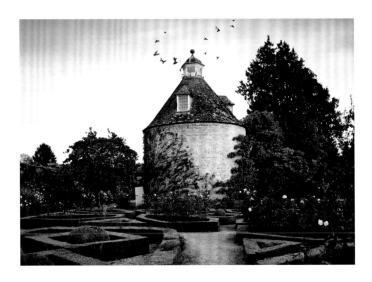

INDOORS AS WELL AS OUT, THERE ARE TREASURES
to be found that have nothing to do with expense. An old house can often
be more beautiful and interesting if it has not had much spent on it. Poverty
can be a great preserver. There are few better ways to ruin a house than by
throwing money at it, and when money is tight, especially across several
generations, there is often an aura of benign but charming neglect.

This is as likely to be true of grand houses as it is of humble cottages.
Rousham, one of my favourite country houses, is not maintained by the
National Trust or English Heritage. Instead, successive generations of owners
have kept it going and, as big old houses tend to eat money, it has hardly
changed over the centuries. It remains largely as its main creator, William
Kent, must have envisioned it.

Both the house and gardens at Rousham are fascinating. The house is
William Kent working in miniature. I think it is his best piece of work and,
like a fine wine, it has matured over time, some 250 years. Nothing about
is has been sanitized to modern taste. There is no tearoom or gift shop, and
nor has it been given a "makeover". As Angela Cottrell-Dormer, the owner,
says, "We just sort of carry on. You do what you can and don't worry about
what you can't."

As a result, you can still sense Kent's vision and, no less important, sense the many generations for whom it has been home. "We're very happy here," says Angela. "And we hope everyone is. There are probably about 50 people living on the estate. Many of them were born and bred here. It's the last of the feudal system, but we love it. It's unspoilt, low-key, traditional and comfortable."

I have visited Rousham many times, and it is always a delight to arrive at the house and smell the beeswax polish in the hall or feel the benign gaze of the portraits of ancestors. There are always fires burning and worn, comfortable armchairs. It has a distinctly homely quality. Even the guided tours, which help to pay for the upkeep of the house, are conducted by the family and advertised by an ancient home-made sign.

The contents of the house have been accumulated by various owners over many generations. The result is not so much a designed interior as a three-dimensional scrapbook of memories. Actually, there are two sets of memories because the "downstairs", or servants' quarters, is as unchanged as the "upstairs". Downstairs is more functional and shabbier, but both have a peculiarly rural authenticity. The bathrooms and kitchen, the peeling paint and battered pots and pans are all part of the house's texture, just as much as the ornaments and photographs in the grander rooms and the musket holes in the front door, bored by Sir Robert Dormer to make the house more defensible during the Civil War. It is a proper home. Everything has been used, enjoyed and considered – it has not been put there for mere display. You could never consciously create this look. Time has made it.

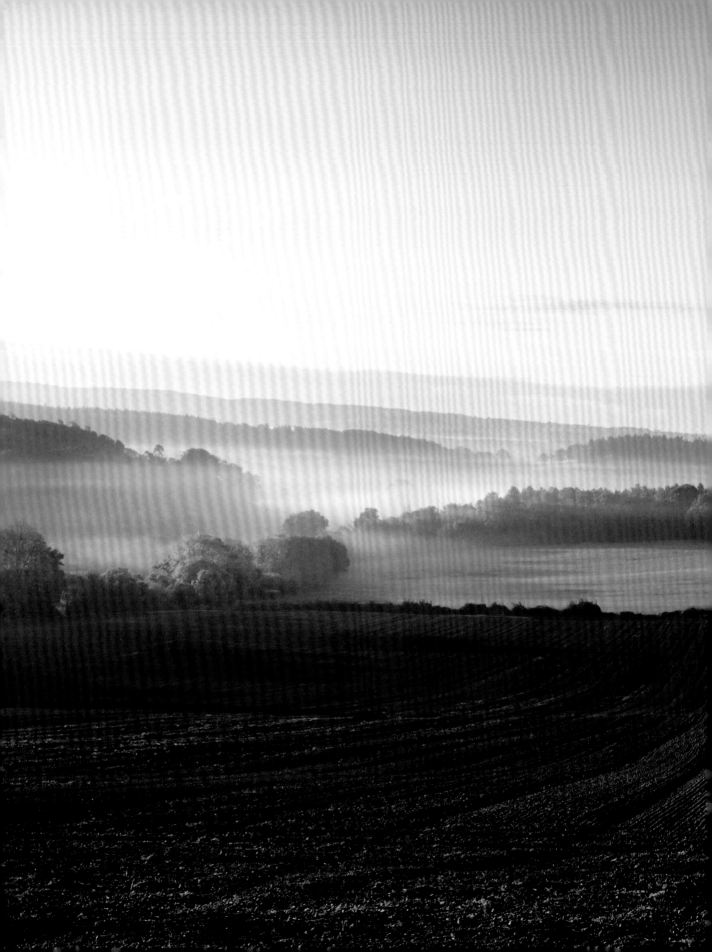

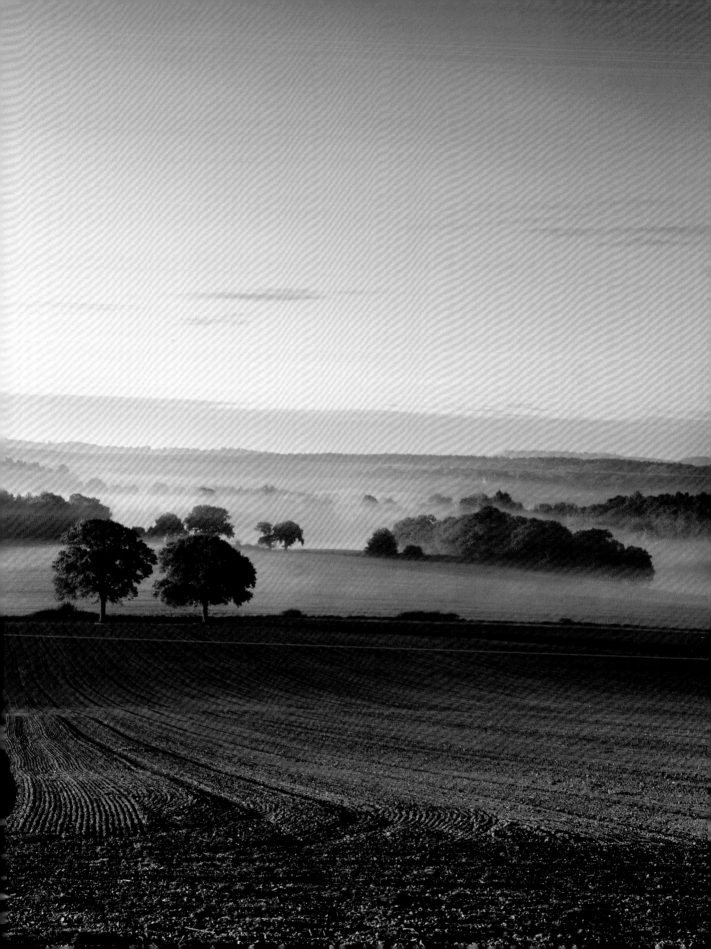

THE SEASONS MOVE ON AS THE
mornings grow colder, but are no less magical.
In the damp autumn air, a familiar landscape
can become an archipelago of wooded islands
rising from a sea of mist, teeming with unseen
life and crying out to be explored. Our farming
methods may have changed, but the "season of
mists and mellow fruitfulness" has lost none of

its romance, and those who are close to the land
still sense something miraculous in the way the
earth yields up its riches.

It is impossible not to be stirred by the harvest
festival at Rousham. The little church is packed
with local people of all ages, soberly dressed,
summoned by bells and giving thanks for the
harvest as countless generations have done before
them. Some bring food, all sing lustily. There is an
overwhelming sense of a community drawn
together by the knowledge that, without successful
harvests, our very survival would be in doubt.

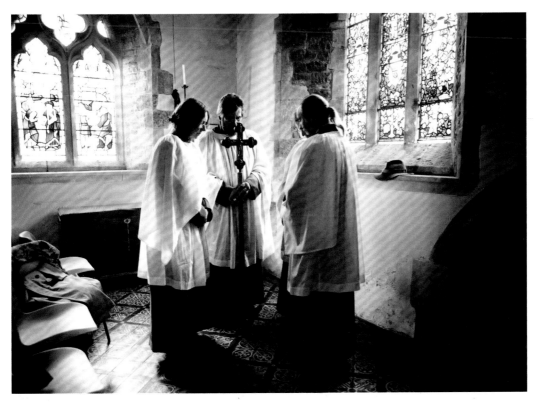

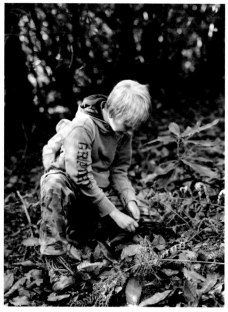

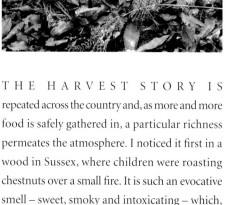

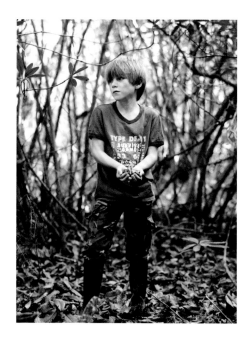

THE HARVEST STORY IS repeated across the country and, as more and more food is safely gathered in, a particular richness permeates the atmosphere. I noticed it first in a wood in Sussex, where children were roasting chestnuts over a small fire. It is such an evocative smell – sweet, smoky and intoxicating – which, once experienced, is never quite forgotten.

It is wonderful that some children, at least, are allowed to enjoy such experiences.

Others are not so lucky. A new edition of the Oxford Junior Dictionary excludes a raft of simple rural words (including "acorn", "ash", "brook", "buttercup", "blackberry", "catkin" and "conker") to make room for words more relevant to the modern world (such as "attachment", "celebrity", "citizenship", "committee", "compulsory" and "database"). It may be ludicrous but, sadly, it is a symptom of a heartbreaking trend. There are so many children who know nothing about the countryside. I wish I could show them all this.

You cannot roast chestnuts without singeing the odd finger, just as you cannot play conkers without the occasional bruised knuckle. Even so, those are not good reasons for discouraging them. They are a part of our memories and as rich and varied as the colours of autumn leaves. Those intense moments of childhood stay with us, to be savoured again in later years. That, in itself, is valuable, but there is also huge value in any activity that allows the act of feeding oneself to become, for a child, an intensely interesting and absorbing activity. The alternative is a future of ready-meals in front of the television.

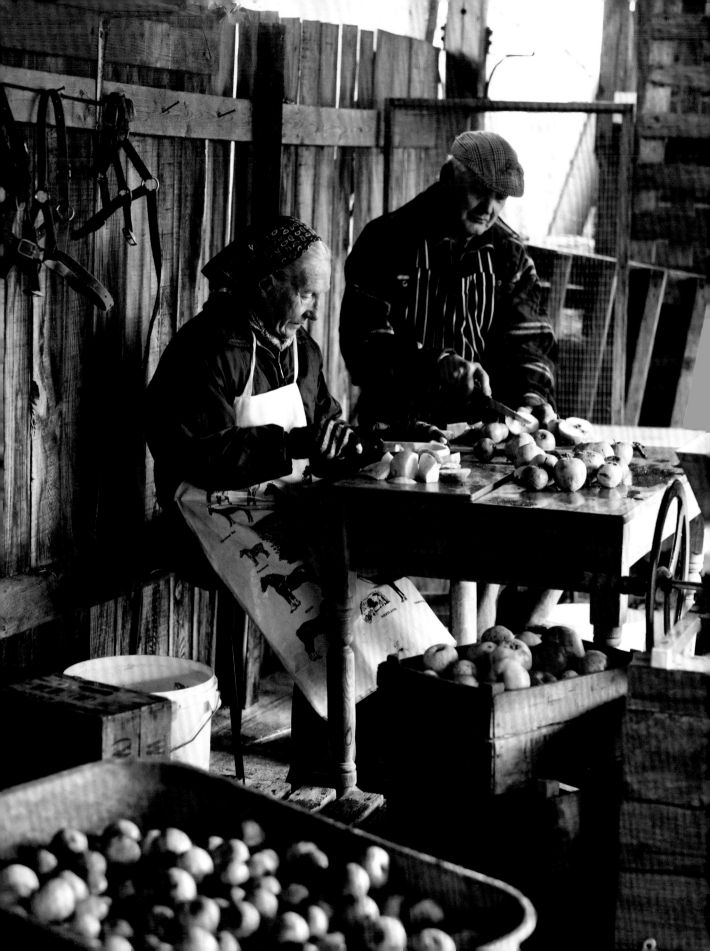

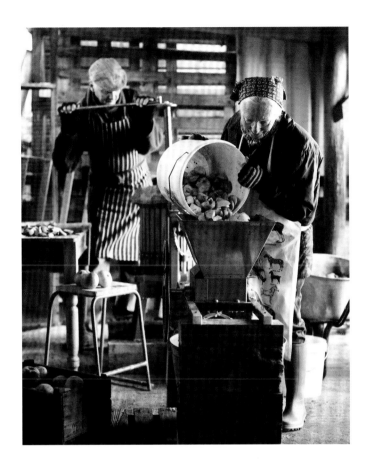

AS THE TIDE OF AUTUMN CONTINUES to rise, those of us lucky enough to be out and about in the countryside can sense its rich scent. In barns and storerooms, there is that lovely, hard-to-define atmosphere of fresh produce, perhaps strings of onions hung up to dry, the earthy smell of newly dug potatoes or the honeyed scent of apples stored on wooden shelves to ripen and mature.

Walking down a country lane you can tell, simply by smell, what fruits or vegetables are ready to be harvested. In Dorset and Somerset, autumn is (in Chaucer's phrase) "heavy with apples". Many have apple trees; some a whole orchard but, more often, just one or two trees. The trouble, if it can be called that, is that too many apples ripen at once. It simply is not possible to eat or cook them fast enough, even if you love them. Nor can you give them away. Everyone else is overwhelmed by plenty, too.

In my part of the West Country, we have a community apple press on a nearby farm. It is run by a formidable local woman called Patricia Thompson (at one point in her colourful life, she was a newsreader in Senegal) and has made a real difference to the lives of small-scale apple growers in the area. Rather than

regretting the apples rotting in our gardens, sheds and kitchens, we take them over to Patricia in the village of Henstridge, just across the border in Somerset, and turn them into apple juice.

It is wonderfully straightforward. After a few hours in her barn, chatting, chopping and pressing, you have enough juice, tasting of apples just plucked from the tree, to last for the rest of the year.

Patricia runs the press, but the local residents bought it. As so often happens in such enterprises, the collective initiative is a boost to local morale. In recent years, many community shops, several hundred across the country, have sprung up to compensate for the decline of the traditional village shop. Publicly owned pubs are a more recent variation on the same idea.

It is reassuring to know that, by acting together, you can make a positive difference to your lives.

There is a life-enhancing quality about going to the farm and seeing Patricia at work. The atmosphere is rich with autumnal smells: the homely old barn, the wooden shelves, the muddy floor, the boxes of apples waiting to be pressed, the fresh scent of the juice. Ripeness seems to permeate the air. The sight of Patricia working so serenely brings to mind Thomas Hardy's description of the woodsman Giles Winterborne, in *The Woodlanders*: "He looked and smelt like autumn's very brother, his face being sunburnt to wheat-colour, his eyes blue as corn-flowers, his sleeves and leggings dyed with fruit-stains, his hands clammy with the sweet juice of apples."

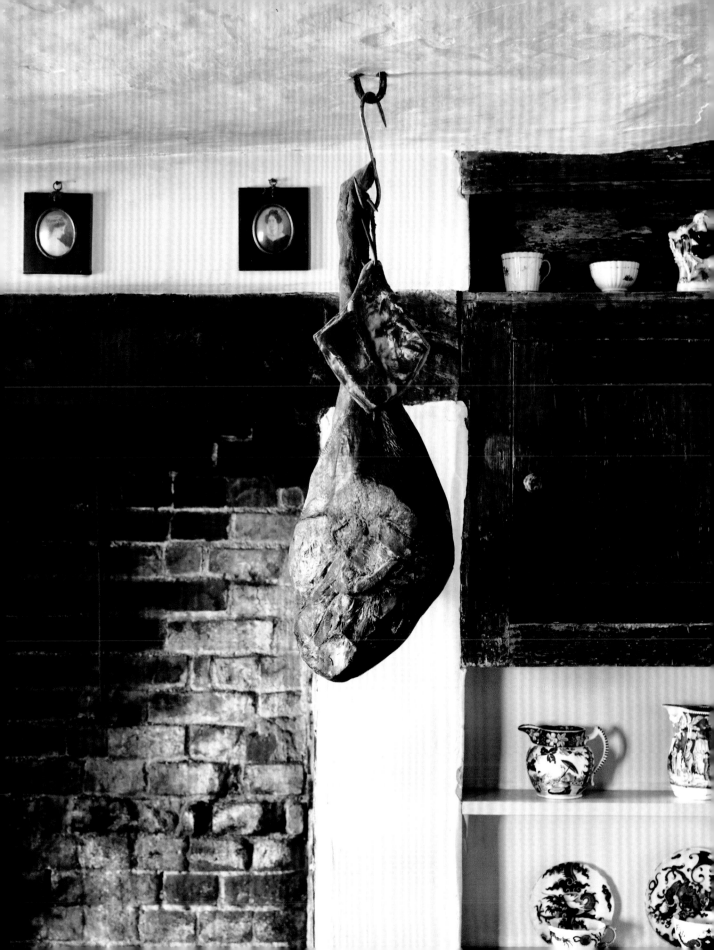

It is a place where the boundaries between people and nature are blurred. That blurring can give a country home its rural character, whether it is wet coats dripping in the hallway or a pile of logs still smelling of the woodshed. There are few more evocative autumnal smells than wood smoke drifting from a cottage chimney while the trees turn black against the sinking sun. It is why the best country homes feel so emphatically rural. There are traces of the land wherever you look, from the home-grown herbs and home-made jams in the kitchen to the locally reared pork hanging from a hook above a fireplace, in which wood gathered from nearby is smouldering.

People are as much a part of the countryside as nature itself. The fire is lit for people to gather around. The old sofa is frayed and scuffed by generations. Food is gathered and prepared so that people can enjoy a meal together.

It is all part of what the countryside means to me; people congregating, food enjoyed close to where it was grown or reared, the warmth of the fireside and the comfort of old, familiar furniture. None of these is a complicated pleasure, but I think that they are all some of the richest that life has to offer.

263

IN HINTON ST GEORGE, IN SOMERSET, EVERYONE
gathers for Punky Night, a local variation on Halloween. Lanterns
are carved from mangold-wurzels, rather than pumpkins; instead
of trick-or-treating, there is a parade through the streets culminating
in a party where prizes are awarded for the best lanterns. No one
really knows when or why it started, but legend traces it to a windy
night when some drunken villagers fell asleep on the way back from
Chiselborough market and were terrified by the improvised lamps
used by their wives to search for them. When you see the enthusiastic
villagers of all generations participating in Punky Night, you can
only feel happy that the custom, authentic or not, persists. It is that
sense of community that helps to keep the countryside alive.

THE NIGHTS LENGTHEN AND, AS THE clocks go forward, thoughts inevitably drift towards Christmas. It is a busy time, with village pantos and carol services to arrange, parties to be juggled, family get togethers to be organized and, of course, presents to be bought and Christmas dinners to be prepared.

In my part of Dorset, it is still possible to do most of your Christmas shopping without getting sucked into the soulless half-world of shopping centres, superstores and Internet deliveries. There are still enough traditional shopkeepers in the towns and villages for the approach of the festive season to generate excitement. I wish more people realized how lucky we are. If we do not use these shops, we will lose them.

In Blandford Forum, there is a wonderful place called the Dorset Bookshop, arranged over a series of rooms in a beautiful old Georgian building near the centre of the town. It has been a bookshop for nearly 60 years and, although it changed hands a couple of years ago, the new owners, Kevin and Denny Cook, have remained true to its spirit as one of those wonderfully personal, idiosyncratic little shops that are a pleasure to visit, irrespective of what you end up buying.

"We don't stock bestsellers," says Denny. "There's no point. We can't compete on price. If WH Smith's are selling the new Harry Potter for 99p, we won't even stock it, or perhaps buy only a single copy. It's not what we're here for. We're here to sell books we think people will like; good books. There are no clear rules, it's just our judgment. You build up a relationship with your customers and try to find things you think they might like."

It is this quality that makes the Dorset Bookshop so popular. It is like belonging to a very charming and well-informed book club. Just seeing what is on the shelves is a stimulating and mind-broadening experience. You discover books you might never even have thought of looking for. It's slower, obviously, than ordering a bestseller online, particularly if you spend hours browsing, but it makes shopping a pleasant experience, rather than a chore.

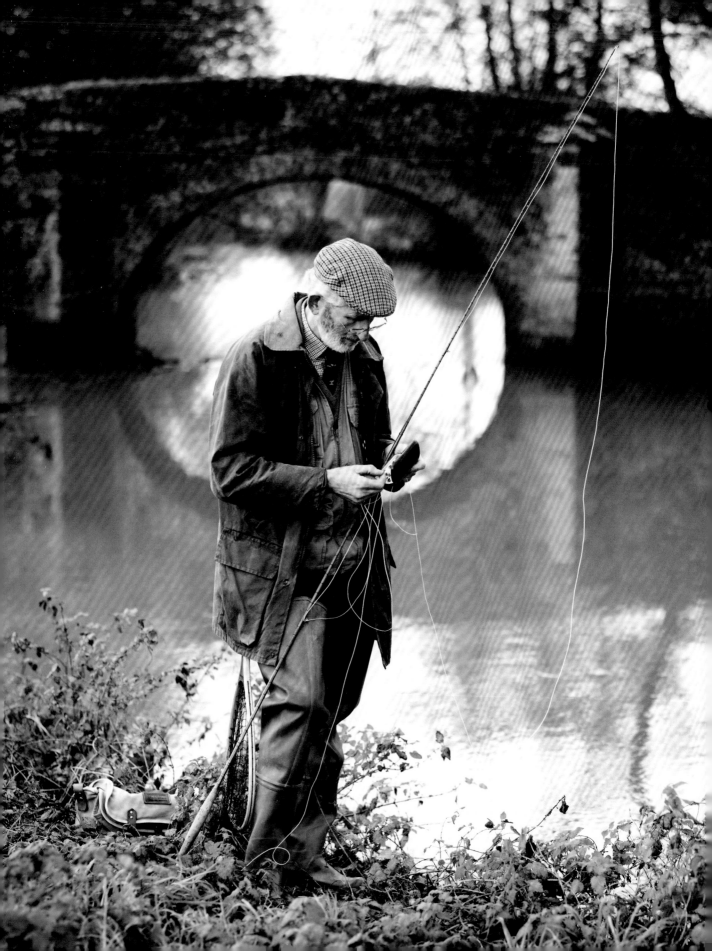

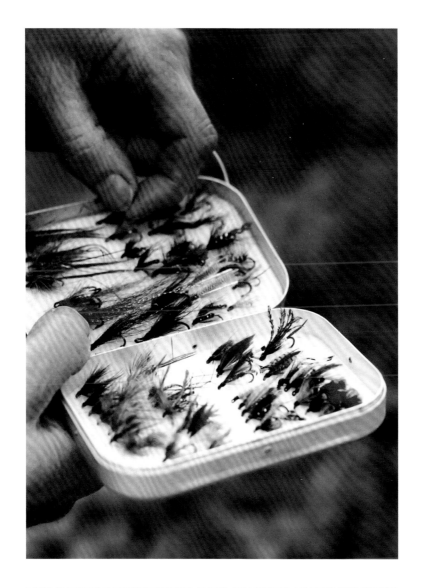

LIFE IN THE COUNTRYSIDE GOES ON EVEN AS THE WEATHER
grows colder and more forbidding. We found Mark Williams waist-deep in the two-mile stretch of the river Rother he manages for the Cowdray Estate in West Sussex. It was closed season for trout, so he was trying his luck at catching grayling, patiently casting and recasting his fly, which he tied with easy grace. He has worked on the estate and lived in the same cottage for 38 years and knows the waters well, just as he knows the haunts of the kingfishers, egrets and moorhens with whom he shares the river. "I still love it," he says. "You don't have to catch any fish. It's just the being there."

Even those of us who have never felt drawn to fishing or shooting might sense at least some of their appeal. They draw you out on days when winter keeps most people indoors. It helps, of course, if you have comfortable shelter near at hand, like the old hunting lodge in Martindale, known as "The Bungalow". It could hardly be called spartan – it was originally built for Kaiser Wilhelm a century ago – but it is, in the best sense, functional; a place that allows you to be warm, comfortable and secure even in the heart of the Cumbrian fells.

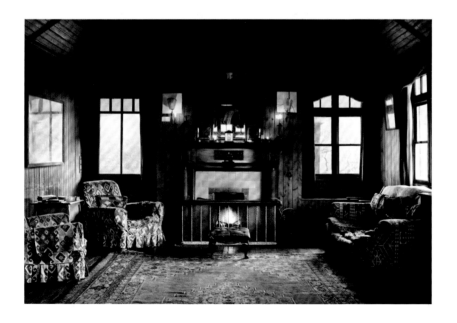

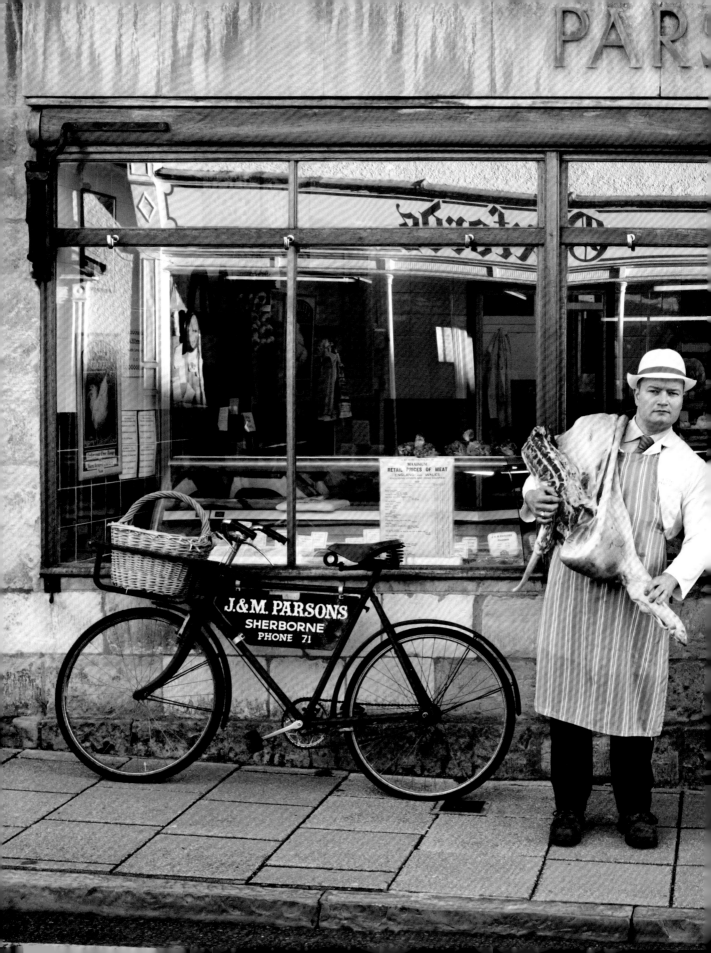

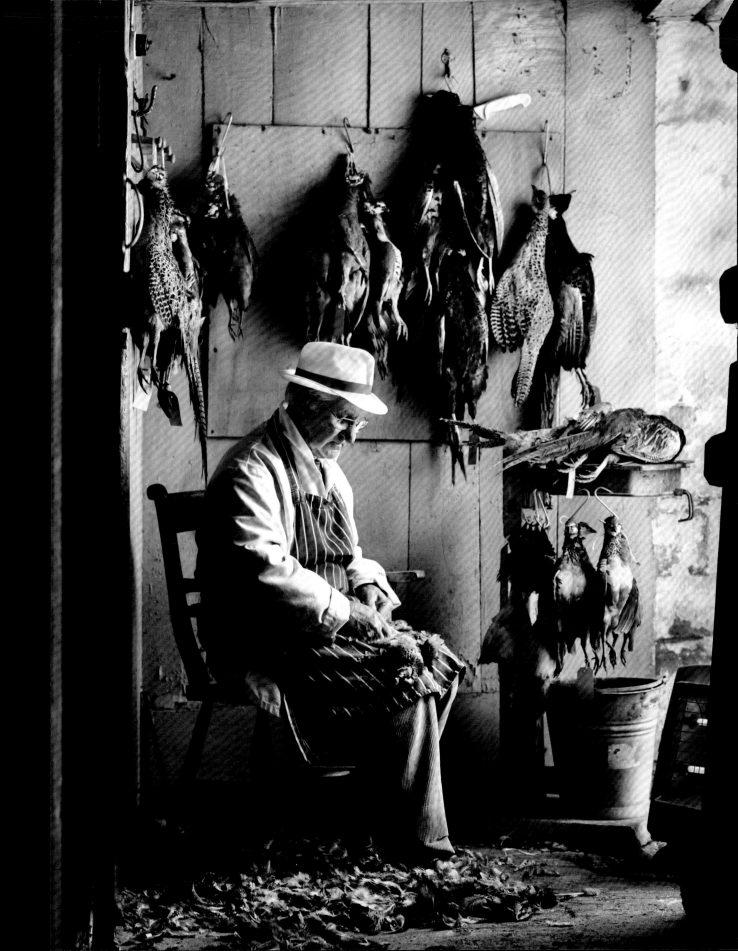

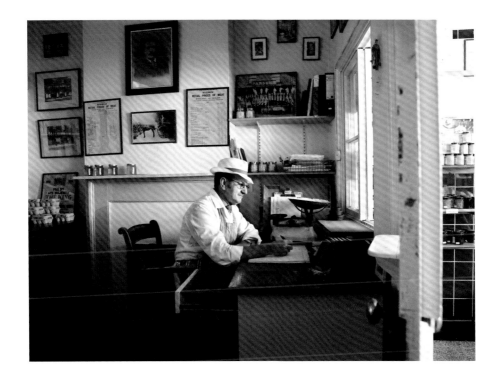

IN MY LOCAL BUTCHER'S SHOP which Peter Baker's family has run for the past 150 years, they are taking on extra staff for Christmas. "Luckily," Peter says, "they're all my children and nephews and nieces, so we don't have to pay them." His brother, Richard, is a partner in the enterprise. They don't share its name, J & M Parsons, because it passed down the maternal line, but the spirit of the business remains as it always has: small-scale and good-natured. If you want advice on a cut of meat or to know its provenance, this is the shop for you. They still buy their meat from local farmers, and butcher it on the premises. "In most cases," Peter says, "I imagine their grandfathers would have done business with my grandfather."

It is, he says, hard to compete with the supermarkets on price, but there are still many people who prefer a more personal touch, particularly for special occasions. They had just ordered 500 fresh farm turkeys and were expecting a hectic Christmas. "I wouldn't say we're thriving," says Peter, "but we're managing well enough."

The brothers learned their butchering skills from their father, who in turn learned his from his father. Are they expecting to pass their skills, and the shop, to the next generation of the family? "It doesn't look likely at the moment. Not unless they get chucked out of university. But you never know. At any rate, I hope I'll be able to pass what I know down to someone."

THERE ARE MANY GOOD REASONS FOR being out in the cold and dark when the days are short. There is Halloween and carol singing, but my favourite is Bonfire Night. There is something so primal about the noise and drama as well as the scent of wood smoke and burnt gunpowder, smelling just as it did four centuries ago. Sadly, the tradition is fading. The burning of guys is increasingly frowned on (too sectarian), while the health-and-safety culture looks like putting paid to traditional sparklers. It is hard to see the benefits. If we shield children from every possible hazard, what childhood will be left? As for guys, I believe that we are all diminished each time a piece of shared memory is lost. At Willisham, villagers watched with varying degrees of awe as a smartly dressed guy was dramatically consumed by the leaping flames. One boy asked his young mother to tell him what the ritual was about. "I don't really know," she said.

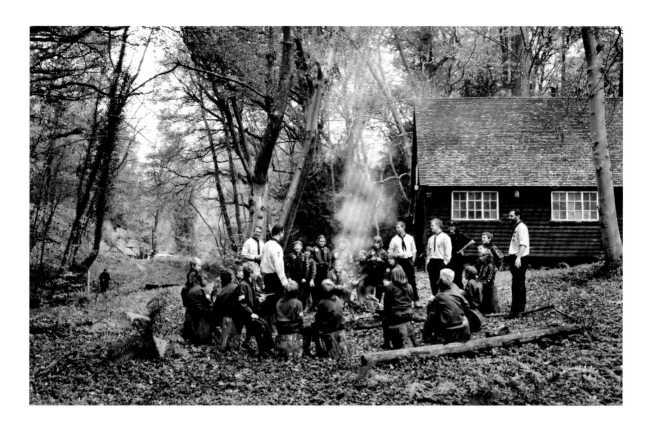

IN WOODS NEAR FERNDOWN, IN SURREY, we found a scout camp. It is hard to think of a less fashionable movement – or a more character-building one. It is not the uniforms and old-fashioned games and songs, but the fact that children are experiencing basic human rites of passage such as learning to sleep in the open and feed themselves from a camp fire, or learning to respect the environment and handle dangerous things safely. Those who sneer at the scouts imagine that it is all bound up with narrow rules and discipline, but the children patently feel liberated by it. Some parents might look at the pointed, smouldering sticks with which the children cook their food and shudder at the potential for disaster (as others do with sparklers). I wish, instead, that they would look at the child holding it, face rapt with concentration and excitement.

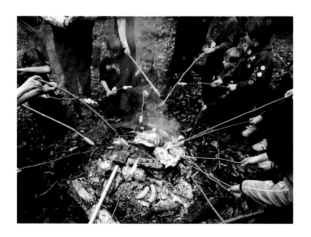

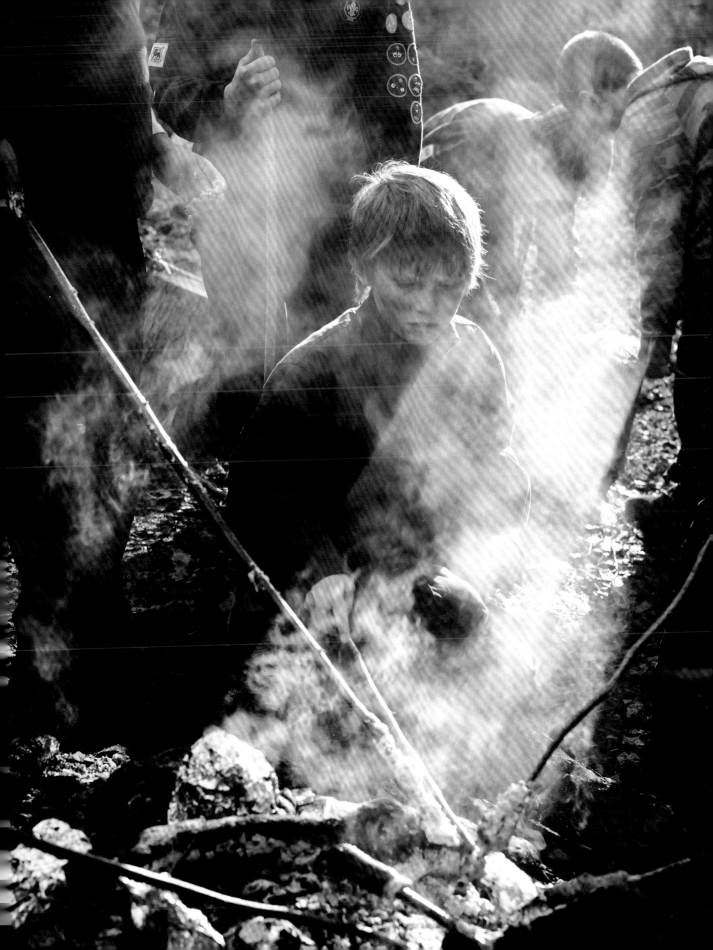

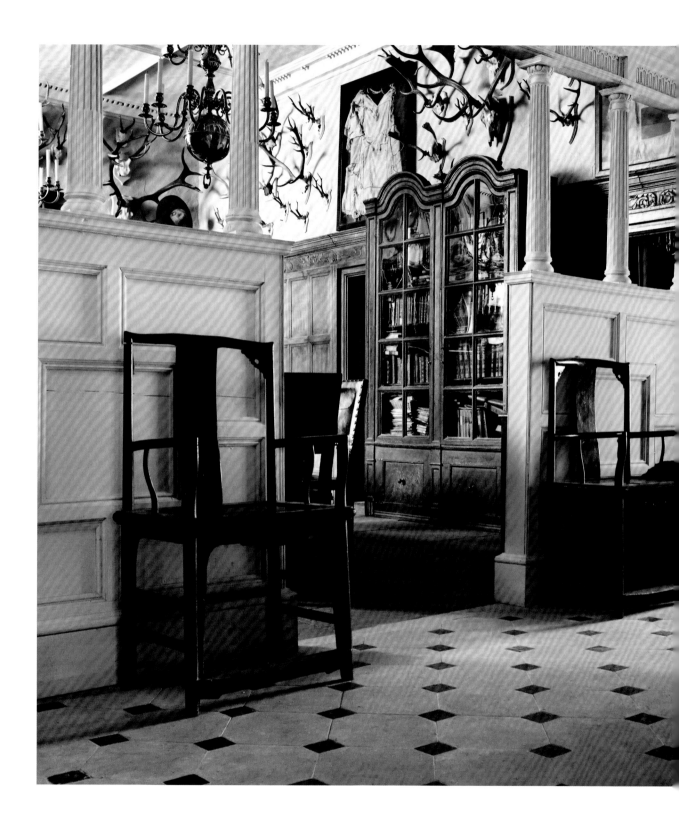

SOMETIMES I WORRY THAT, IN OUR EAGERNESS TO eliminate unpleasantness or dangerous things from our lives, we are also taking away much of the colour. Strange old customs are smoothed away, and links with the past are broken. Life becomes more predictable, safer and more uniform.

Happily, my year of rural rambling has reassured me that the countryside I love remains a more chaotic place than health-and-safety headlines suggest. Yes, there are places where idiosyncrasies and traditions are being lost, but ultimately the dominant notes of country life are still local, individual, unpredictable and eclectic.

Looking back over my travels, I realize that everyone has a slightly different version of the rural dream. For Marwood Yeatman it is about an authentic approach to food; for Andrew Dodge it involves chickens; for Tim Hurn it

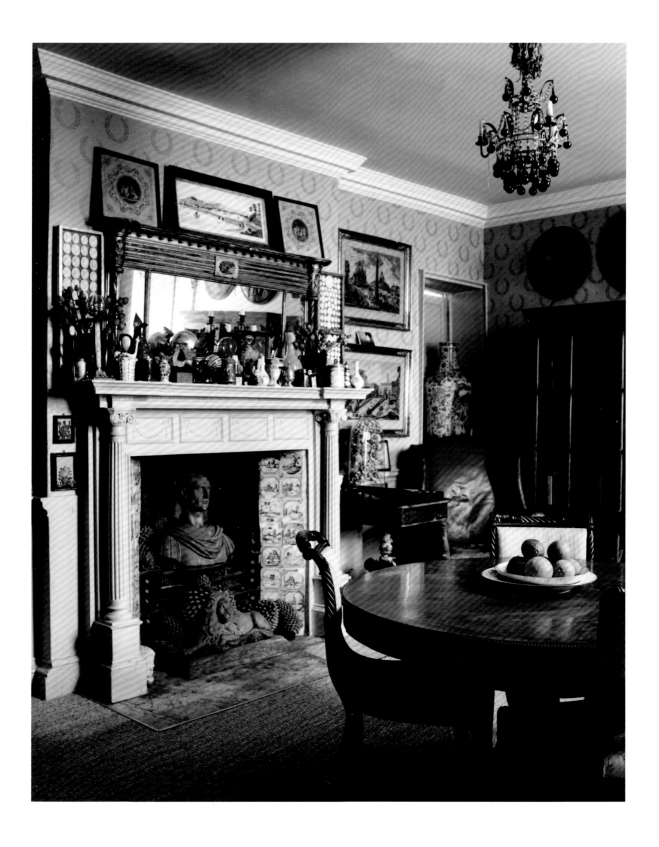

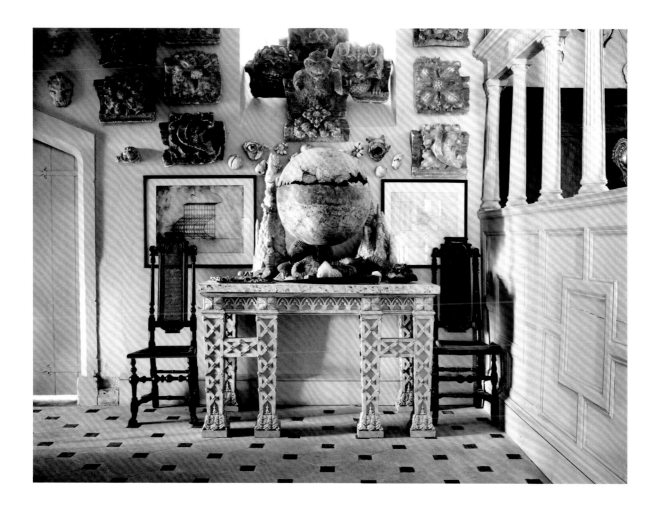

is about pottery; for Rupert and Jane Grey it means living in a very natural, traditional way; for Gordon Newton it is about Morris dancing; for Felicity Irons it is bulrushes; for the Monies family it is farm and family; for Richard Pinney it is oysters; and for Nell Gifford it is the circus. They are all doing what they love. They had a dream and followed it, just as Isabel and Julian Bannerman have done. They live in a restored medieval manor on the edge of Bristol and are famous for their extravagantly inventive garden. Their imaginations are just as fertile when it

comes to interior design. The house overflows with eclectic clutter. "We're terrible magpies," says Isabel. "We'd both accumulated masses of junk before we even met." They have lived in the house for 15 years and have only just finished doing it up. "The garden always comes first. We're hoping to open it to the public soon, so we can afford to stay here. There's never been a grand vision for the house. We just make it up as we go along."

The enormous hall is festooned with antlers ("I got a lot of them from eBay."), and the fireplace in the library is based on

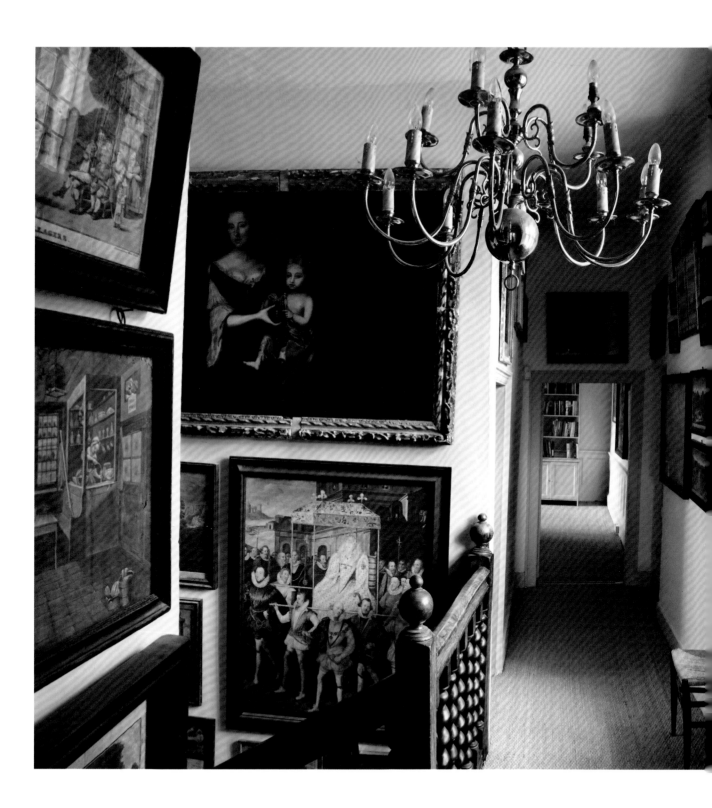

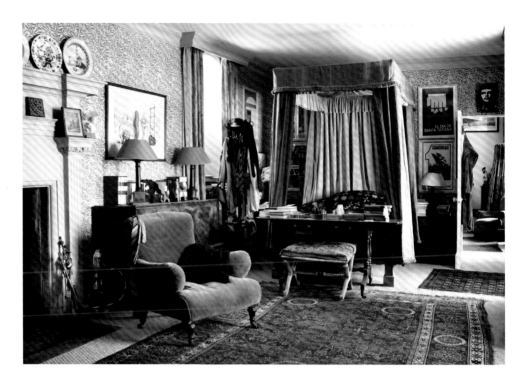

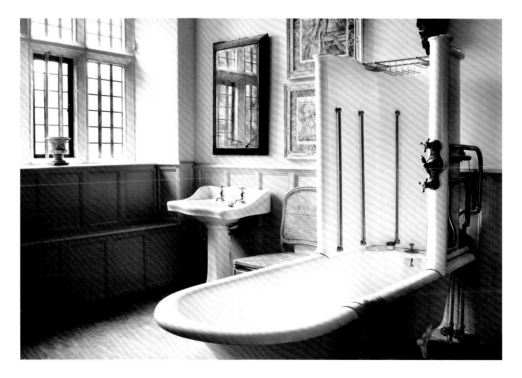

an old organ. Some tattered garments on display in the hall, worn by soldiers of the Mahdi army at the Battle of Omdurman in 1898, came from a skip in Edinburgh. Several of the paintings on the walls are posters or pages from books. "Everything is chipped or broken," says Isabel. "Most of it is just rubbish." Even so, the effect is extraordinary, like wandering through a vast emporium of bric-a-brac, never knowing what delight you might stumble across next.

On a table is what looks like a stylish piece of modern art; a metal globe, artfully weathered and distressed, with a crack across it like a wry grin. It turns out to be the gilded ball with which Sir Christopher Wren topped Tom Tower at Christ Church, Oxford. The tower was restored in the 1950s and a new ball installed. The old one, cracked, eroded and long since gildless, was discarded and eventually found its way into the Bannermans' treasure trove. The medieval bosses on the wall behind it are

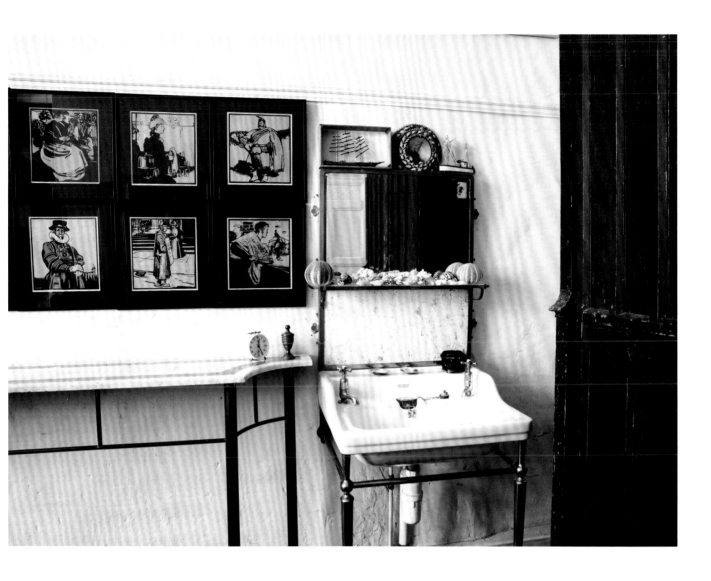

also Oxford discards; nineteenth-century casts taken from stone carvings and used as a record prior to restoration before being discarded. Isabel found them in a reclamation yard.

It is not so much grand as charming and, although Isabel makes it sound artless and random, it has clearly been done with great sensitivity and painstaking restoration. It is, for all that, a country interior expressing its owners' eclectic tastes, rather than a designer's blueprint. It feels authentic, a real country house of the imagination, and has a strong sense of home. It is, ultimately, a place to be lived in.

Look at the smouldering fireplace, overleaf. Who doesn't want to sit in front of such a fire? It may not be as large, but the embers will have the same comforting glow, the ashes the same pale dust, the flames the same lively warmth. A carefully positioned armchair makes a cosy retreat from which to gaze into the flames and dream.

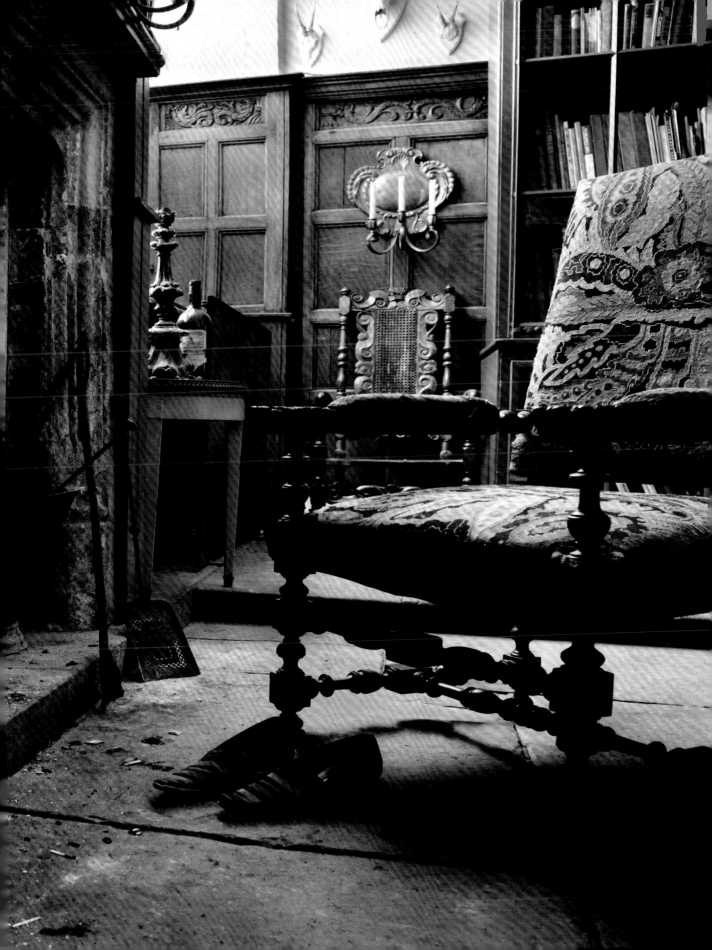

ONE OF THE LAST STOPS ON MY JOURNEY
was the rugby club on the edge of Sherborne, where the drabness
of a small, functional clubhouse had been banished by colourful
Christmas decorations and a lively, happy crowd.

It was the night of the annual revue. Not a glamorous show or,
by West End standards, a very slick one, it was instead uproariously
enjoyable. There were sketches and songs and dances and jokes,
all carried off with robust good humour and culminating in a
show-stopping number based on *The Sound of Music*. You could
see wives and brothers in the audience wondering if they were
hallucinating as some of the toughest men in Dorset were
miraculously transformed into the singing Von Trapp children

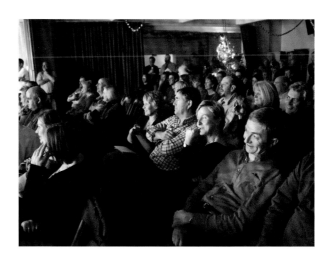

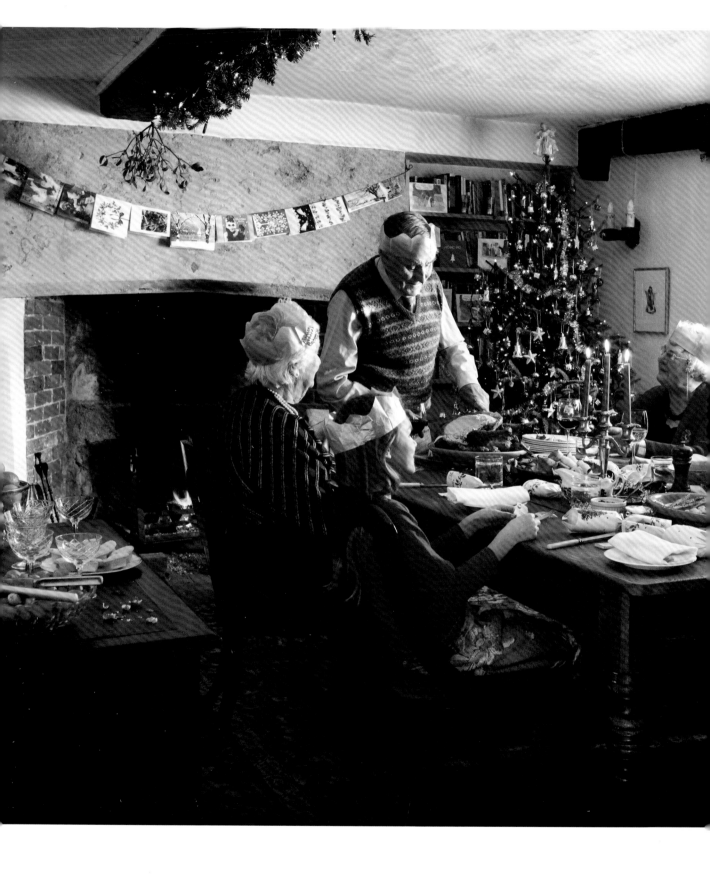

(and, in one case, a singing nun). I doubt many of those involved will go on to a career on the stage, but for sheer collective high spirits it was an unbeatable show-business moment.

"We've been doing this for years," explained Mike Burks, a garden centre manager and first-team second-row rugby forward who wrote much of the show. "Sometimes it's a revue, and sometimes it's a panto. Sherborne is a small club, and we're very strong on the social aspect. A lot of people take a certain amount of persuading to perform but, as the night approaches, they suddenly get hooked. Often it's the quiet ones who really let themselves go. It can be very, very funny."

And so it was, but it was more than that; it was uplifting, an explosion of conviviality. Although there was nothing overtly traditional about it, it seemed to tap into an important rural tradition of bonhomie and shared goodwill. That's why, as the year draws to its close, the countryside can feel even more alive than it does when everything is in flower. In the cold months of winter, people turn to one another for warmth.

In grand houses and little cottages, market towns and remote hamlets, people congregate for the most traditional of all our festivals: Christmas. Presents are wrapped and unwrapped; feasts are prepared, cooked and eaten. Old friends and relatives are visited; too much is eaten and drunk. Rituals, such as wearing paper hats or setting fire to the Christmas pudding, connect us to the benign ghosts of Christmas past. This is what we did last year; what we did when we were younger; what our parents or grandparents did. It is what we will do next year, too. We give thanks for the good things in our lives. It is about family and friends, a celebration of being alive.

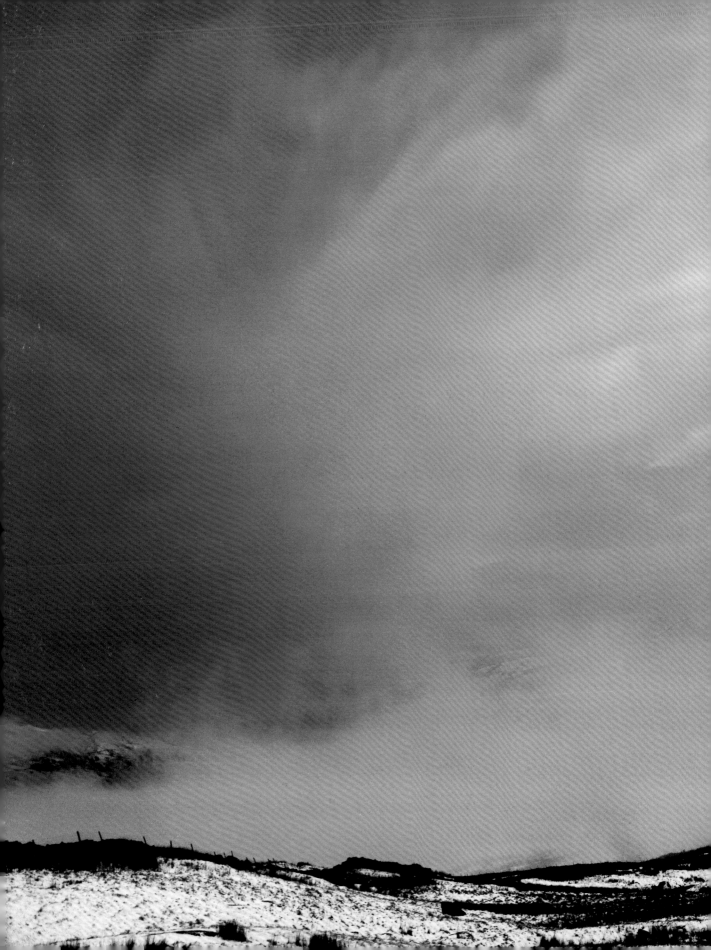

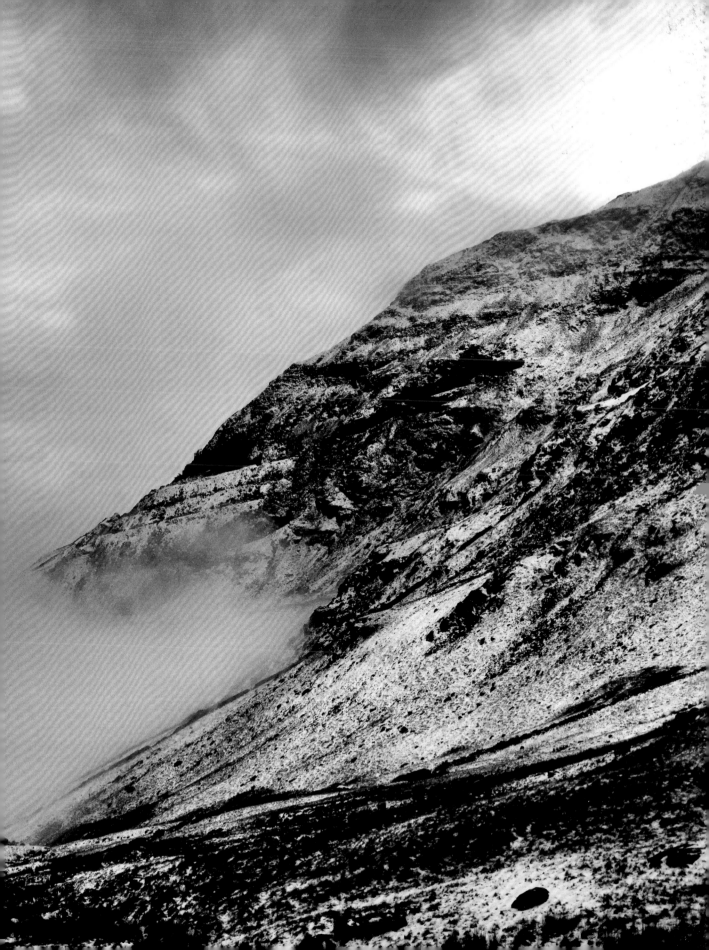

POSTSCRIPT

I finished my journey full of hope, thankful for the abundance of our countryside and the generosity of the land, the people, the buildings and the history; thankful for nature itself. When I look back on my year of exploration, the image I cherish is of a perfect early morning when half of England seemed to be spread out, sleeping beneath the light silver blanket of dawn. This is the countryside as it is meant to be, as natural and unspoiled as it was in Shakespeare's day, or Chaucer's.

The idea that the countryside should never change is absurd. It has been in flux for centuries, and it will go on changing. My hope is that, even as we move forward, we remember the simple things the countryside has to offer and treasure them, for ourselves and for future generations. There is so much to be lost in forgetting and so much to be gained in celebrating and preserving our heritage.

ACKNOWLEDGEMENTS

The author would like to thank: Andy the traveller; Richard Askwith; Auntie Mary and Uncle Bob; the Bannermans; Jake Barrett; Mary Bell and family; the Blackmore & Sparkford Vale Hunt; Bob and Linda at the King's Head, and all who frequent her; Sally Brampton; Mike Burks and the Sherborne Rugby Club; Buster, Quincy and Frankie; Butley Orford Oysterage; James Campbell and Scott Richards; Harold and Tess Carter; Dr Simon Cave and Colonel; Jonathan Christie; Caroline Conran; Ned Conran and family; Kevin and Denny Cook; Mr and Mrs Cottrell-Dormer; Lorraine Dickey; Andrew Dodge; the Doggrell boys; Thomas Faulkner, Tim Fowle and the other "ducks"; Gifford's Circus; Karin Grainger; Rupert and Jan Grey; Robert and Jane Hasell-McCosh; Katherine Hockley; Tim Hurn; Edward and Jane Hurst; Felicity Irons; Barbara Lake; Dante Leonelli; Sybella Marlow; Anne Misselbrook; Bridget Monies and her family at Tremedda Farm; Andrew Montgomery; Jenny Montgomery; James Moriarty; Trish O'Hara; Parsons butcher's; Pateley Bridge sweet shop; Lord and Lady Sandwich; Judith and Ray Silsby; the sweeps; Patricia Thompson; Keith and Gloria Tordoff; Mark Williams; Andrew, Ruth and Georgie Wilson; Eileen Wilson; the Wilton Hunt; Marwood and Anya Yeatman.

First published in 2010 by Conran Octopus Ltd, a part of Octopus Publishing Group, Endeavour House, 189 Shaftesbury Avenue, London WC2H 8JY www.octopusbooks.co.uk

A Hachette UK Company www.hachette.co.uk

First published in this edition in 2012

Distributed in the US by Hachette Book Group USA, 237 Park Avenue, New York NY 10017 USA
Distributed in Canada by Canadian Manda Group, 165 Dufferin Street, Toronto, Ontario, Canada M6K 3H6

Text copyright © Conran Octopus Ltd 2010;
design and layout copyright © Conran Octopus Ltd 2010; photography © Conran Octopus Ltd 2010

British Library Cataloguing-in-Publication Data. A catalogue record for this book is available from the British Library.

Publisher: Lorraine Dickey
Consultant Editor: Richard Askwith
Managing Editor: Sybella Marlow
Art Direction and Design: Jonathan Christie
Production Manager: Katherine Hockley

ISBN: 978 1 84091 608 9
Printed and bound in China